D

Dominant Wave Theory

photography by Andy Hughes

Booth-Clibborn Editions

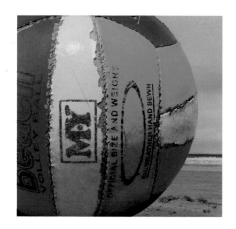

First published in 2006 by
Booth-Clibborn Editions
Studio 83
235 Earls Court Road
London SW5 9FE
www.booth-clibborn.com
© Booth-Clibborn Editions 2006

Photography © Andrew Hughes 2006
Text © Chris Hines, Josh Karliner, Lena Lencek, Dr Christopher Short, Dr Richard Thompson

Design: David Carson; Assistant designer: Kohei Shimizu
Editor for Booth-Clibborn Editions: Eszter Kárpáti

The information in this book is based on material supplied to Booth-Clibborn Editions by the author. While every effort has been made to ensure accuracy, Booth-Clibborn Editions does not under any circumstances accept responsibility for any errors or omissions.

A Cataloguing-in-Publication record for this book is available from the Publisher.

ISBN 1-86154-284-4

Printed and bound in Hong Kong

Essays

Dominant Wave Theory - The title of this

book refers loosely to a scientific term used in the prediction and observation of wave models. Wave models depict sea heights, fetch areas and swell propagation patterns for the oceans of the world. They construct an estimate of sea heights, period and sea swell headings over time using current and projected wind data from atmospheric models. In simple terms, it is the interaction of wind on water that creates waves.

The Work

Dr. Christopher Short-

Across the body of photographs contained in this book, we may identify three dominant issues, each of particular importance to Hughes' encounter with West Cornwall in general and St Ives - Hughes' home for nearly a decade - in particular. The first is the formal, aesthetic engagement of the land and sea that was so important to leading British modern artists in and around St Ives from about 1930. Hughes describes his relationship to this tradition as ambivalent, at one moment developing in relation to it, at the next seeking to avoid it. The second is the remarkable increase in tourism in the area in recent years, fuelled not only by the beauty of the land and sea but by the extraordinary success of Tate St Ives in bringing tourists - cultural and recreational - with money to the area. This has impacted most importantly (in the present context) on the quantity and quality of art produced in and around the town for sale in the town's innumerable galleries. As a contemporary artist living and working in the area, Hughes has inevitably developed a critical relation to such practice. The third is the beach itself which, for both locals and visitors alike, serves as a site of escape from the pressures of commercial life and, at the same time, as a site of contamination, as the place where the excesses of that commercial life - food wrappers, drink containers, sewage - get washed-up. As a surfer and frequent walker of the shorelines in and around St Ives, the beach forms an important focus for Hughes' recreational as well as professional activities. The following will attend to each of these issues in turn, exploring the ways in which it impacts upon the photographs.

The story of art's importance to St Ives begins at least as early as 1811 when Turner visited it. In 1877 the Great Western Railway arrived facilitating the development of tourism and bringing with it an influx of artists. Whistler and Sickert visited the town in 1883-84 and about this time, the Newlyn School was founded eight miles south of St Ives. The town's first full-time studios were established in 1885 and in 1888, the St Ives Art Club was founded. As the town's fishing industry fell into decline, a new economy began to develop, one based in tourism and which brought with it an art community that would, in time, become increasingly important as an object of tourism itself.

The permanent collection of Tate St Ives gives a clear indication of the kind of art which came to be produced from the late 1920s, the beginning of St Ives Modernism. Although a variety of styles is evident, much of the painting and sculpture tends toward the abstract while remaining rooted in nature. Popular accounts of such art describe the use of colour and form as direct products of the particular quality of light that is apparent in and around the town, the extraordinary colours of the sea, the forms of the granite outcrops and cliffs, and so on. **Those accounts that highlight the importance of such natural forces of the country and seaside are, in part, accurate.** For the artists, the move from city to country was a kind of return to nature, a recovery of a more authentic existence that would be embodied in their art. This was accompanied by an interest in the primitive, the quest for which led to the painters Ben Nicholson (1894-1982) and Christopher Wood (1901-1930) discovering and learning from the naïve paintings of the retired seaman, Alfred Wallis (1855-1942). Place and art, then, configured as a retreat from the decadent forms of the city and corrupt civilisation, as a primitivism shared with much of modern art. Throughout Europe and North America, such artists' colonies arose as alternatives to perceived social and cultural decay. But set against this quest for the primitive and the jettisoning of convention, stands evidence of considerable learning, the antithesis of the primitive as it was conceived. Without a knowledge of Cubism, there could be no Nicholson; without a serious engagement with international constructivism, there could be no Barbara Hepworth (1903-1975); without the precedents of European and American Expressionism, no Patrick Heron (1920-1999). **St Ives Modernism is important not merely as an escape from the horrors of modernity, but as a radical and important part of the history of the development of British and international modern art.**

In conformity with much international constructivist art, Hepworth described how the formal concerns of such abstract art could assume social and political significance: "A clear social solution can only be achieved when there is a full consciousness in the realm of thought [... The artist's] conscious life is bent on discovering a solution to human difficulties by solving his own thought permanently [...] formal relationships have become our thought, our faith, waking or sleeping - they can be the solution to life and to living. This is no escapism, no ivory tower, no isolated pleasure in proportion and space - it is an unconscious manner of expressing our belief in a possible life."
Hepworth goes on to write of the emancipation of people from all social classes in attainment of freedom. It is clear that such concerns are thoroughly embedded within the formal ambitions of her abstract art. In contrast, the commitment of a number of other important St Ives moderns, such as Heron, was purely to the formal and compositional development of abstract art. Thus, Heron wrote of the importance of art's autonomy precisely from such socio-political

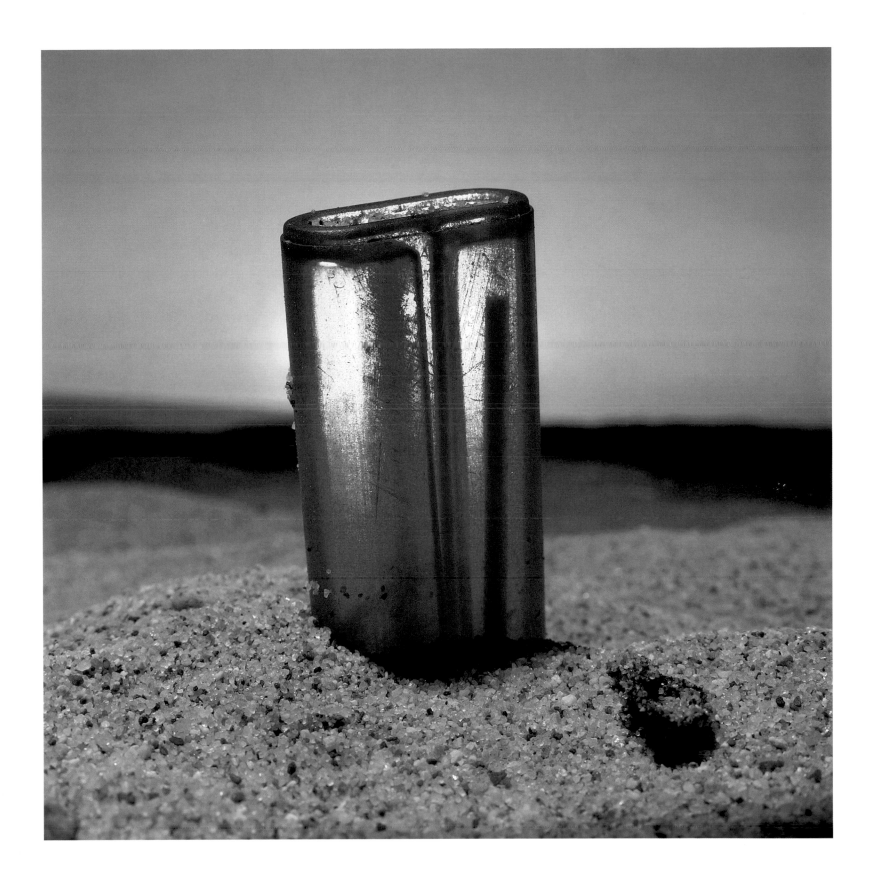

concerns, and in favour of a radical, purely artistic pro-
gramme.

At first glance, the realism of Hughes' pho-
tographs is quite remote from the economy of Hepworth's
constructivism or the colourism of Heron. What could be fur-
ther removed from such formalism than a crumpled plastic
bottle lying on a beach? Yet it is also clear that, for exam-
ple, the photograph on page 26 converts a lowly bit of detri-
tus into a monumental, sculptural form, one in certain
respects reminiscent of precisely the sculpture of Hepworth.
The photograph undermines the object's status as a bottle.
The extraordinary angle from which it is photographed sug-
gesting the enormous scale of the object, the intense light
and tonal values, the deep saturation of colour - all com-
bined to remove from the object its previous function and
attribute the piece of detritus a purely formal status: it
becomes abstract art.

The same is true for very many of the photographs con-
tained in the present volume. Take for instance the formal
beauty of the image on page 50: a perfectly articulated yel-
low line cuts through the sand-coloured foreground, the
blue sea and the sky. A plastic packaging tie, the line is
nonetheless first and foremost an element of formal beauty,
its shadow merely an index of the source of such intense
colours. Contradicting the rectilinear form of the yellow line
is the caprice of the blue line - actually, discarded wrapping
tape – on page 29. The energy here is quite different, but it
is a line that configures in relation to its environment no less
beautifully than the yellow tie. In both cases, we are pre-
sented with images which call attention to themselves as
primarily arrangements of form and colour.

Repeatedly, however, the previous identity
of the objects depicted threatens to return, to
destroy the purely formal quality of the work.
Unlike Hepworth's social message that remains buried within
the form of the work of art, Hughes' photographs speak with
two, apparently contradictory voices. The aesthetic dimen-
sion of the photographs is challenged the moment that each
object, as waste, speaks. The voice with which it speaks is
social and political: it speaks of responsibility, of economic
excess, even of destruction. This conflict between pure form
and political content, though, is not a relationship of either-
or; the tension between the two is precisely what is at
stake. In these photographs, pure form couples uneasily
with the pollutants of an industrial society.

More troubling is what happens when the "escapism
[and] isolated pleasure in proportion and space", against

which Hepworth warned, is isolated from St Ives
Modernism's radical artistic (sometimes social and political)
ambitions and serves a merely economic one. This is pre-
cisely what has happened in recent years, as art has
become a leading commodity within the tourist trade of St
Ives. Thus, we arrive at our second issue of importance to
understanding Hughes' photographs.

As one walks along Fore Street, St Ives and explores the
alleys leading to and from it, one is presented, apart from
the pasty and surf (clothing) shops, with a series of 'gal-
leries' and art shops selling images and constructions, most
of which relate to the town and its surrounding country and
seaside. From postcards depicting views and fishermen
made of shells, to reproductions of paintings, original paint-
ings by unknown artists and paintings by known artists, the
variety of stuff - with prices to match every pocket - is
extraordinary. Within these latter artistic forms, we identify
the development of a kind of 'house-style' of original
painting, one which depicts the land and sea but deploys a
near abstract manner. In such works, the radical ambitions
of St Ives Modernism, which had probably run its course by
the early 1960s, are reduced to a completely formulaic
enterprise. Thus, the only value attached to the objects
is one of exchange, the imagery is reduced to pure sur-
face that simulates art, that generates nothing other
than profit. It is what one of modernism's foremost critics,
Clement Greenberg, called "kitsch" ersatz culture to placate
the masses and to ensure that their meagre income is
returned to the privileged minority.

Such art feeds off the tourist trade and, at the same time,
becomes a tourist attraction. The broader effects of tourism
are still more profound. Those who travel to St Ives bring
much needed money to the region; the bi-products of that
spending are far less desirable. Through the summer months,
vast quantities of food are consumed and converted into
effluent which finds its way into the sea and, sometimes, the
guts of swimmers and surfers. Other stomach-churning
waste also finds its way to the sea via underground sewage
pipes; thus the ubiquitous condoms and panty liners that
grace the shore. Like the beautifully described yet amor-
phous patches of white, cream and bright orange within the
central orb of the image on page 79 - forms simultaneously
reminiscent of bacterial growth and vomit - such waste sug-
gests putrifaction and provokes a sense of abjection. Arriving
more directly on the beach are fast-food and drink wrappers
left after days in the (occasional) sunshine; plastic bottles,
cardboard packages, tin cans and crisp packets. Residues of
the residual fishing industry - broken nets, ropes, floats -

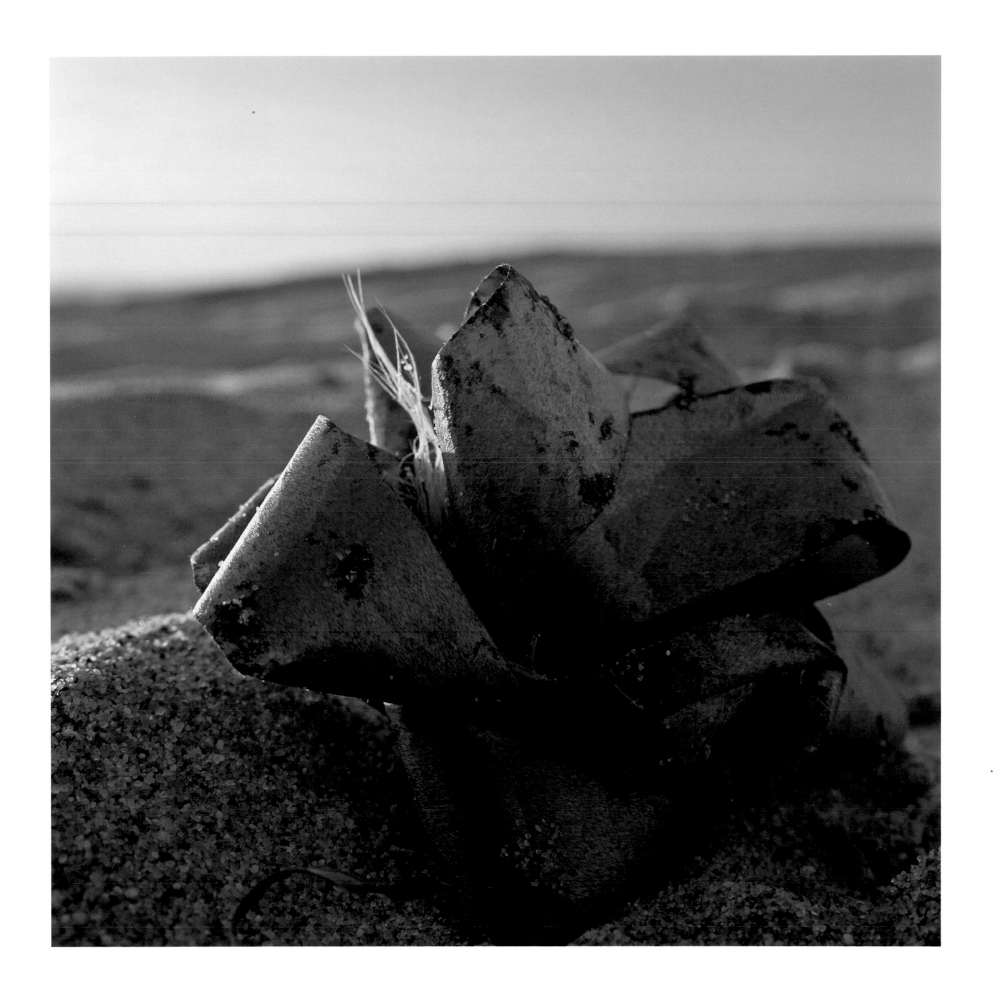

contest this space; at least they have a rustic charm and seem to 'belong'.

All appear in Hughes' photographs. They are the visual culture of contamination, a culture that recurs in less visible form in the water and air as the pollutants of an advanced capitalist economy. Such culture would appear to be the complete antithesis of that which the town and country around St Ives is known for: man living and working in harmony with nature. Like the spectrum of light created by oil on water, as we touch that which seems most beautiful, we destroy it. In their sinister beautification of the visual culture of contamination, Hughes' photographs constitute a critique of the pollutant outcomes of our commodity culture. As representations of beach, sea and landscape, the natural beauty they offer is a spoilt one and thus, the photographs also constitute a critique of the purely aestheticising house-style of St Ives which contributes to the commodification (and thus destruction) of the landscape.

The beach as a site simultaneously of escape and of contamination, our third issue in understanding Hughes' photographs, is clearly to be seen in relation to the second, and the first. People go to the beach to escape the pressures of the urban lifestyle. The beach at Gwithian, round the corner from St Ives, where many of the photographs were taken, is vast compared to those adjoining the town. It is a place for romantic escape and return to nature and natural forces. Few clues to these forces are offered explicitly in the photographs. No crashing waves, no vegetation bending in driving winds, the sort of weather common to such open beaches; rather, nature's forces make themselves felt more covertly.

> Few clues to these forces are offered explicitly in the photographs. No crashing waves, no vegetation bending in driving winds, the sort of weather common to such open beaches; rather, nature's forces make themselves felt more covertly.

Hughes ensures, through composition, scale and lighting, that each of the items photographed is the principal focus of the viewer's attention. But that attention is always informed by the ground - beach, sea, sky - against which each item stands. From the tiniest grains of sand in the greatest of detail to the greatest of celestial bodies in the most uncertain of detail, the vastness of nature is always present to these photographs, and it is against this that each object, as figure, appears.

Consider the image on page 160. A plastic ball stands on the beach, set against a deep, dark sky. The apparently infinite regression of space from fore- to background brings with it a sense of awe, and of the awful. Such space completely exceeds our understanding, and is beyond anything we can fully picture. Thus, the ground creates in the viewer not only the feeling that something much greater than ourselves is 'out there', but that something threatens to overwhelm us. In the photograph, the infinite becomes a dark, sinister presence which speaks of the invisible force of nature, the 'natura naturans', that can only make itself felt as a mysterious absence. Set against and in complete contrast with this, the sphere, as figure, is quite finite. It nestles into the landscape, yet conflicts with it fundamentally. Paradoxically, it dwarfs the infinite; its size and position dominate nature and confront the viewer. Its finite form enters into conflict with the infinite force of nature. Thus, space (nature) and scale (culture) combine to provoke awe and threat.

In these photographs, the object of detritus appears like a lone wanderer, a solitary figure set against the vastness of nature. In this aspect, the photographs are oddly reminiscent of certain paintings by Caspar David Friedrich in which man's encounter with nature is couched in terms of the sublime: threatened by the vastness of nature, instilled with a sense of terror and awe before its infinite magnitude, man, nonetheless, through the reassertion of reason, gains pleasure from this encounter. The pleasure born of pain. In Hughes' photographs waste displaces man. Yet each item becomes curiously animate as the now dead commodities are resurrected and, set against nature, they are not merely that which nature threatens to overwhelm, but also that which threatens to overwhelm nature. Beneath the beauty of the photographs, then, lurks something sinister, something threatening. The pain born of pleasure.

The three issues raised as of importance to the photographs in the present volume have been related to three concepts. From the universal harmony that underwrites a Hepworth sculpture to the formal unity of grains of sand, some discarded tape and the horizon; from indices of vile taste on Fore Street to the putrified residues on the base of a drink container; and from the awesome forces exercised between land and sea at Gwithian to the infinite regression of space in a photograph: abstract art, the effects of tourism, and the beach can be aligned with the beautiful, the abject and the sublime. The truth of St Ives, of course, is that art, tourism and the beach are inextricably linked; that beauty, the abject and the sublime will stray across these fields.

In relation to this truth, what makes Hughes' photographs so important, is the ways in which responses described by these concepts coincide variously within individual photographs. Thus, an image of great beauty is simultaneously threatening; a dramatic, exciting formal arrangement is curiously disturbing, even sickening. Such aesthetic responses combine to reinforce the politics of the photographs; they are the secret messages of that which has become so familiar as to be, so often, overlooked.

Hepworth, Barbara, *Circle: International Survey of Constructive Art*, London, 1937, as quoted in Harrison, Charles, *English Art and Modernism 1900-1939*, Yale University Press, New Haven and London, 1994, pp. 270-271

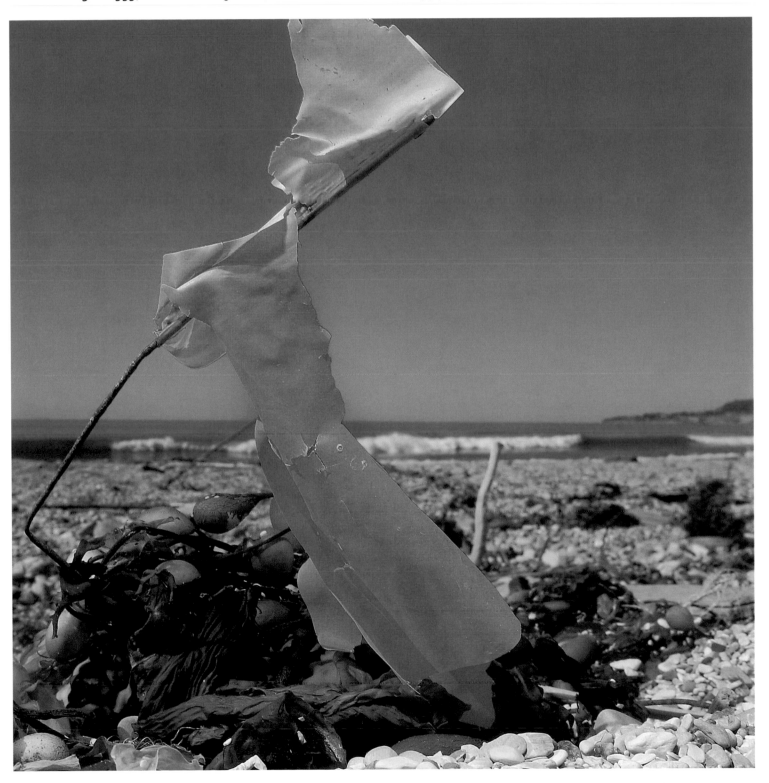

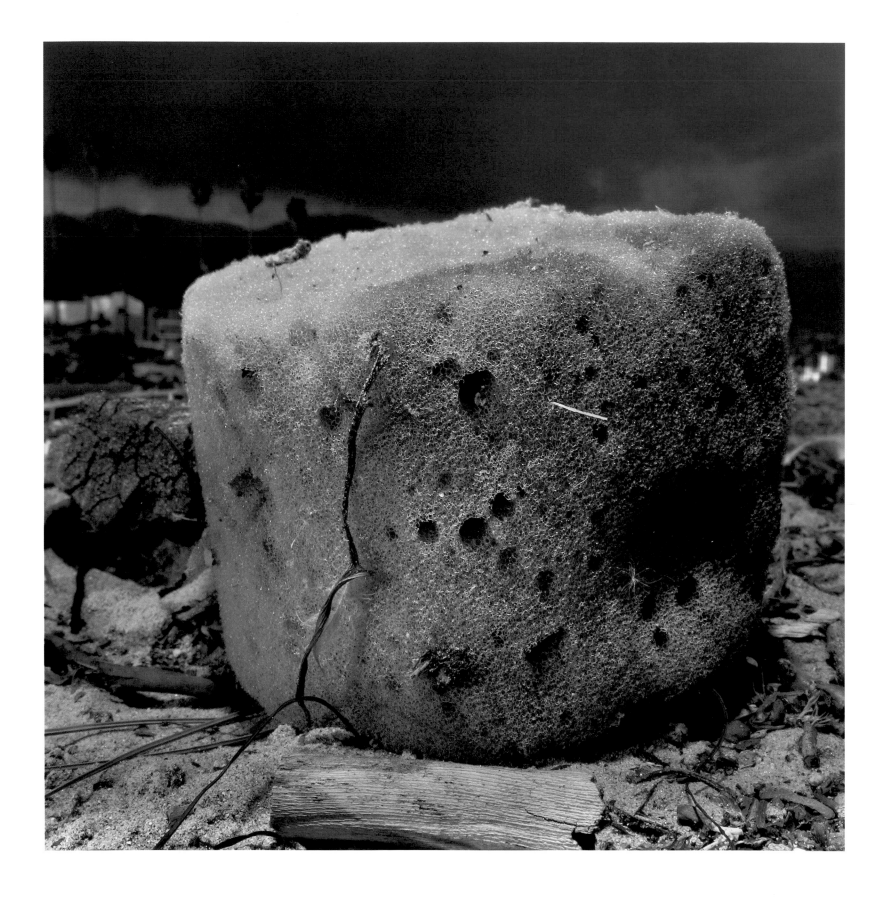

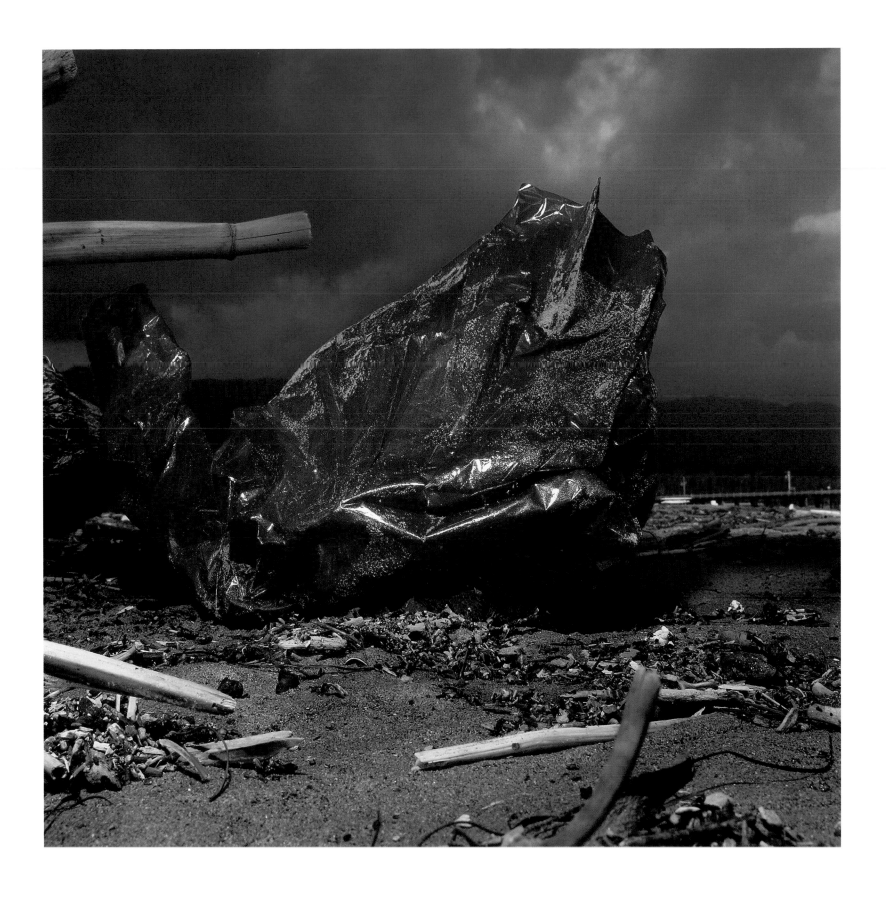

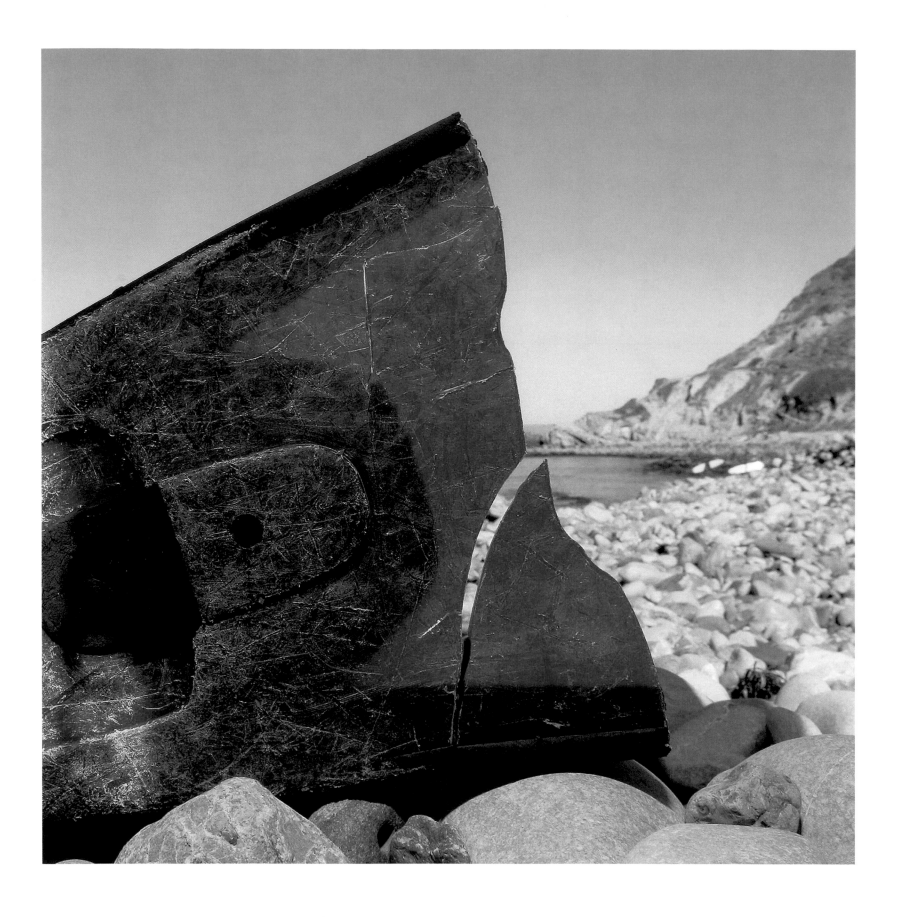

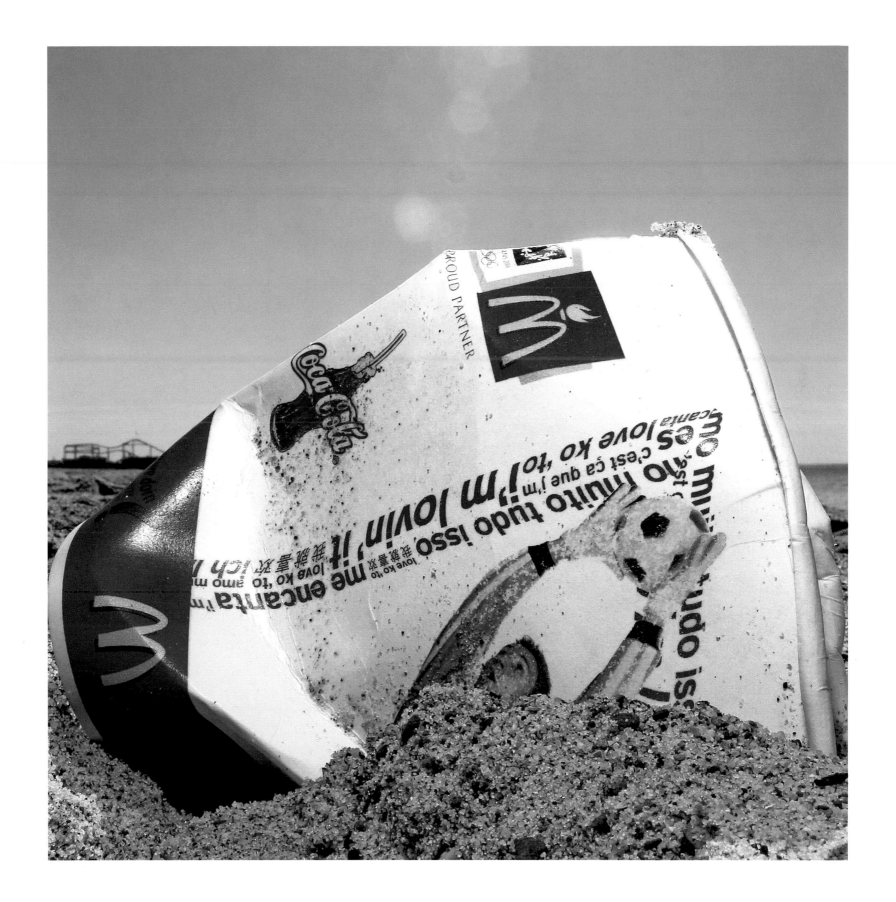

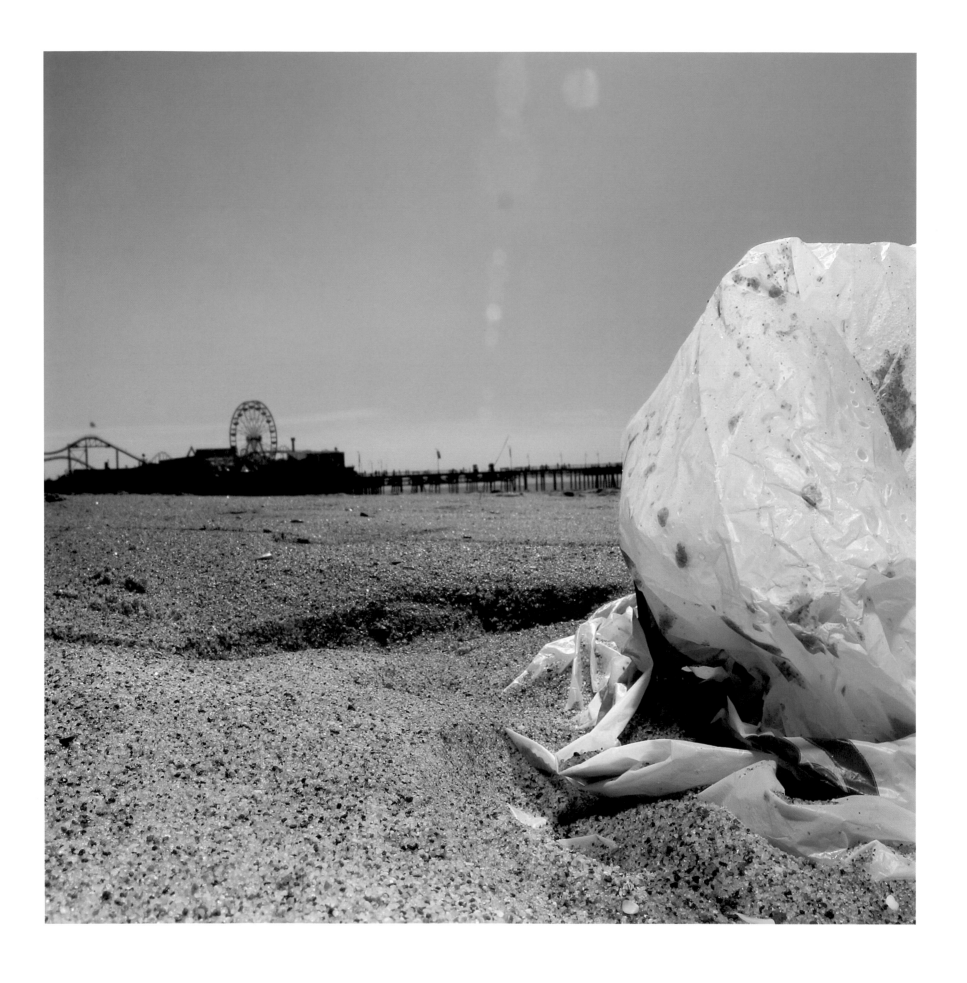

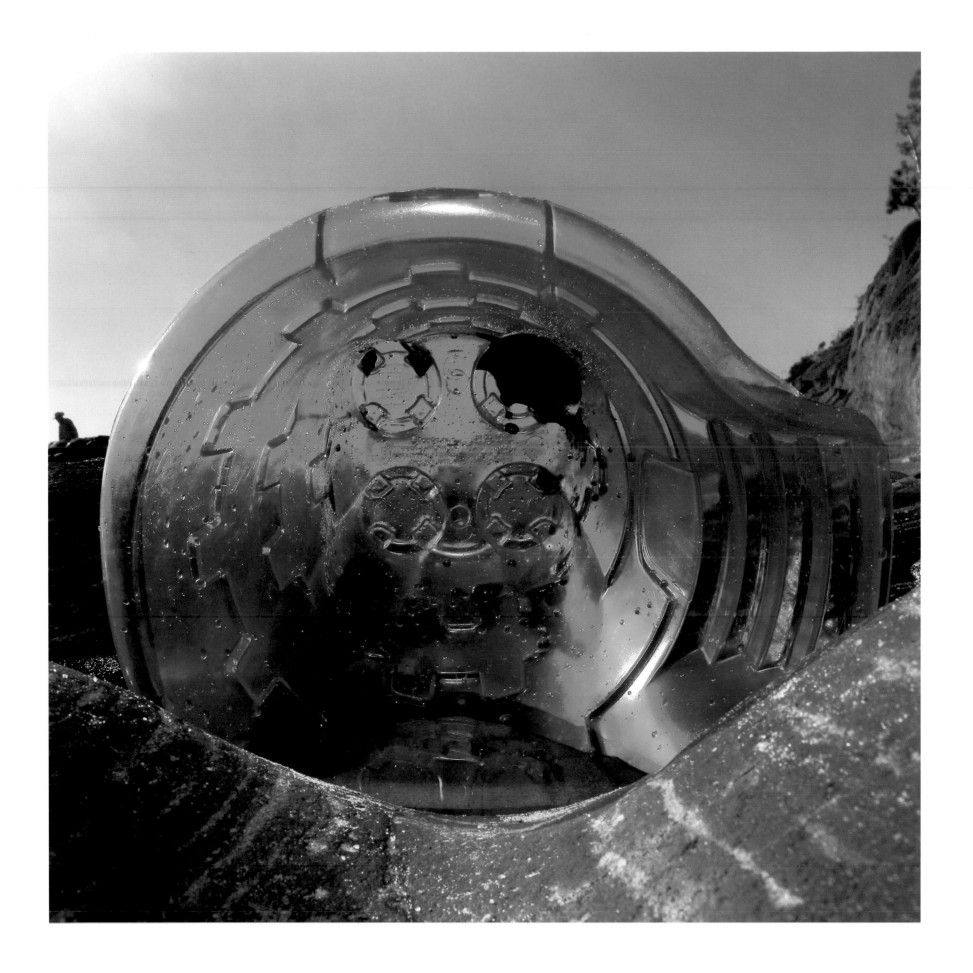

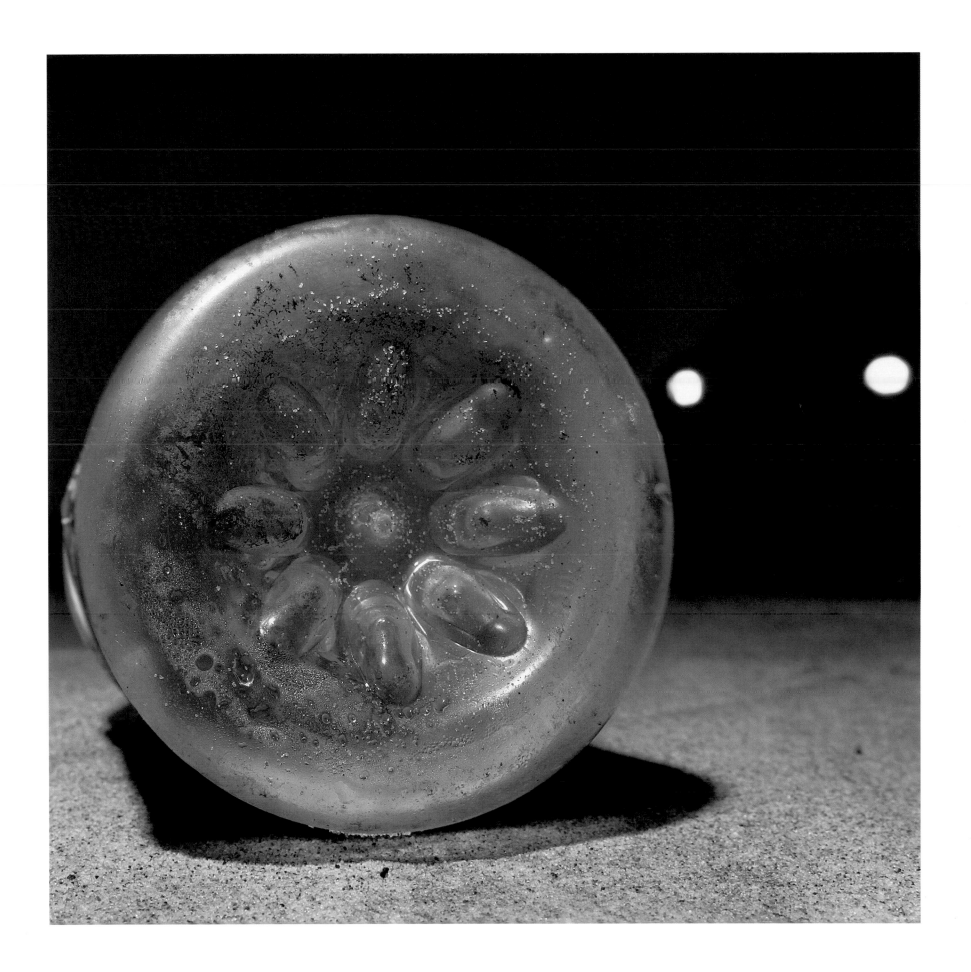

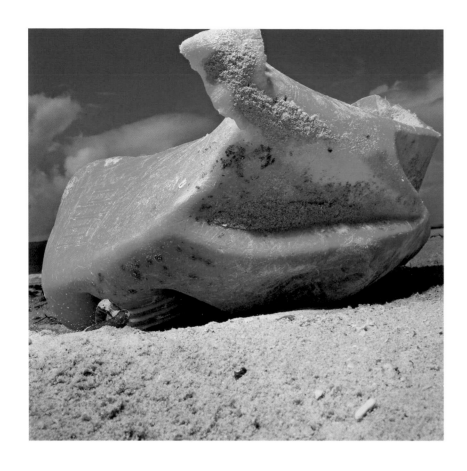

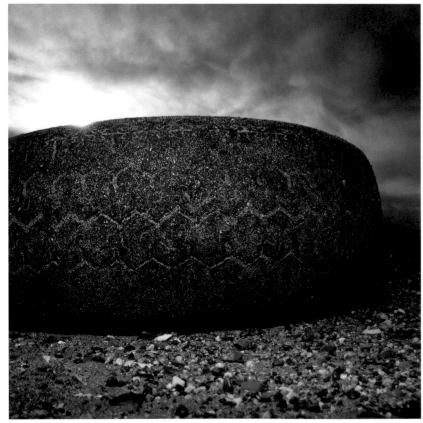

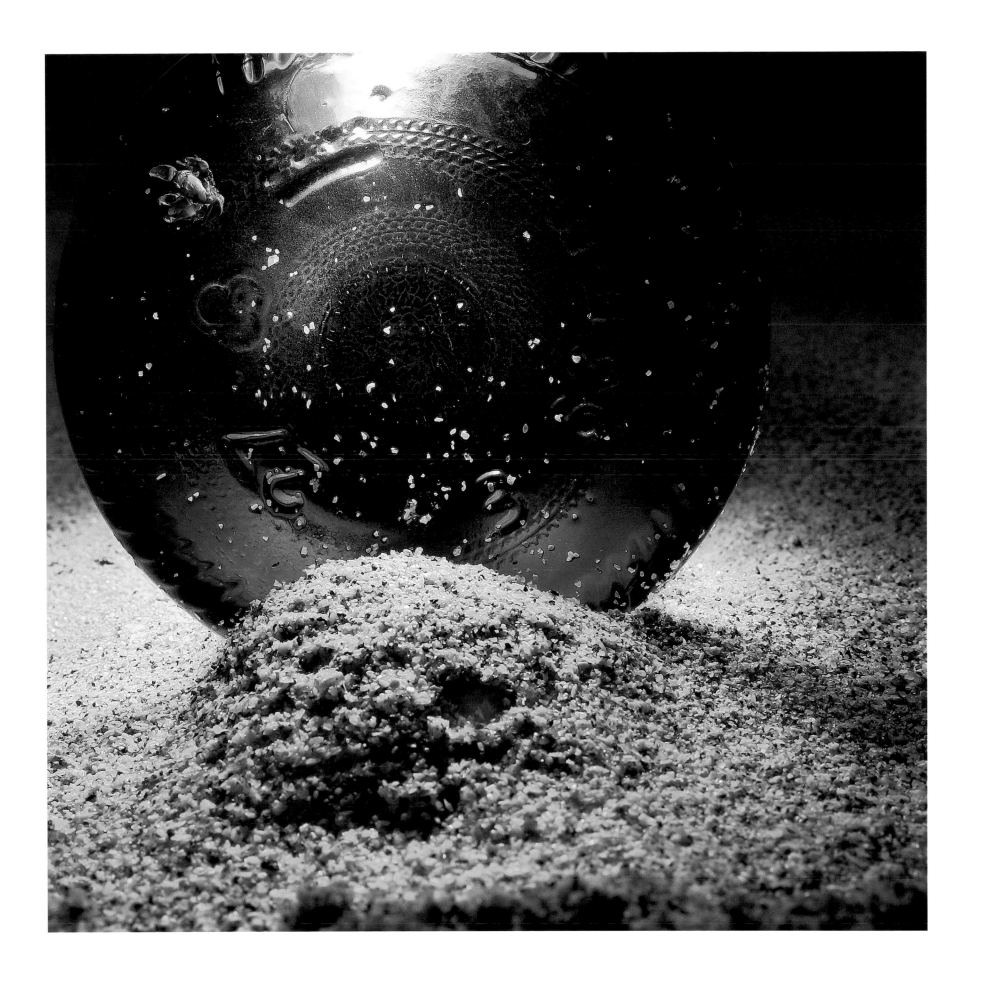

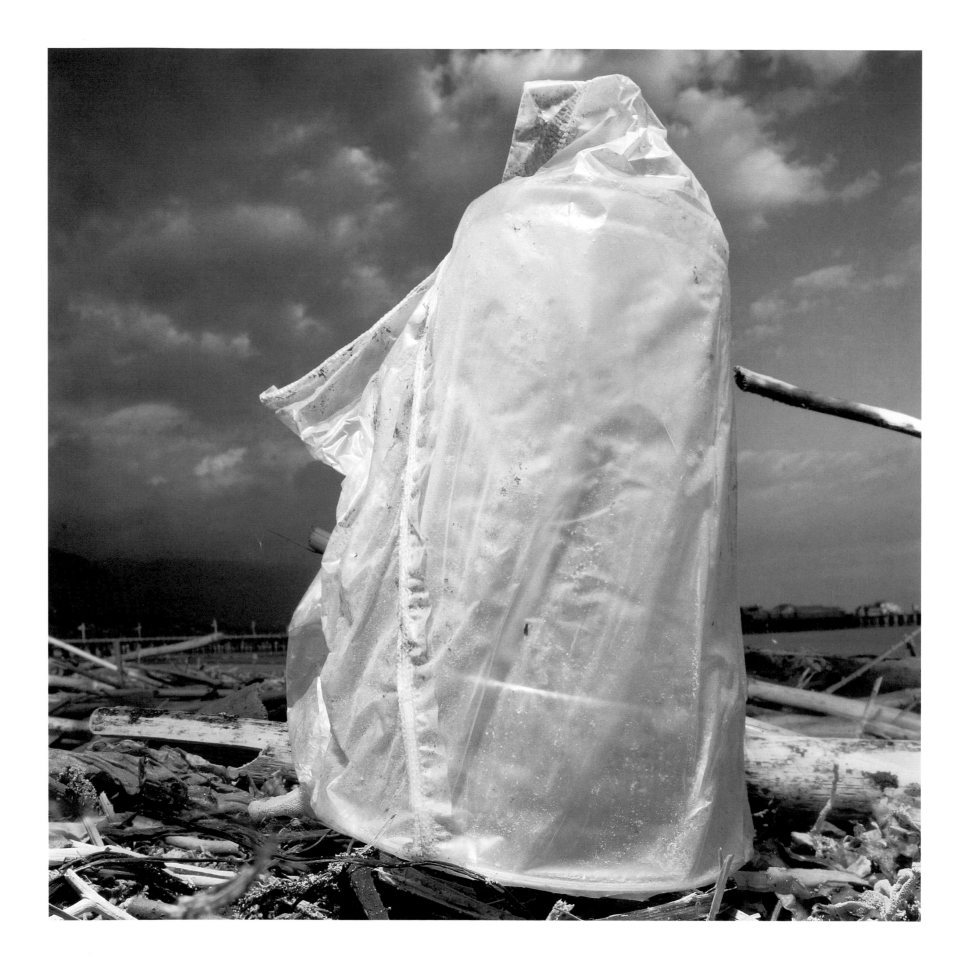

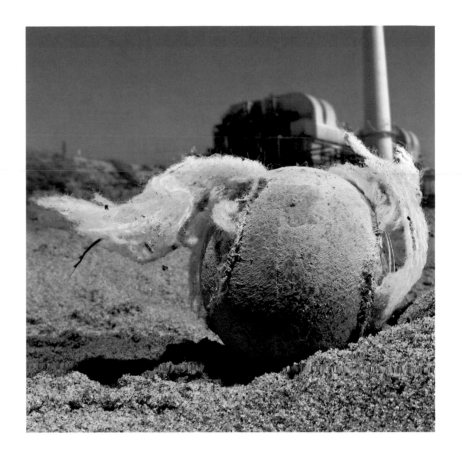

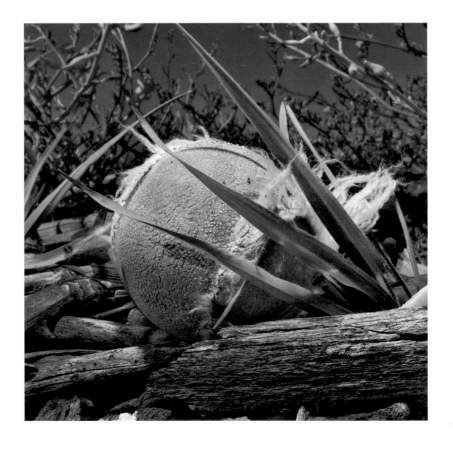

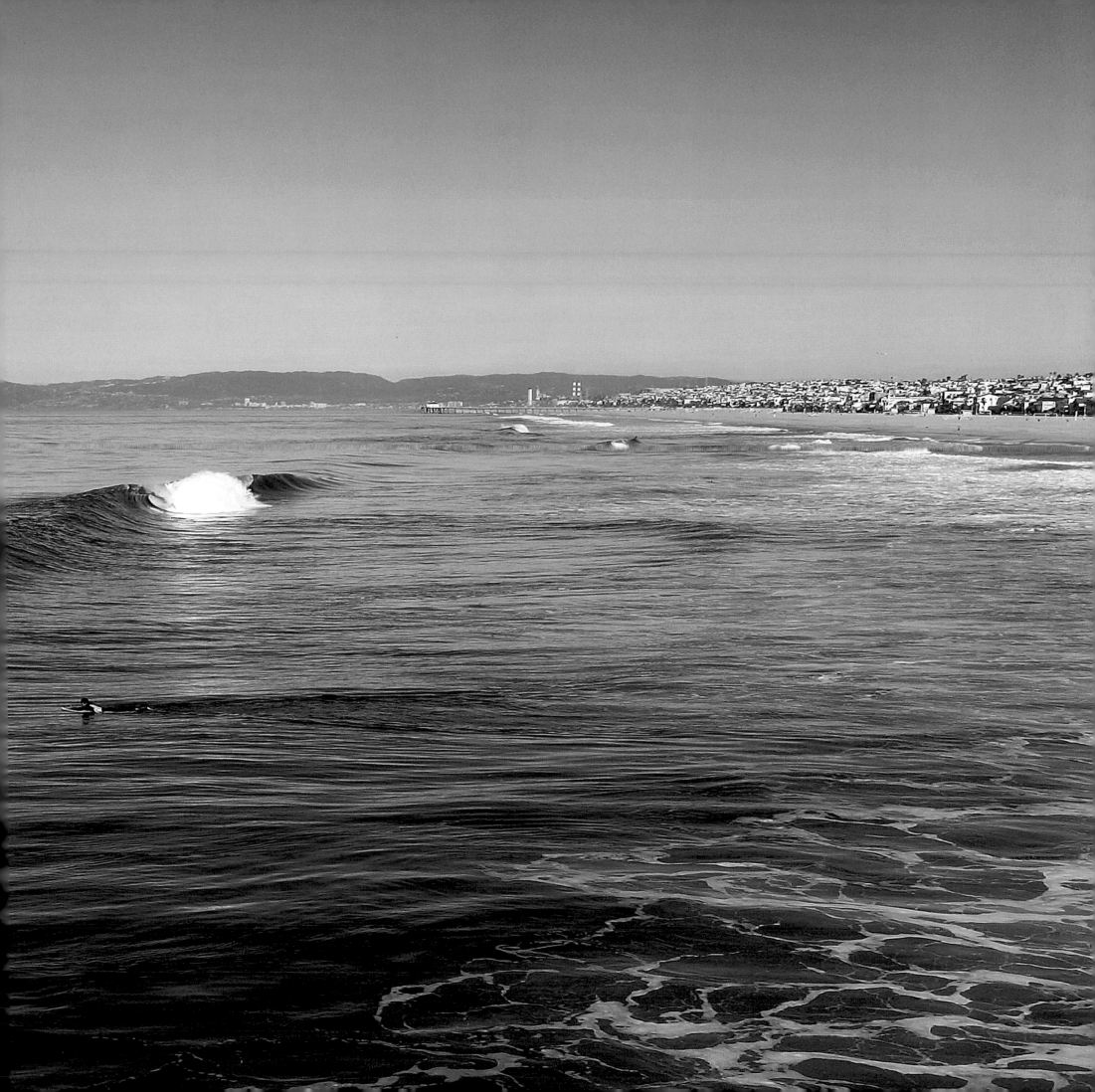

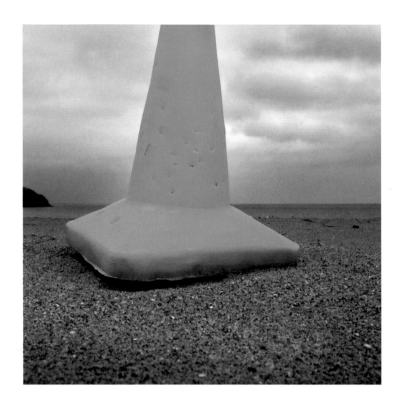

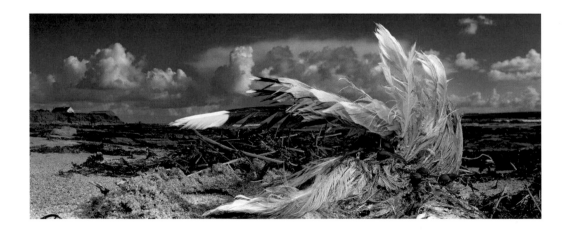

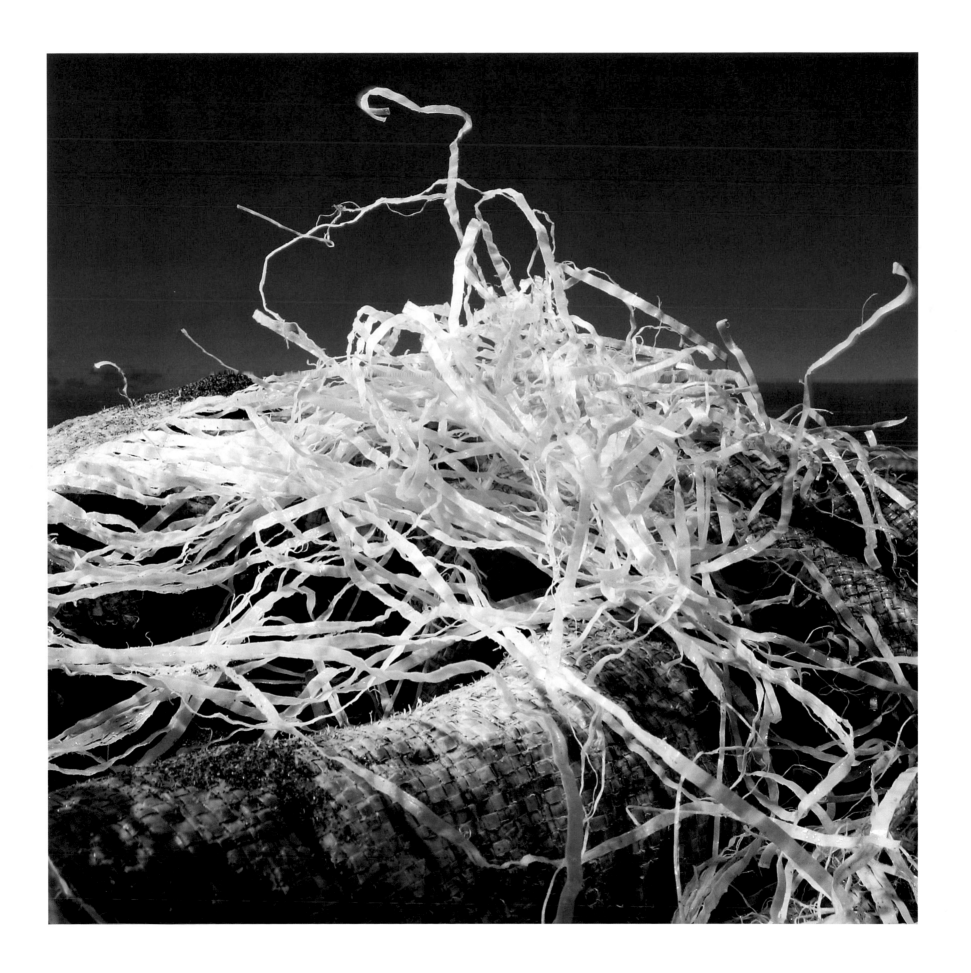

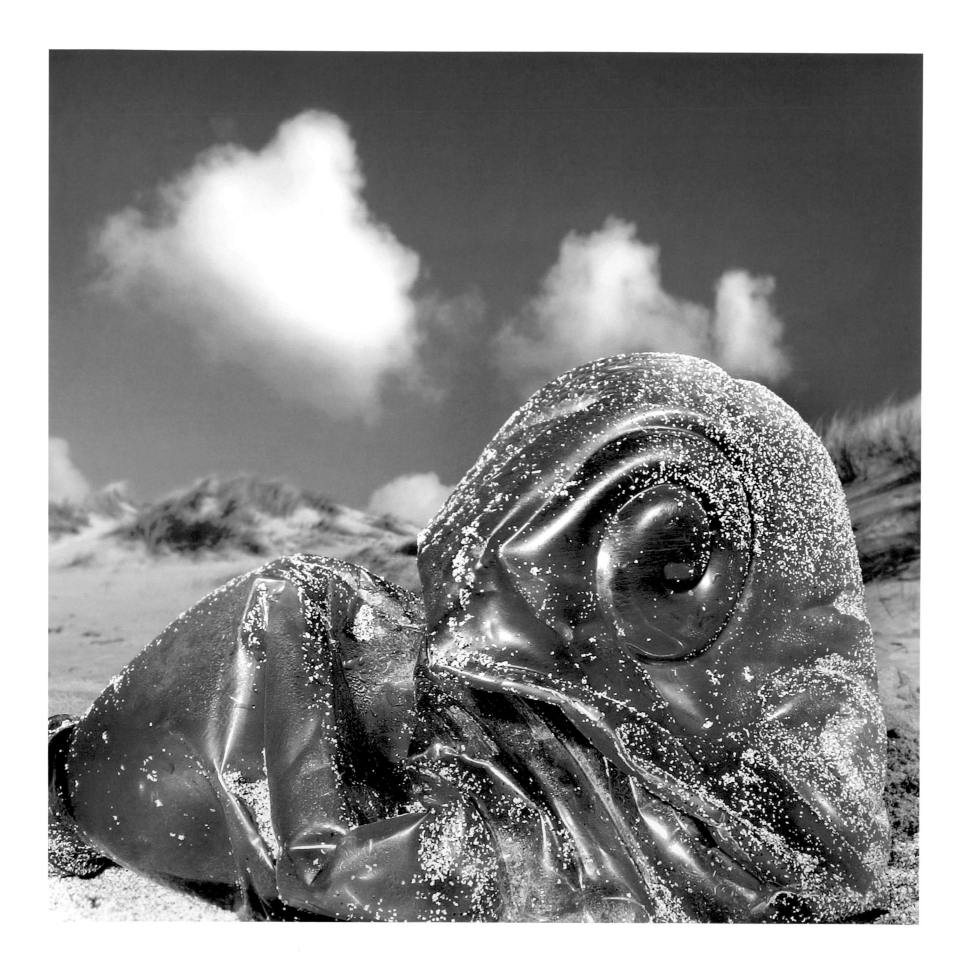

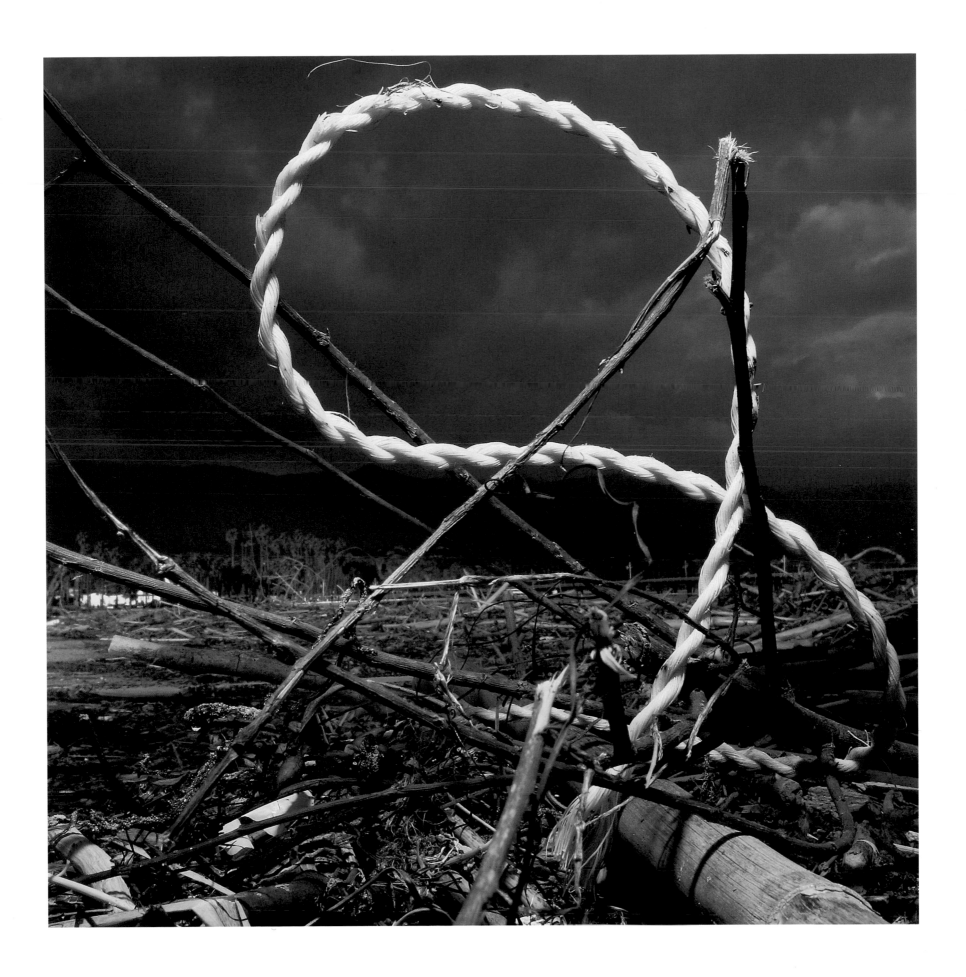

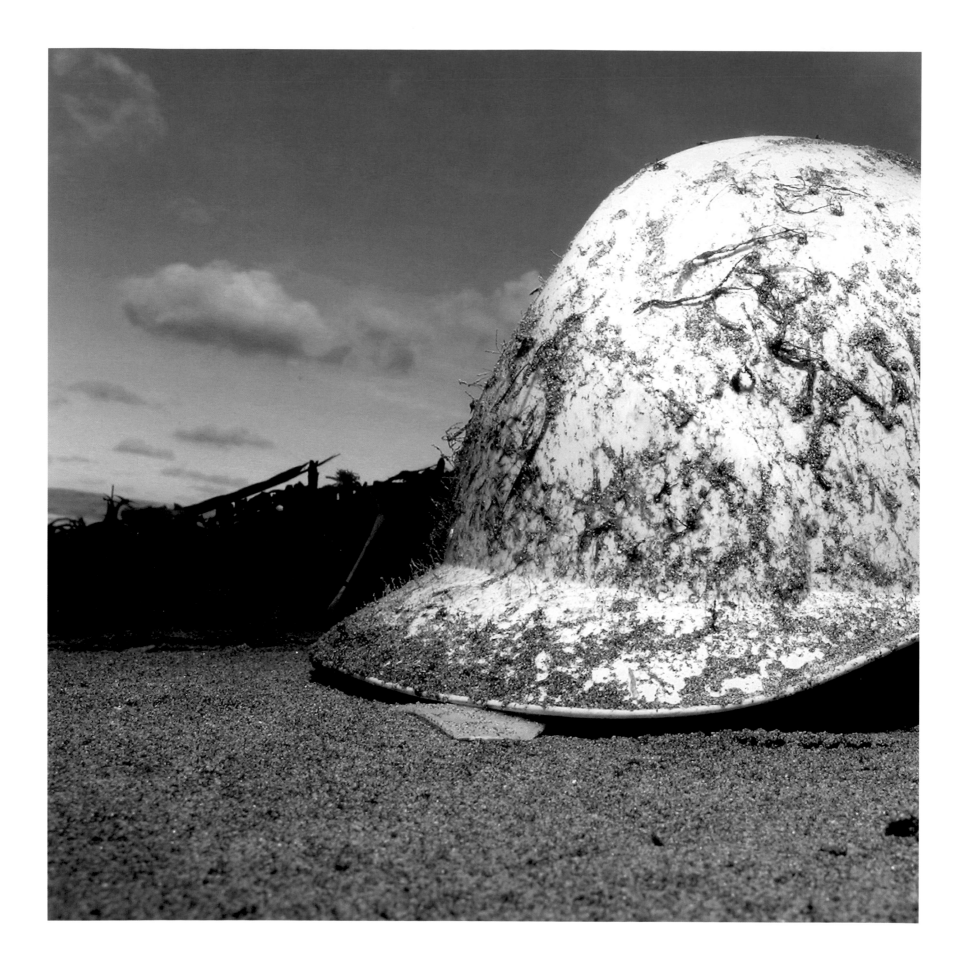

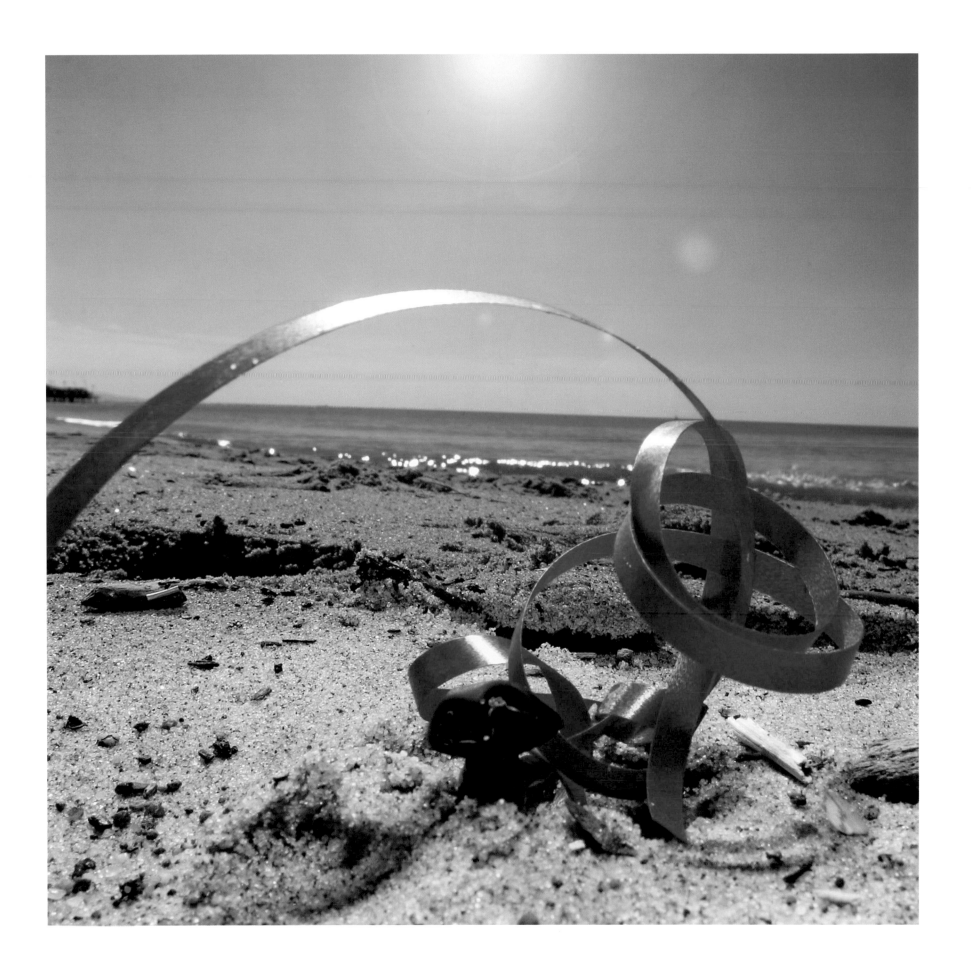

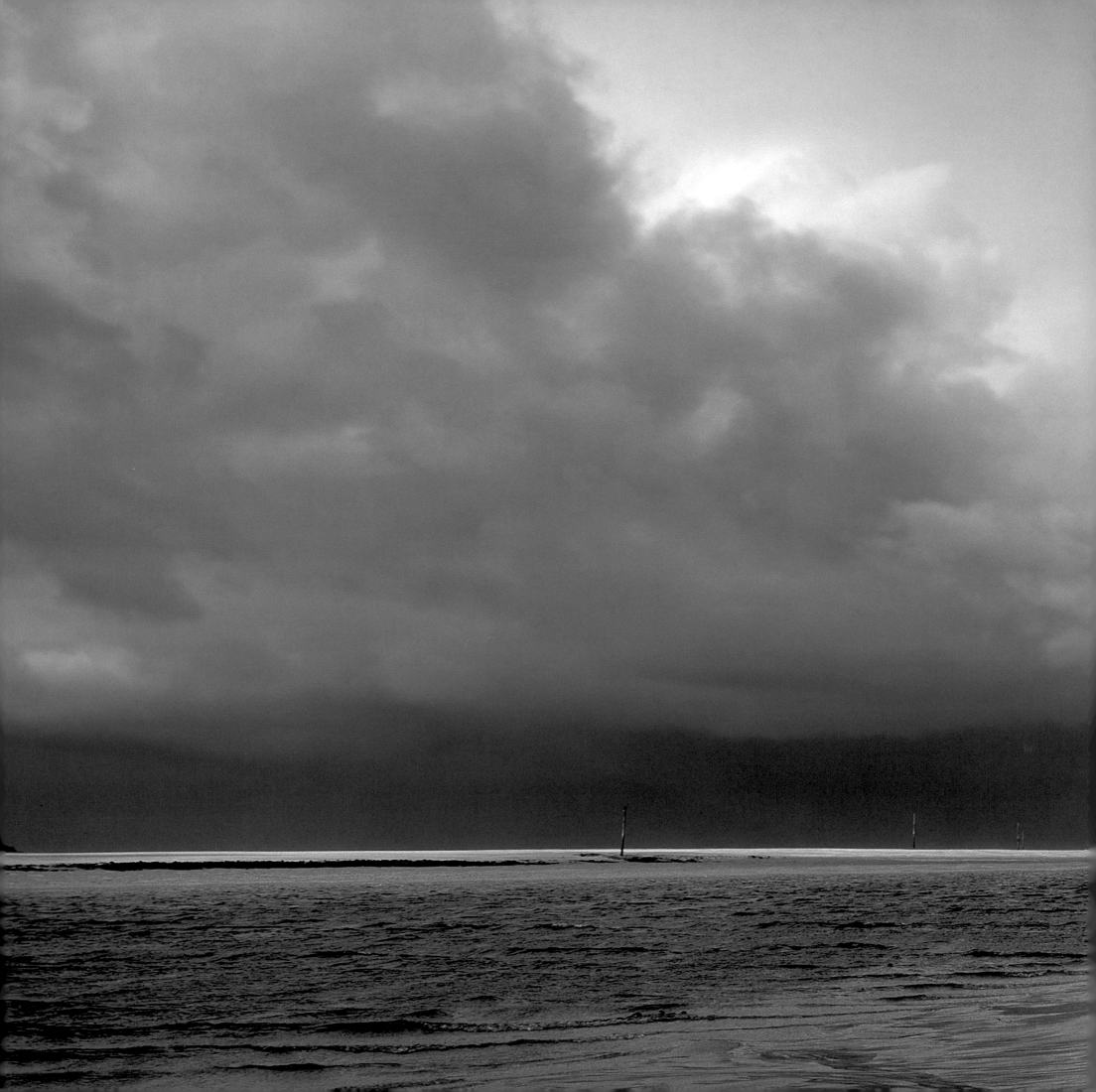

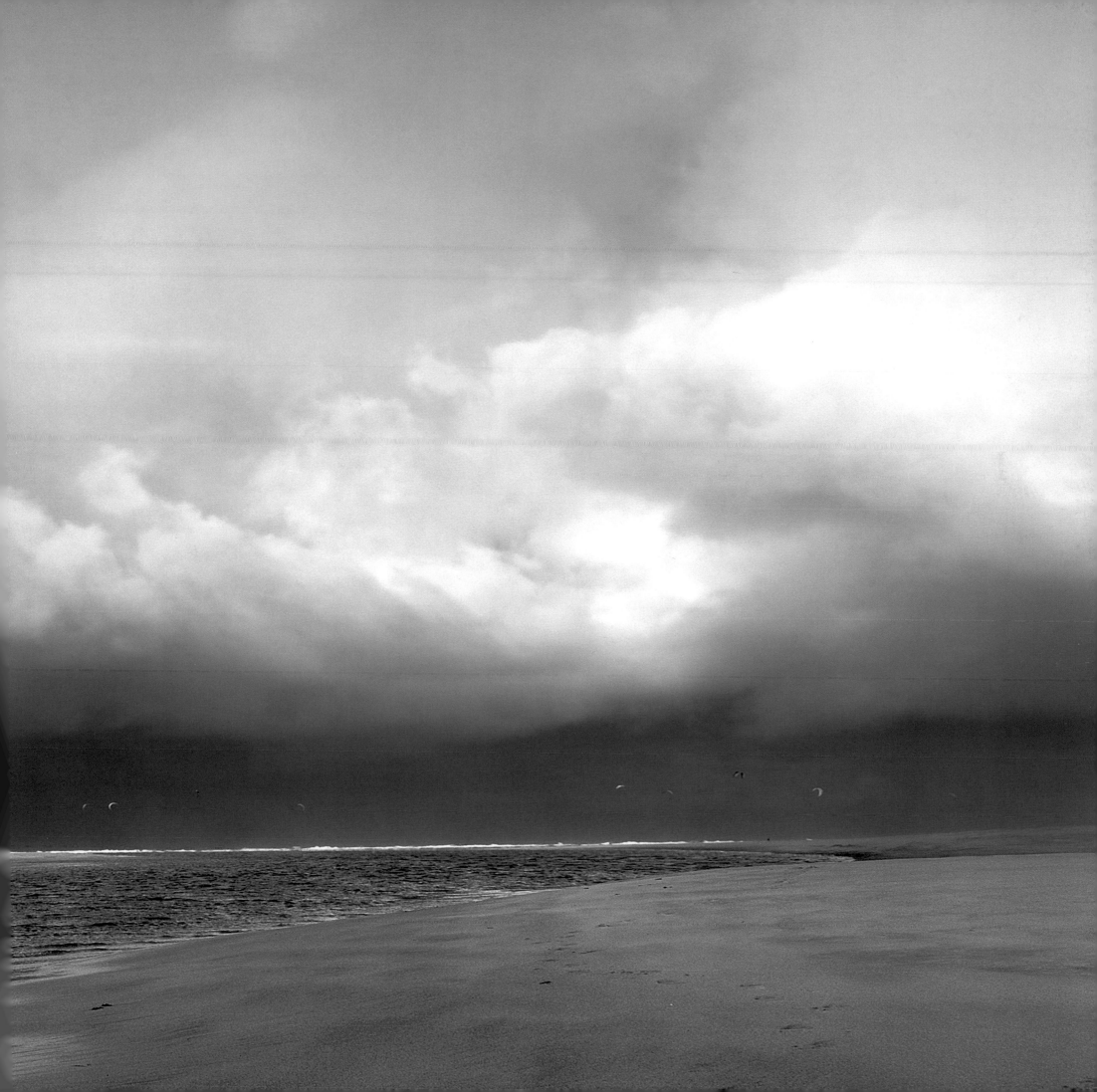

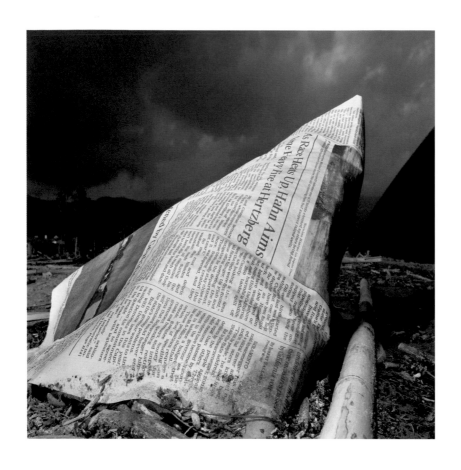

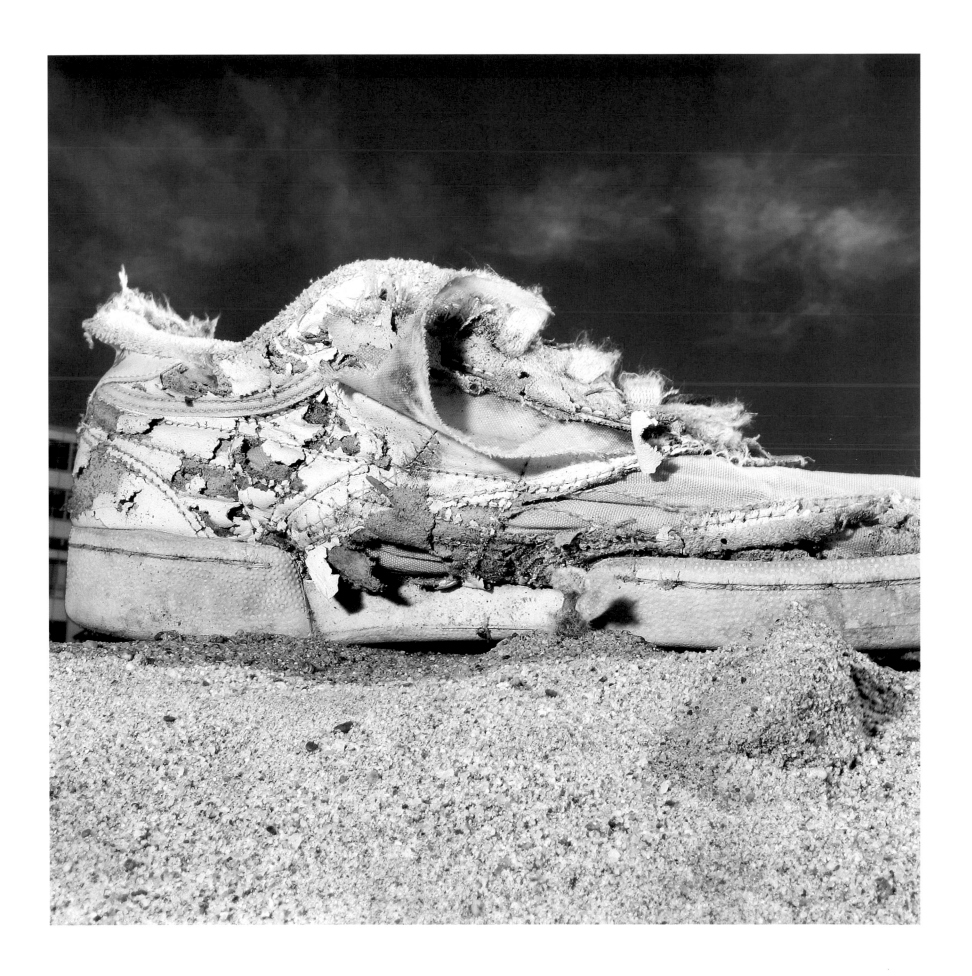

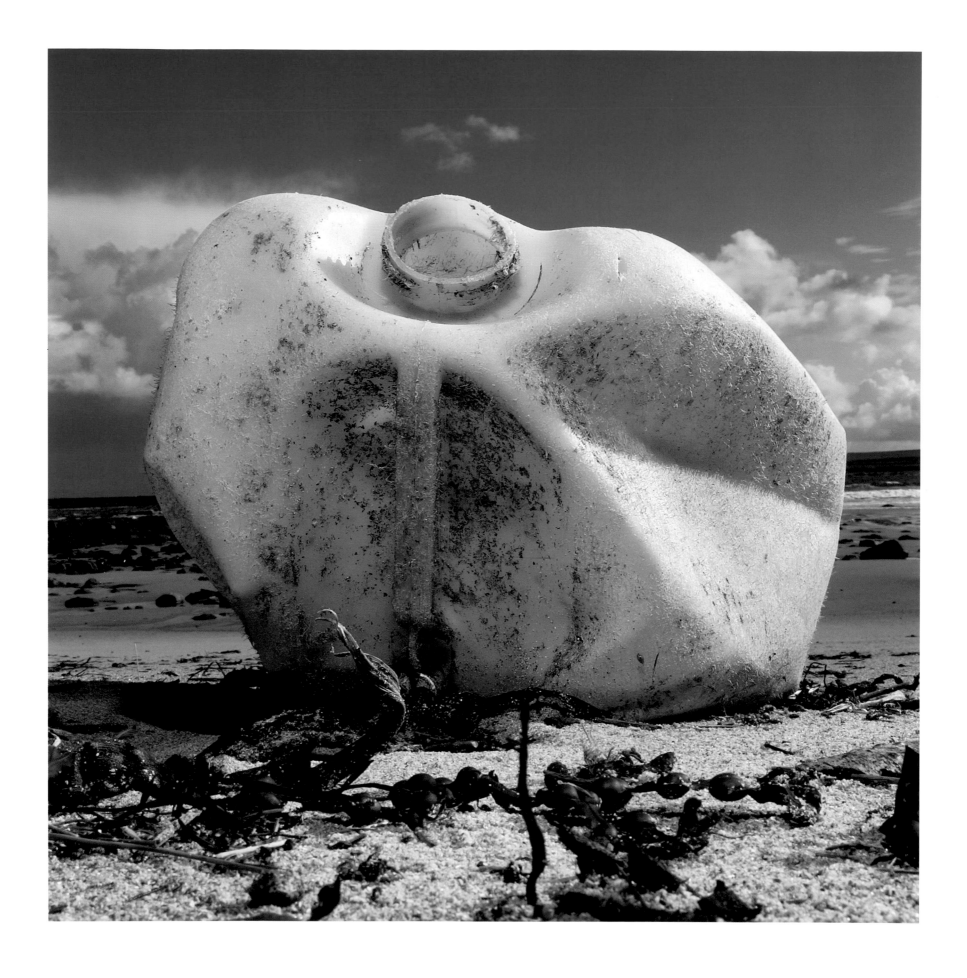

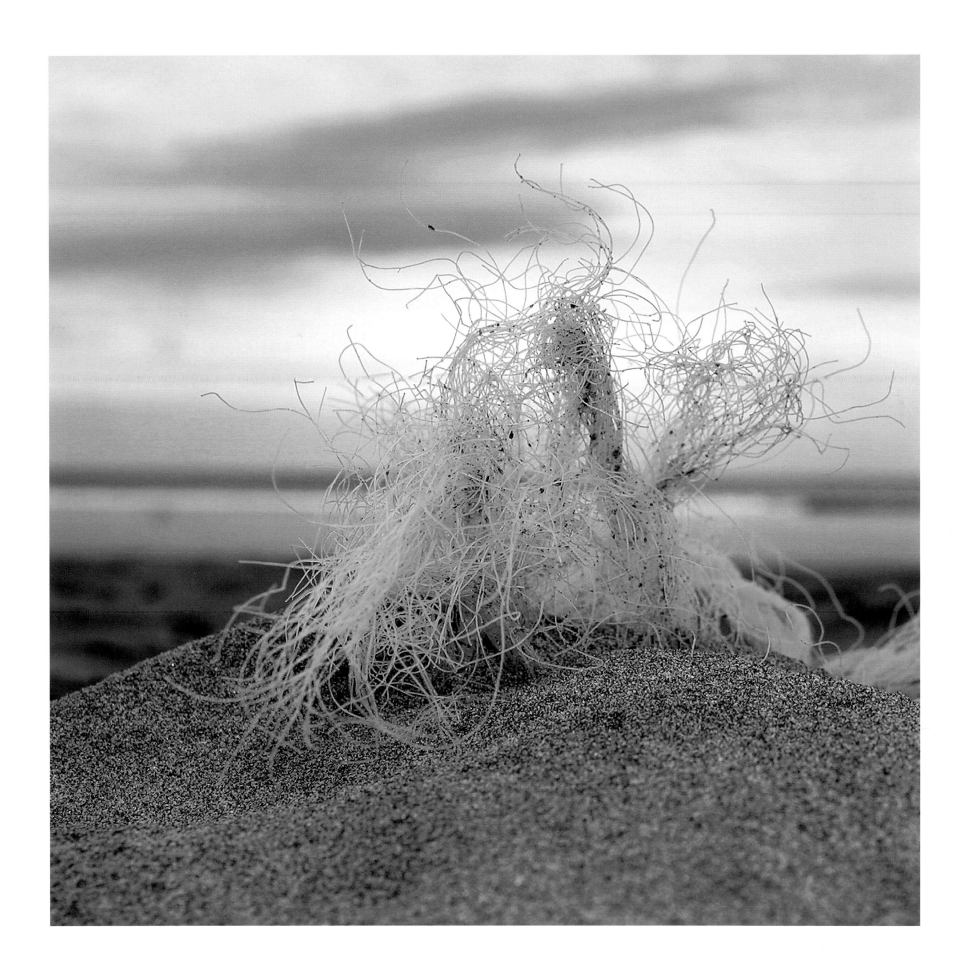

Facing Up

Chris Hines-

For millions of people, including me, the beach is one of the most beautiful places in the world. It's where I go for fun, for reflection, inspiration, sometimes I eat there and I have even made love there. It is a place where I have laughed till my sides ache and it is a place where I have been more scared than at any other time in my life. It is the place where I have come closest to death and the place where I have lived my life to the fullest.

On a planet whose surface area is seven-tenths water there are a lot of beaches. Beaches are everywhere, in towns, cities, remote rural and industrial shadowed areas, and they reflect our humanity - good and bad. Beaches highlight the interaction with the natural environment not only in physical, glossy images of the cliffs and high rise, the toxic plumes and soaring clouds, but also in the items we find on our shorelines.

For ten years I was privileged to run an organization in Cornwall called Surfers Against Sewage (SAS) that aimed to tackle the four hundred million gallons of sewage that was discharged around Britain's coast every single day. During this period I travelled to beaches across Britain: I have seen clean pristine sand stretching for miles and I have seen beaches where the high tide is a blanket of sun dried used toilet roll. One of our often repeated and true campaign lines was, "There is nothing worse than duck diving through a wave and coming up with a panty liner stuck to your head." Yet it was partly those highly visible panty liners that allowed SAS to achieve the level of profile that it did. It is harder to see sewage when it has been broken up by waves into tiny pieces, but panty liners, they gave the game away like flags marking the presence of the sewage slicks.

We surfed amongst slicks of sanitary wear and condoms with the odd hypodermic needle, toilet brush and/or toothbrush, mixed up with seaweed and feces. I watched surfing contests where the crowd of spectators was oblivious to the fact that this slick was washing round their ankles. That is until their child tugged on their hand and asked, "What's this, is it a turtle's egg sack?" "Jeepers, no it's a condom, put it down now!" We helped two young mothers take a case all the way to the High Court in London to enforce the law on the water company and get the mess cleaned up.

As a nation, the UK used to have a schizophrenic attitude to the sea. On the one hand we were proud of our maritime history, of empire and wealth, on the other we treated it like a handy waste dump. The sheer size and scale of the oceans and the continual movement make it very much an 'out of site - out of mind' disposal option…that is until it washes back up again.

Our waste will outlive us all and will keep rolling up on beaches for centuries to come.

In a world of logo placement maybe there should be more care over where that logo ultimately ends up. These proud icons of our corporate world look sad and out of place on the sand. A drinks cup with a corporate logo, held by a world athlete, in a commercial advertisement tells a very different story from that same cup in an image produced by Andrew Hughes. That is not to say this is all the fault of corporates. It is our rubbish and therefore our collective problem. We used to say, "It's coming face to face with your feces."

Try this test next time you're at a beach: walk for five or ten minutes depending on levels of debris. Collect all the bits you see and check their connection to you.

These are the results of my test:

Insulation foam from a car (this is actually from a ship called the Mulheim which was wrecked next to Land's End in 2003) — yes, I have a car so I am connected.
Plastic water bottle — yes, I have even got another one in my bag.
Foil drink carton — sometimes, therefore yes.
Foil food snack wrapper — yes.
Glass spice bottle — yes.
Panty liner — yes, not personally but as part of the human race: my partner, mother, sister and potential female children all menstruate, and if they did not, I would not exist, so whether I like it or not, this is also my business.
Small piece of plastic bucket — yes.
Polystyrene packaging —it comes with my sound system, television set etc. therefore yes.
Plastic tubing and a plastic bottle top — yes.
Varying bits of fishing gear (commercial and recreational) — I do not fish but I eat fish, so yes, I am connected.

Now put all that waste in a bag, take it home and dispose of it properly. Though that in itself can be a problem as in some parts of the world the city dump is the cliff edge or the beach. Taking it home and sending it out with your rubbish will only start the cycle again. But is this not the crux of the whole issue, our attitude to waste, our throw-away consumer society? **We consume more and more with little thought or planning as to what happens to the items once they have fulfilled their purpose.**

These items, in the most part, are benign, they will sit there and very slowly break

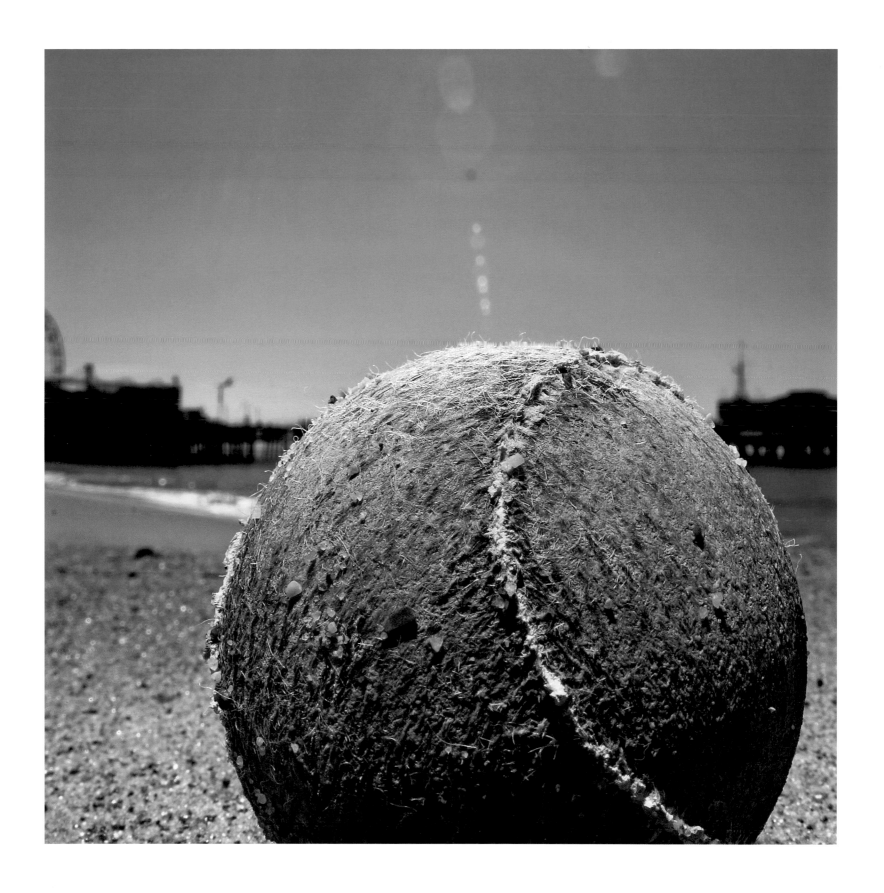

down but there are other forms of waste that have more serious impact, and some we cannot even see and Hughes cannot photograph.

Here follows three 'toxic' stories from my time as Director at the SAS:

1. St. Agnes, Cornwall, 1998.
Two local surfers, James Hendy and Shaun 'Skippy' Skilton were surfing at a local beach when a metal shell casing came bobbing into the lineup. Being responsible surfers, they brought it to our office. We rang the Environment Agency and the local council, and gave the code numbers on the casing. Ten minutes later they rang back and told us to evacuate the building; the fire service was on its way. To remove the shell, they used full chemical suits complete with breathing apparatus. Then an ambulance arrived and we were taken to the Accident and Emergency Department.

On arrival we had chest x-rays and electro-cardiographs, blood sucked from both vein and artery. The doctors put the details into a database and contacted the National Poisons Information Service. We were taken to the Admissions Ward where the curtains were drawn around the bed, and a doctor quietly and calmly told us that the shell contained dangerous chemicals which could have serious affects on the human body. "We do have to inform you that, although it's extremely unlikely in the dosage levels you have been exposed to, the effects could be fatal." My colleague and I had to stay for a seventy-two-hours observation. Eventually, we were given the 'all-clear' and sent home, but it was an experience that left a deep impression.

2. Rest Bay, Porthcawl, South Wales, 1994.
During August Bank Holiday we took a call from a Welsh surfer. He had been surfing a small summer swell on the South Wales coast when suddenly there were a series of small explosions in the shore break. People fled the water, yelling and screaming. He described the experience as a cross between Jaws and Apocalypse Now. After some investigation, we discovered that the explosions were caused by discarded flares from a boat. Some of these then exploded due to the impact of the waves in the shore break. Thankfully, no one was hurt - this time. There are also many marine munitions dumps around the British Isles…when an electricity company wanted to lay a cable between the mainland and Northern Ireland, their preferred route ran straight through one.

3. Dounreay, Thurso, Scotland, 1990s.
Scotland has some of the most remote and beautiful beaches in Britain. This remoteness was one of the prime reasons why the Dounreay Nuclear Power Station was sited there (see p.24 and p.189). In recent years radioactive particles have been found on Sandside beach in Caithness and there are warning signs to stay off the beach. However, surfers cross here to get to the nearby surf break. The chances of ingesting a radioactive particle must be remote but, nevertheless, the risk is there. Yet again the waste originates from the need for something that we all consume: in this case, our ever-increasing demand for power to heat and light our homes and use the myriad of electronic gadgetry that fills our lives. Right now I am typing on a com-

puter consuming power, so again, I am connected. One of my solutions is to use Green Tariff electricity which is sourced from or invests in renewable power generation.

Recently, there was a real 'Thunderbirds' international rescue in the news. A Russian mini-submarine had become trapped on the floor of the Pacific, tangled in a web of fishing lines and cables. The world watched the news whilst a British rescue team raced against the clock and a rapidly depleting supply of oxygen to cut through the cables. They successfully managed to free the Russian crew and the relieved rescued faces were broadcast globally. Yet I was unaware of any debate in the media about the cause of the problem.

We simply do not like to deal with certain problems. It is that 'out of sight - out of mind' mentality. Sometimes we go even further and do our best to cover up problems. We dubbed this the 'Jaws syndrome': politicians, people and society often choose to cover up or deny the existence of a problem rather than address the root cause. Councils clean beaches on a regular basis during the summer months in order to present a pristine environment to the much needed tourists. Cleaning usually takes place in the morning or at night. Of course, most rubbish washes in with the tide. High and low tides do not fit to this timetable. Once the tourist season is over, most beach cleaning ends. And as for the locals who live by the beach and use it all year round, well, they are used to it.

There were times when the SAS was almost chased out of town for scaring the tourists away by controversial activities such as carrying a gigantic, inflatable turd in public. There were some who treated us as if we were criminals. Thankfully, some authorities chose a different tack, realising that the problem would not go away and needed to be confronted. They helped drive the change in sewage treatment and disposal methods. Jersey, one of the Channel Islands, led this push and won awards for its foresight. The Welsh, Wessex and Yorkshire water companies followed suit and so did the government finally. There is still a lot of work to be done by the SAS and much of it is complex. These days, from a distance, I watch with pride as they campaign with the original values of righteous outrage.

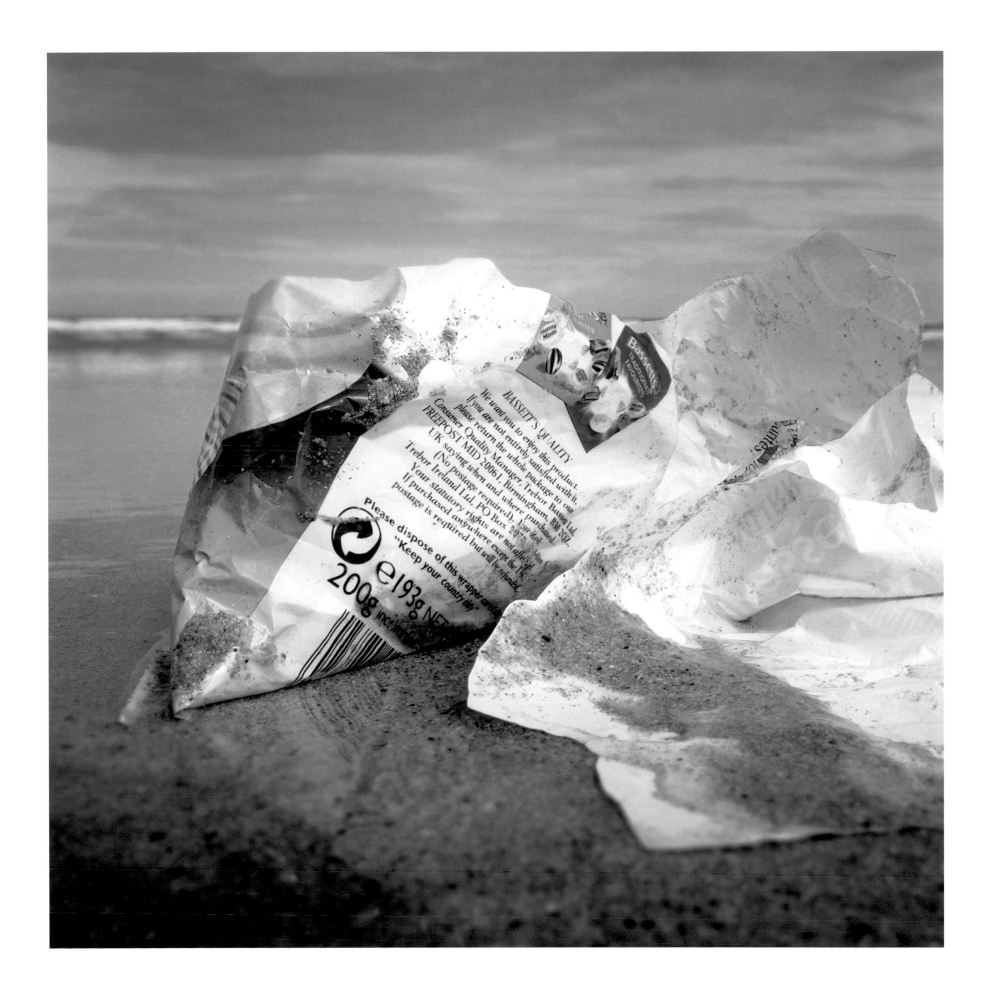

I should end this essay on an optimistic note. If I had only focused on the problems then this would be a wasted opportunity. The 21st century should not only be about flagging up our problems but more importantly about delivering solutions. We can do it. As a species we can do anything we put our collective minds to. It is just that we have been using the wrong palette of materials and technologies, carrying some imbalanced priorities. We can bring about change.

I am lucky in that I have been, and hopefully continue to be, part of a huge change for the positive. When Surfers Against Sewage started in 1990 there were 400 million gallons of crude, untreated sewage being discharged around the coast of the UK every single day. By the time I left in 2000, we had helped win an agreement from the UK Government that all continuous discharges would receive a type of treatment that resulted in a much improved disposal service for up to fourteen million people. And that's pretty clean.

Currently, I am Sustainability Director at the Eden Project in Cornwall, a regeneration of a china clay waste pit in which an extraordinary structure has been built. Established as one of the landmark Millennium projects in the UK, one of Eden's main aims is to promote the understanding and responsible management of the vital relationship between plants, people and resources leading to a sustainable future for all. We not only address the issues of our waste but we go up our supply chain to deal with the waste at source. By designing the waste out, or making products from materials that can be either recycled or composted, you can really tackle waste.

Any popular beach is a display of our plastic obsession gone mad: beach balls, Frisbees, windbreaks and surfboards are just a few examples. At Eden we have chosen the iconic imagery of the surfboard. Boards used to be made from natural materials but performance and mass demand resulted in surfers now riding on extremely toxic sports equipment. We have worked with local craftsmen on a prototype board with a balsa core, laminated in hemp cloth and plant based resin. When these boards are broken, old or simply out of fashion, we can chop it up and throw it on the compost heap.

We need to know what our products are made of - not just food – in order to have a greater understanding of their impact. Consciously seeking out new sustainable materials and technologies will allow us to live within the carrying capacity of this wonderful planet.

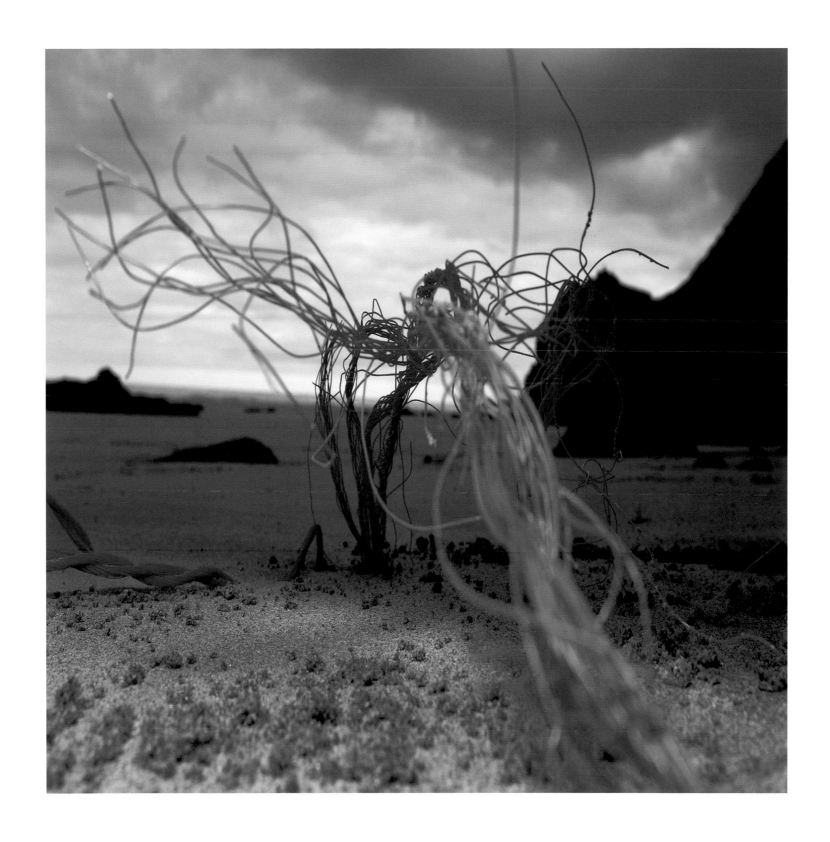

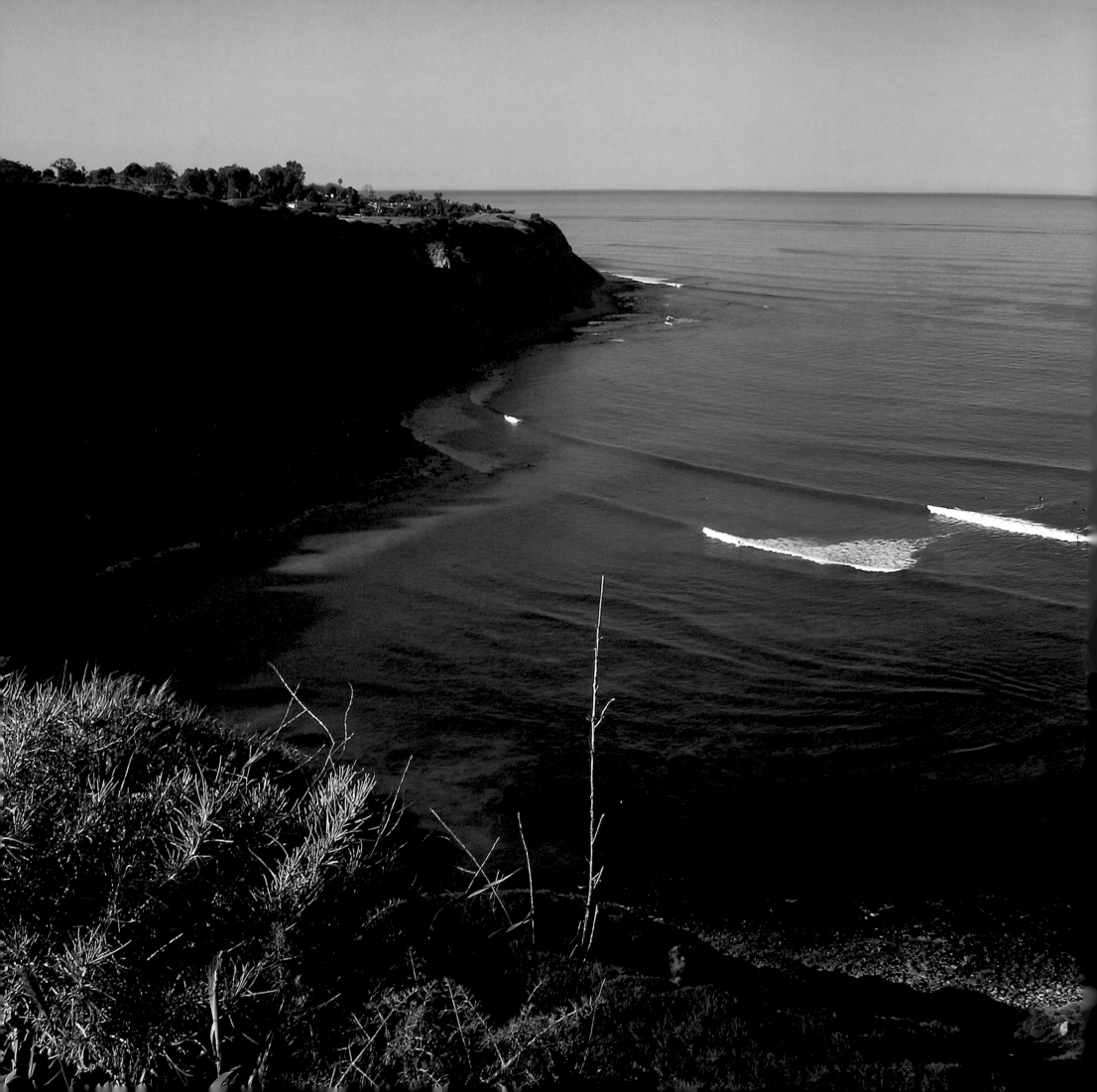

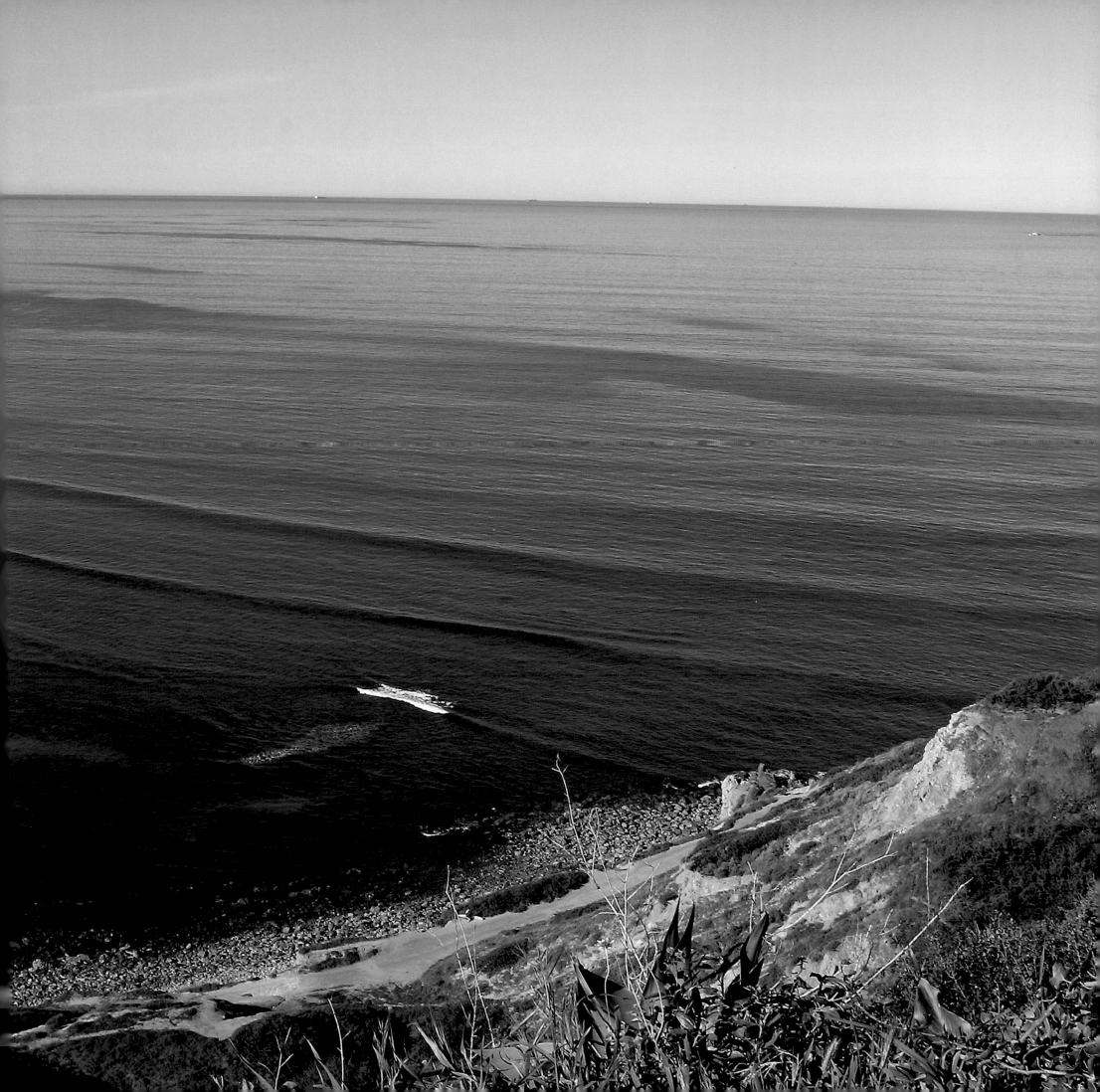

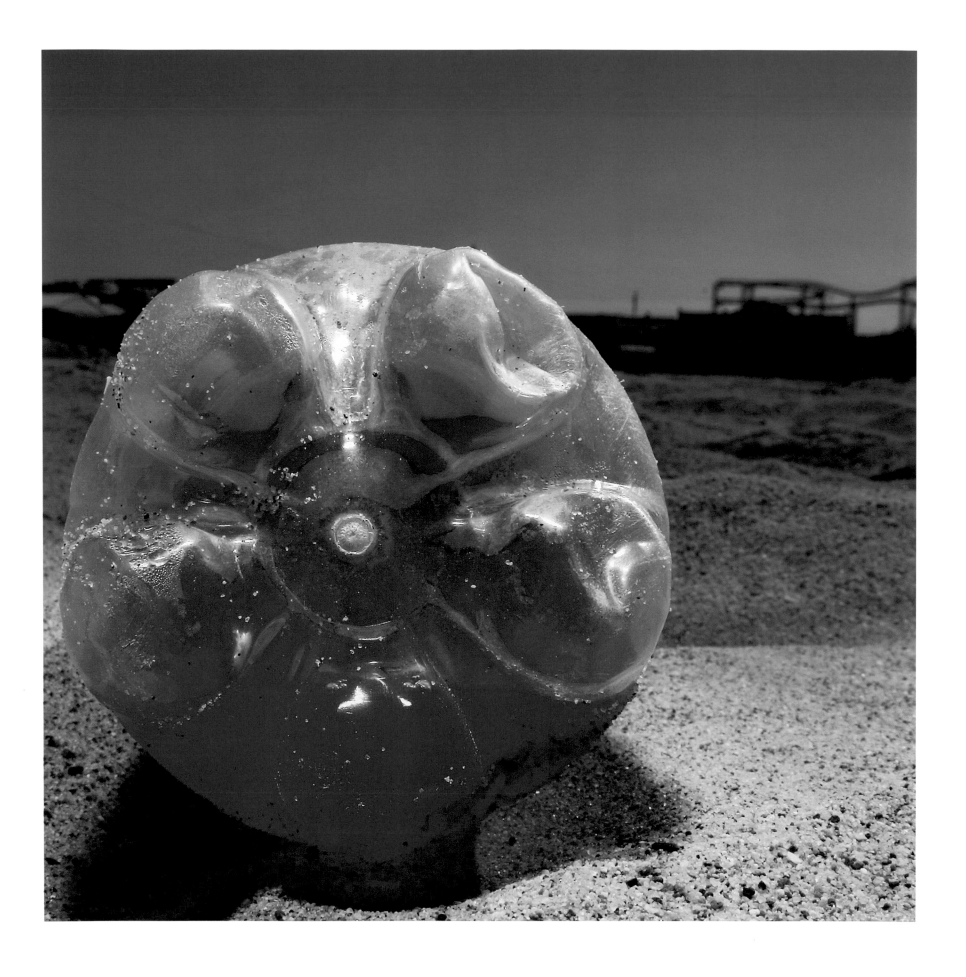

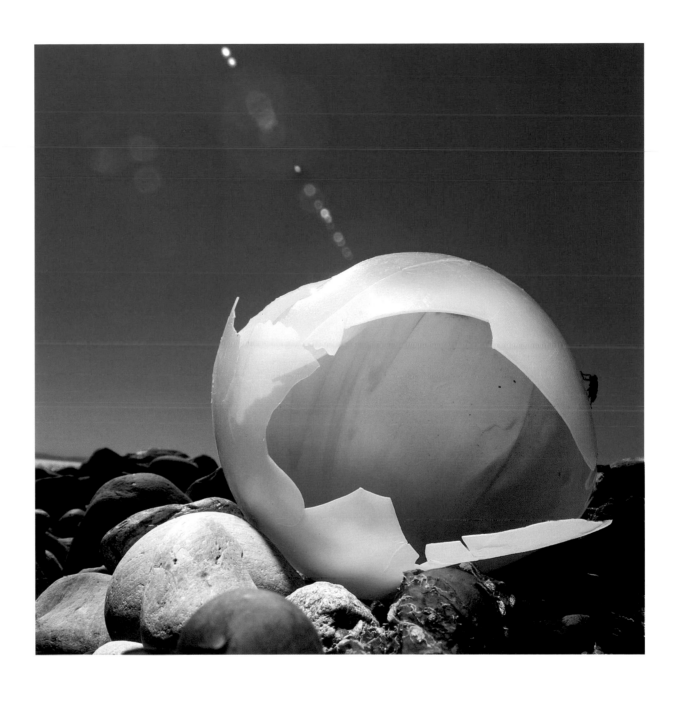

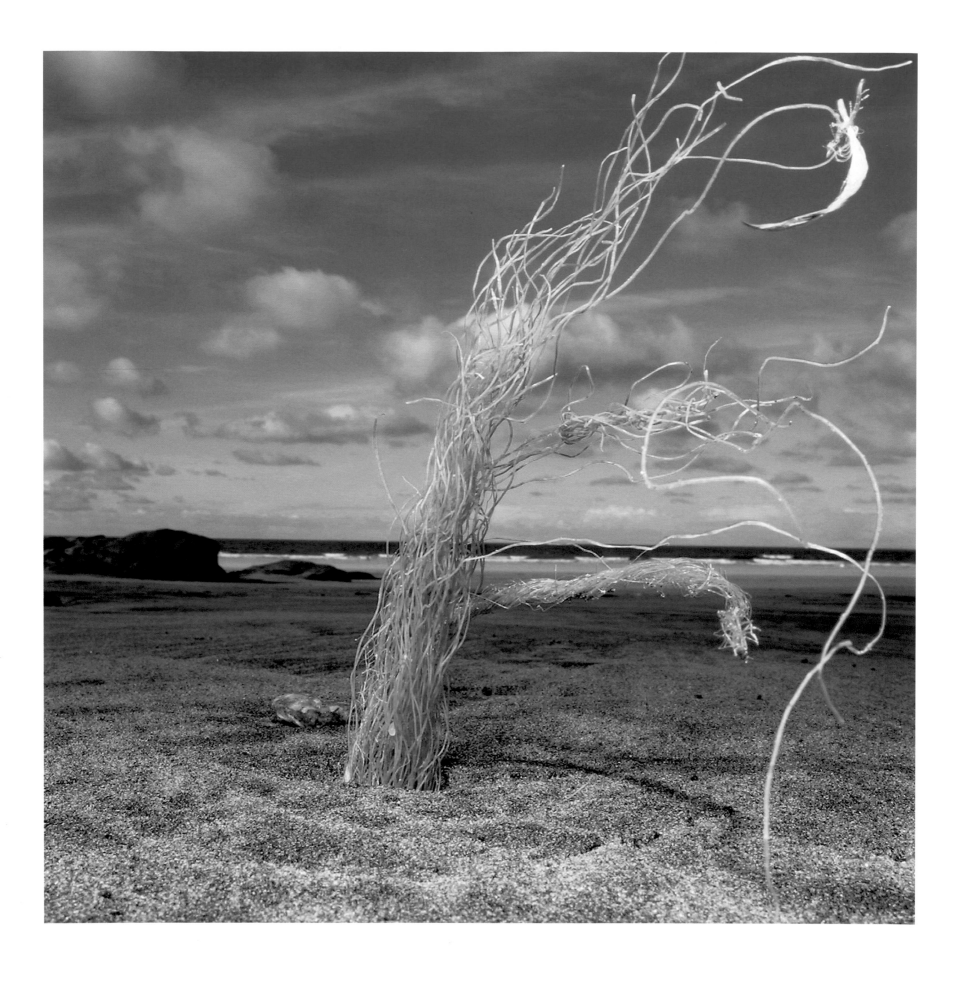

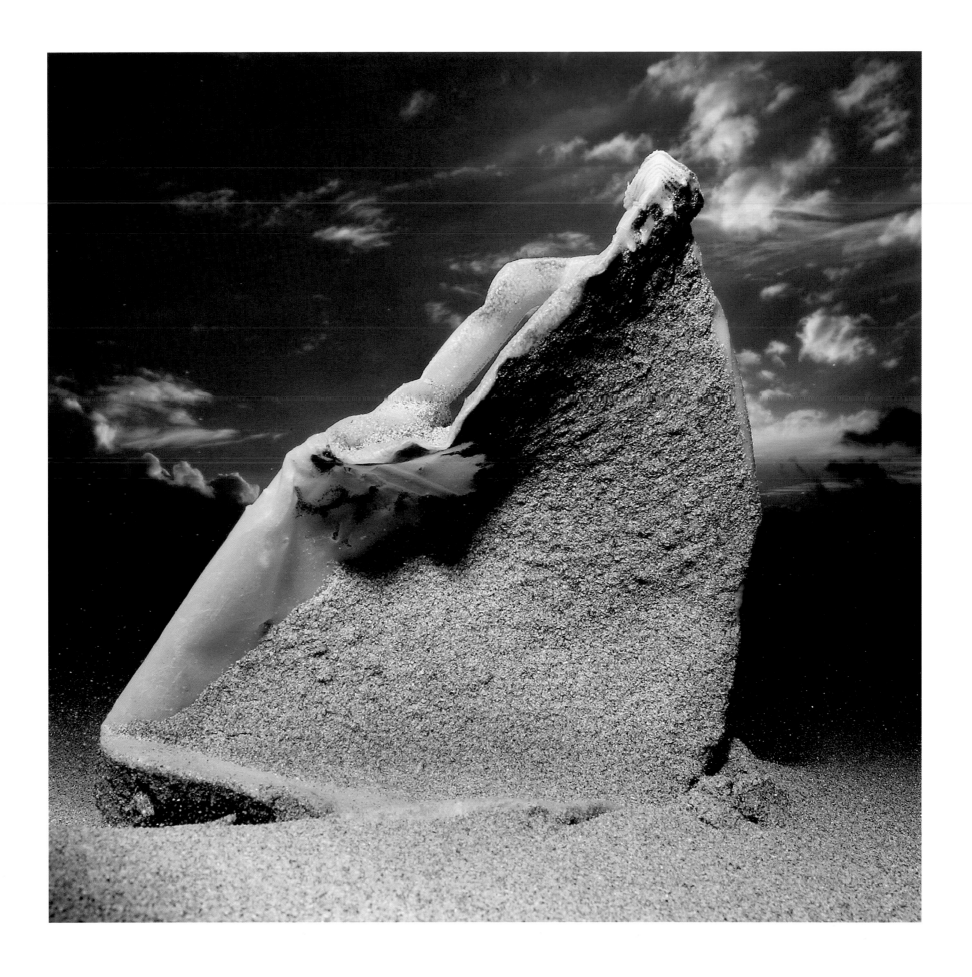

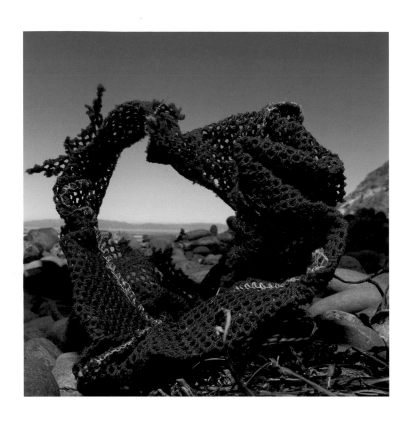

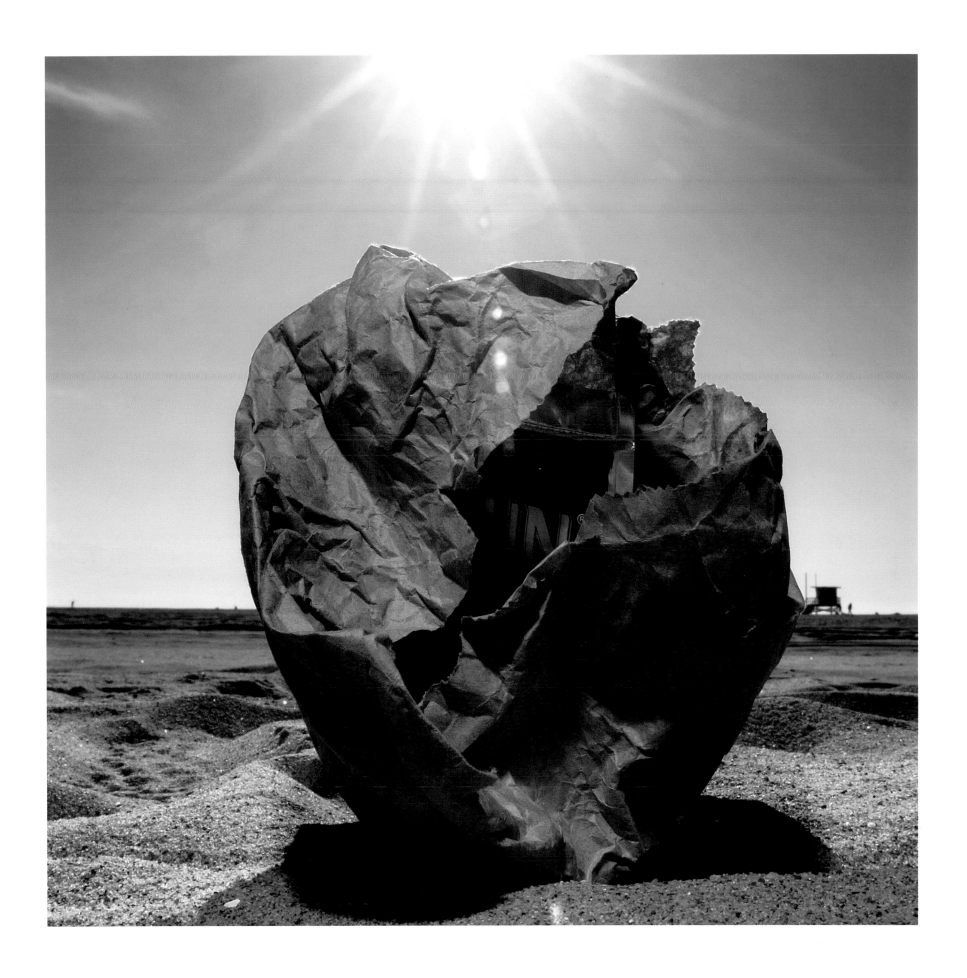

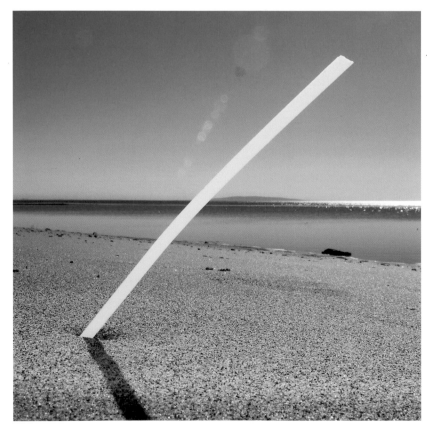

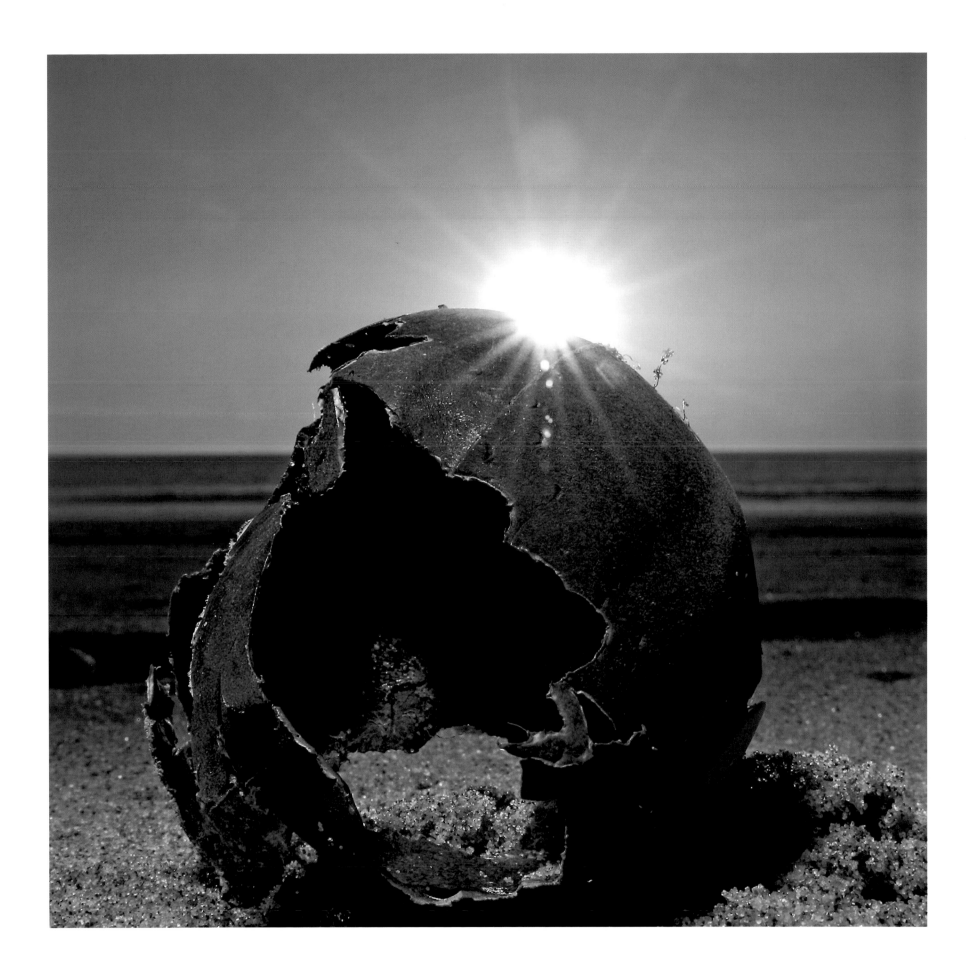

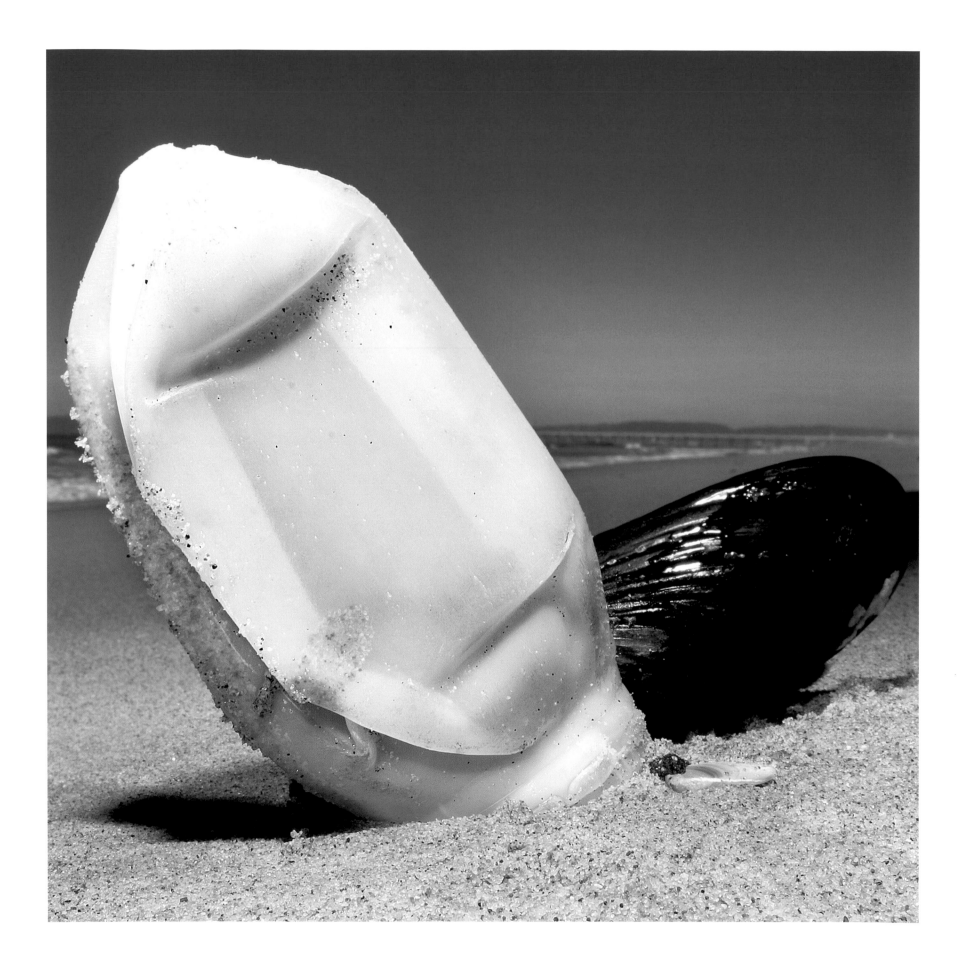

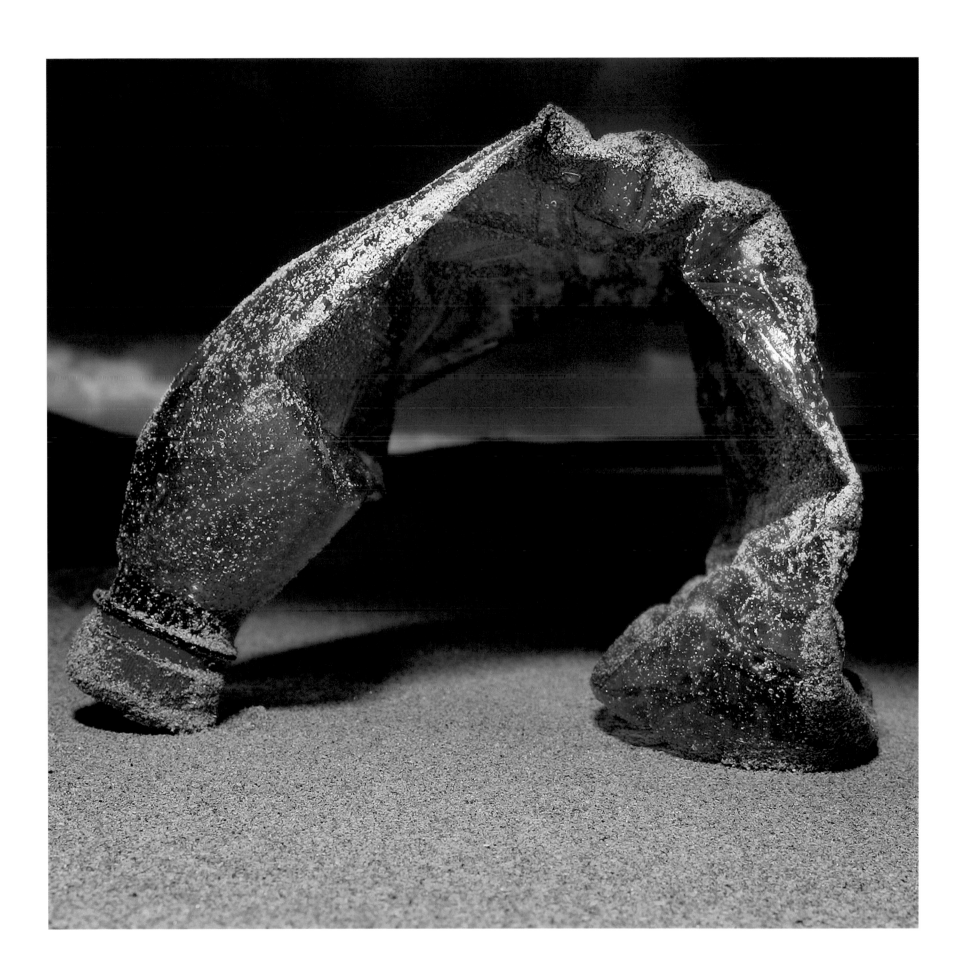

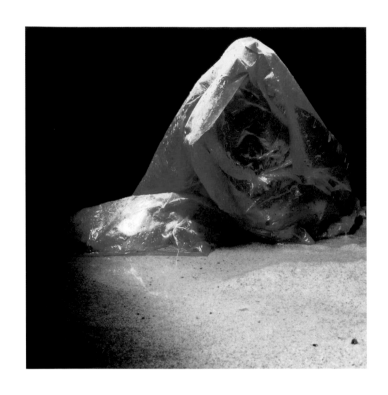

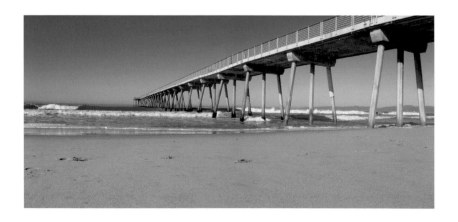

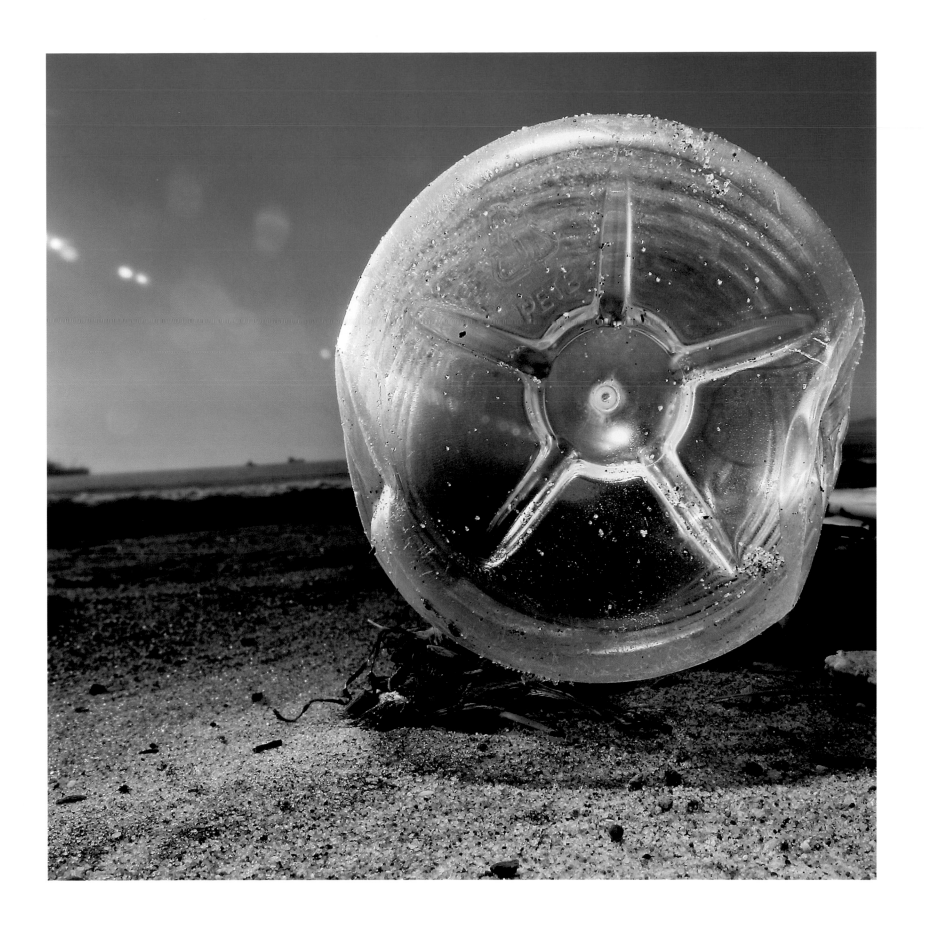

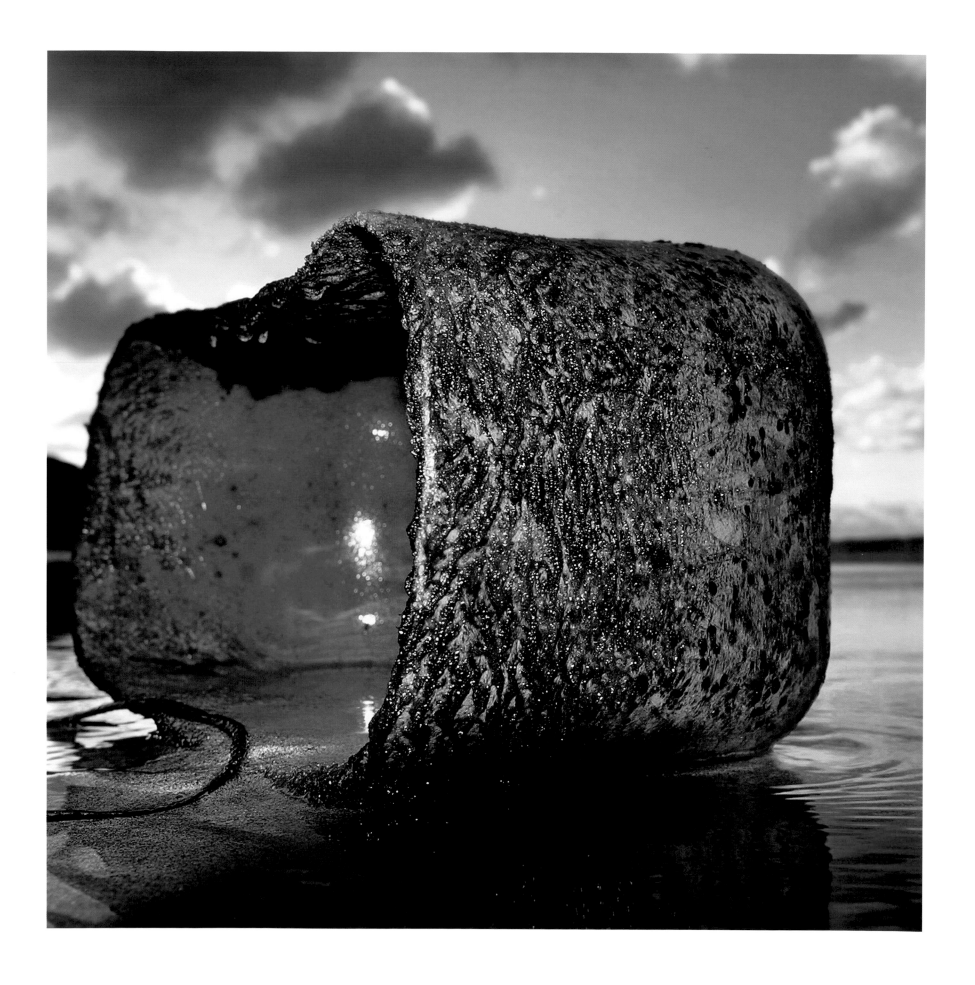

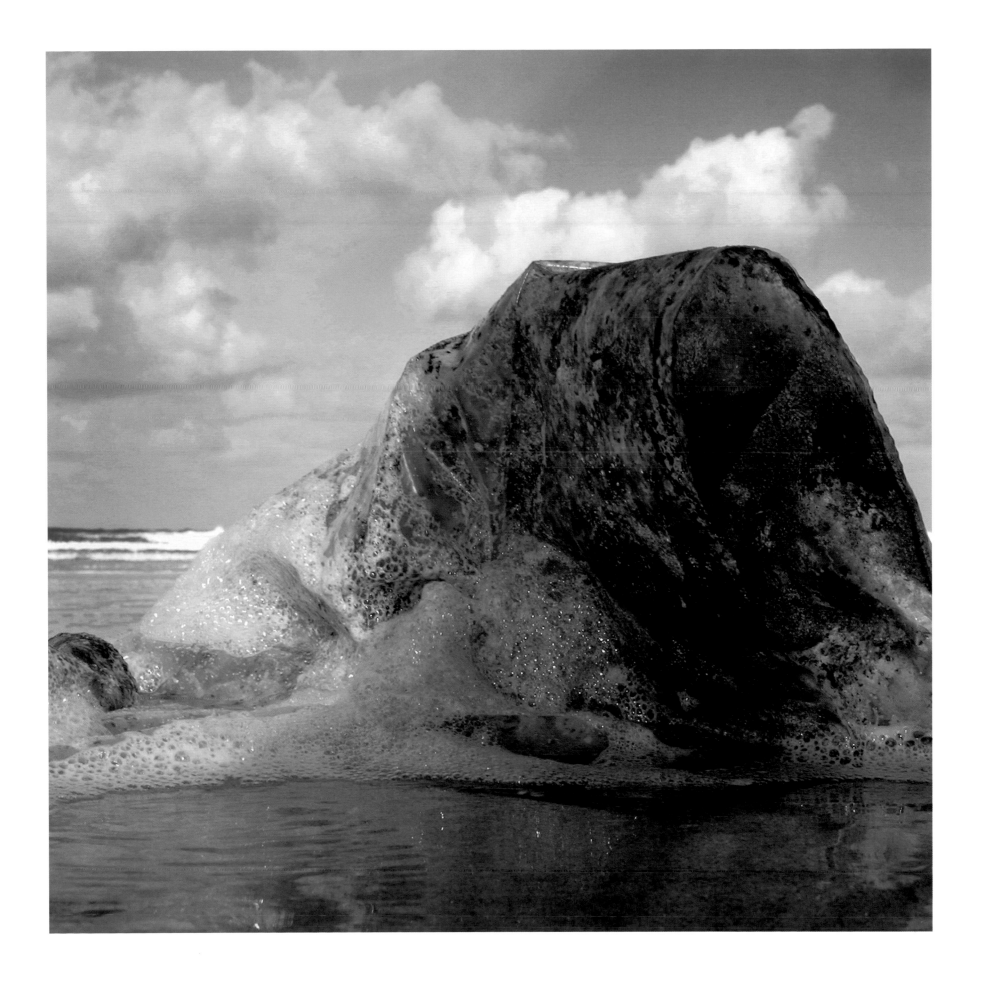

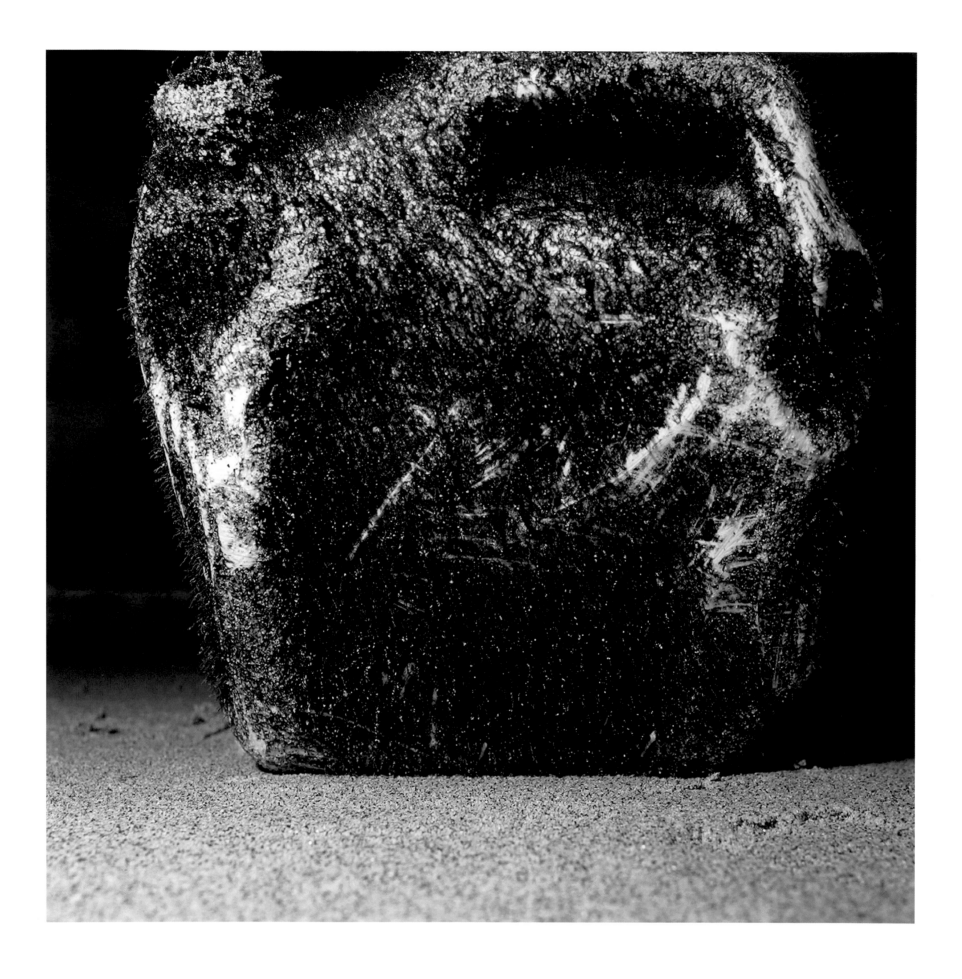

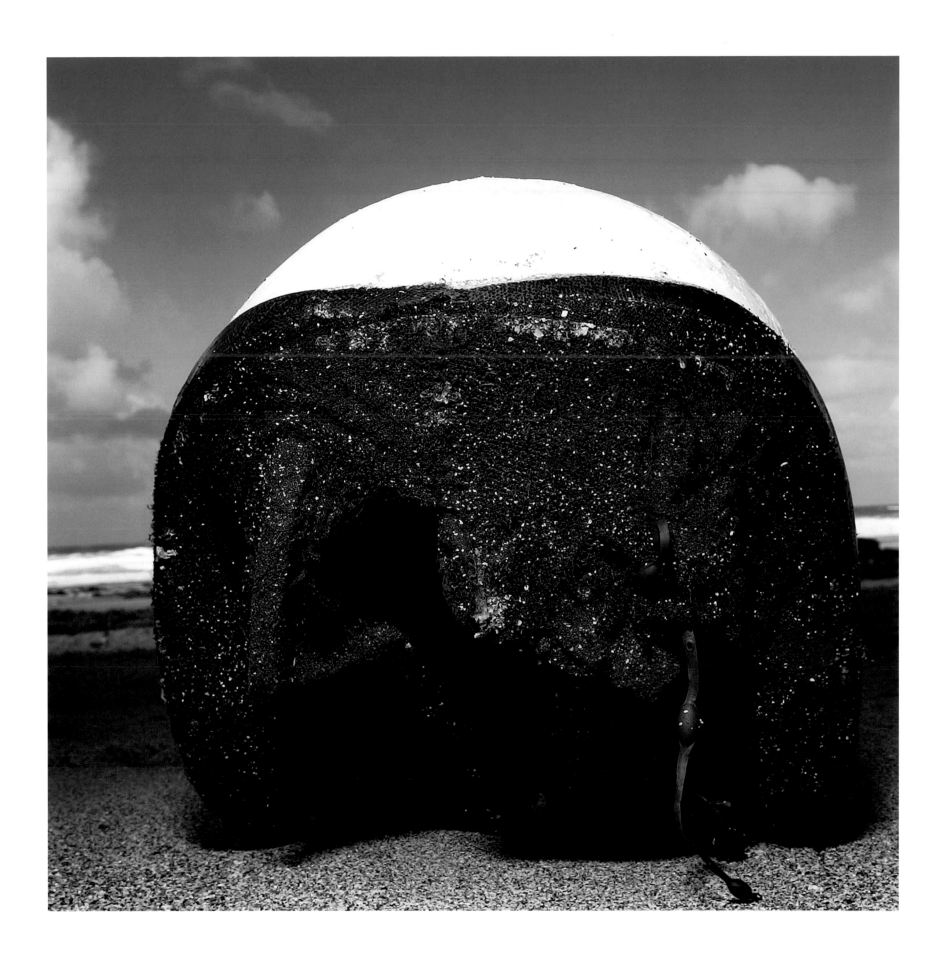

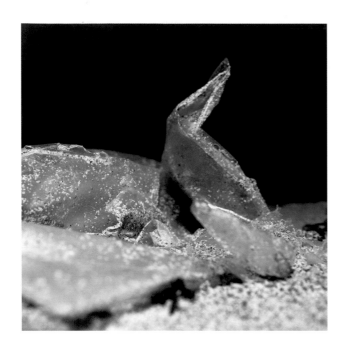

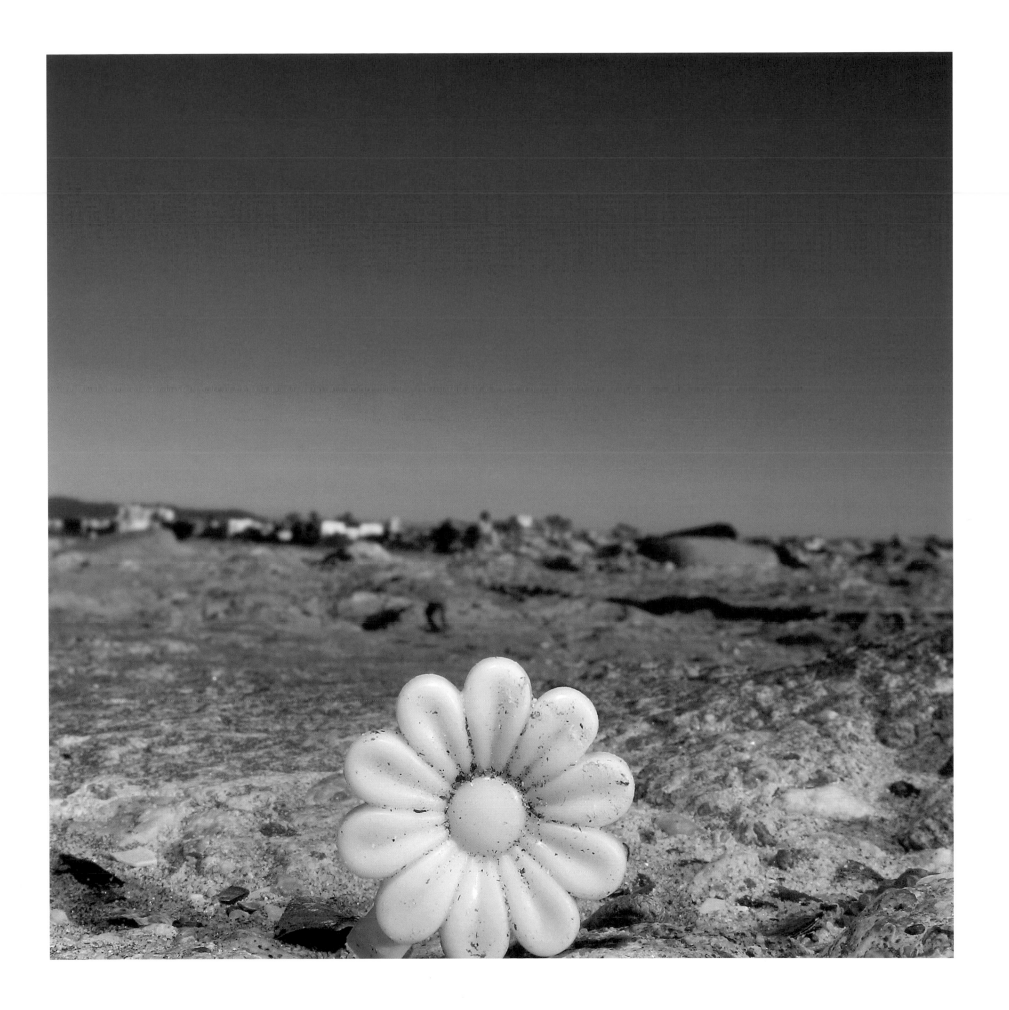

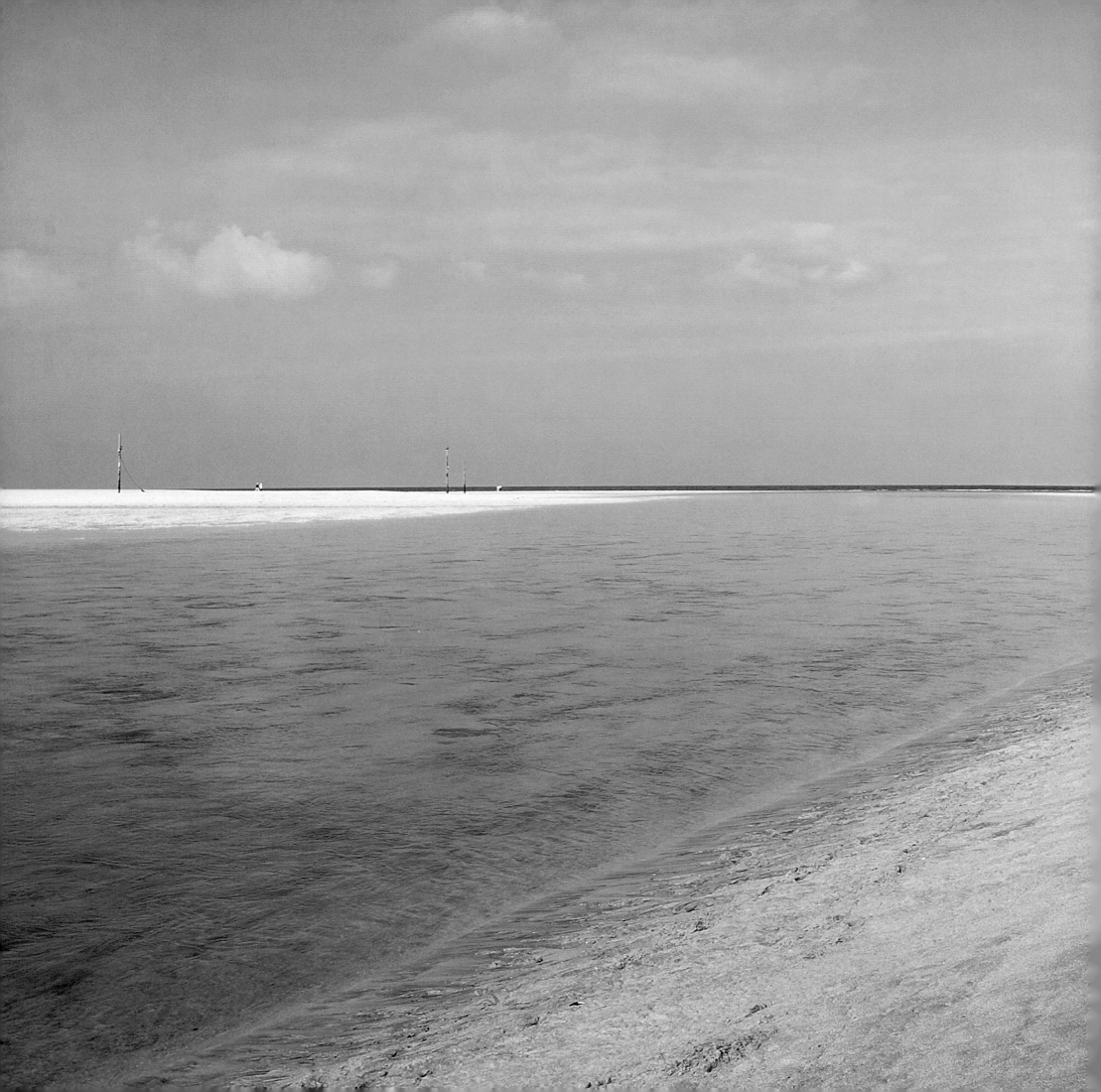

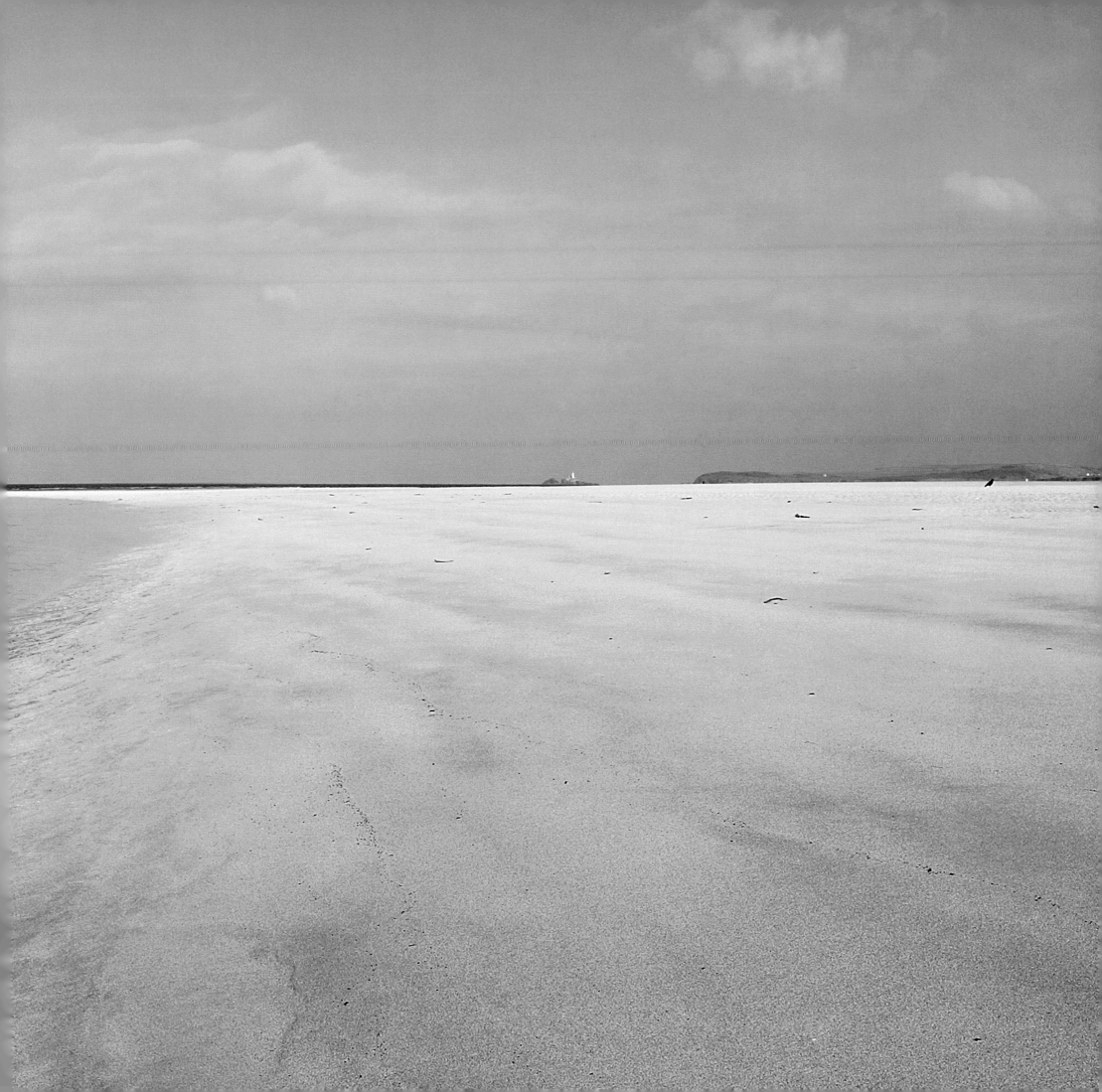

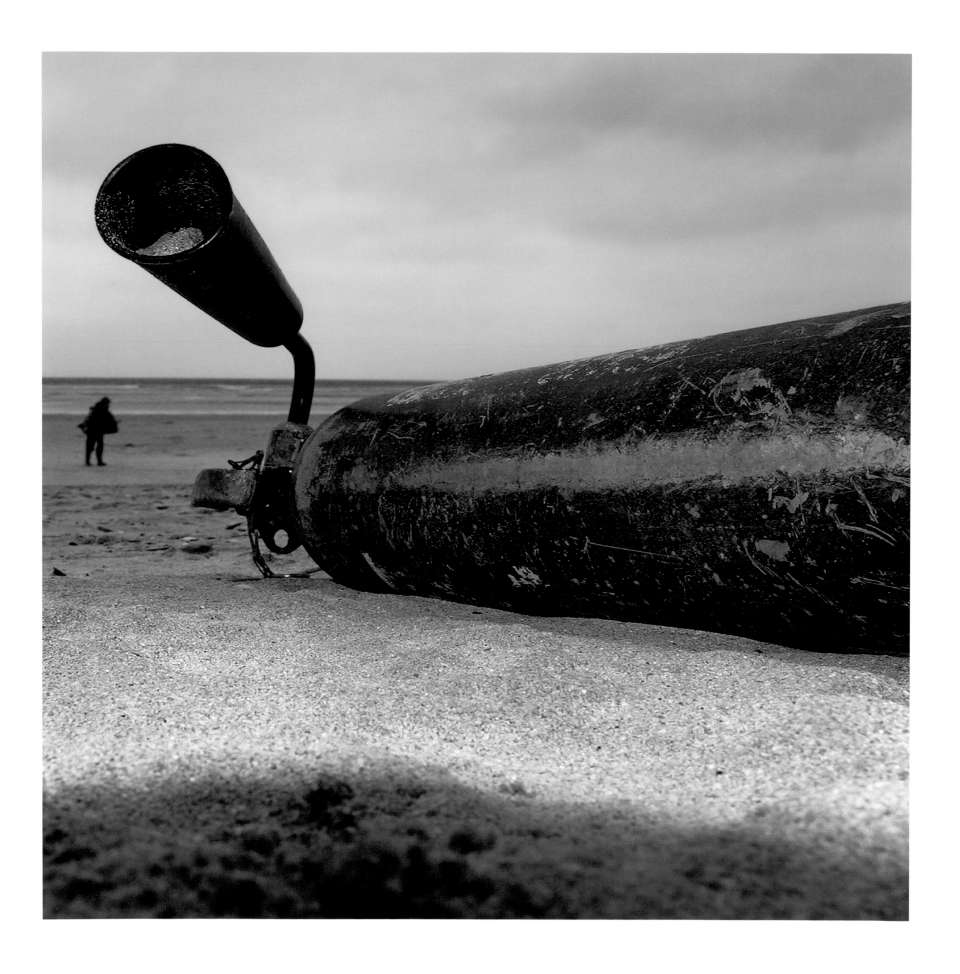

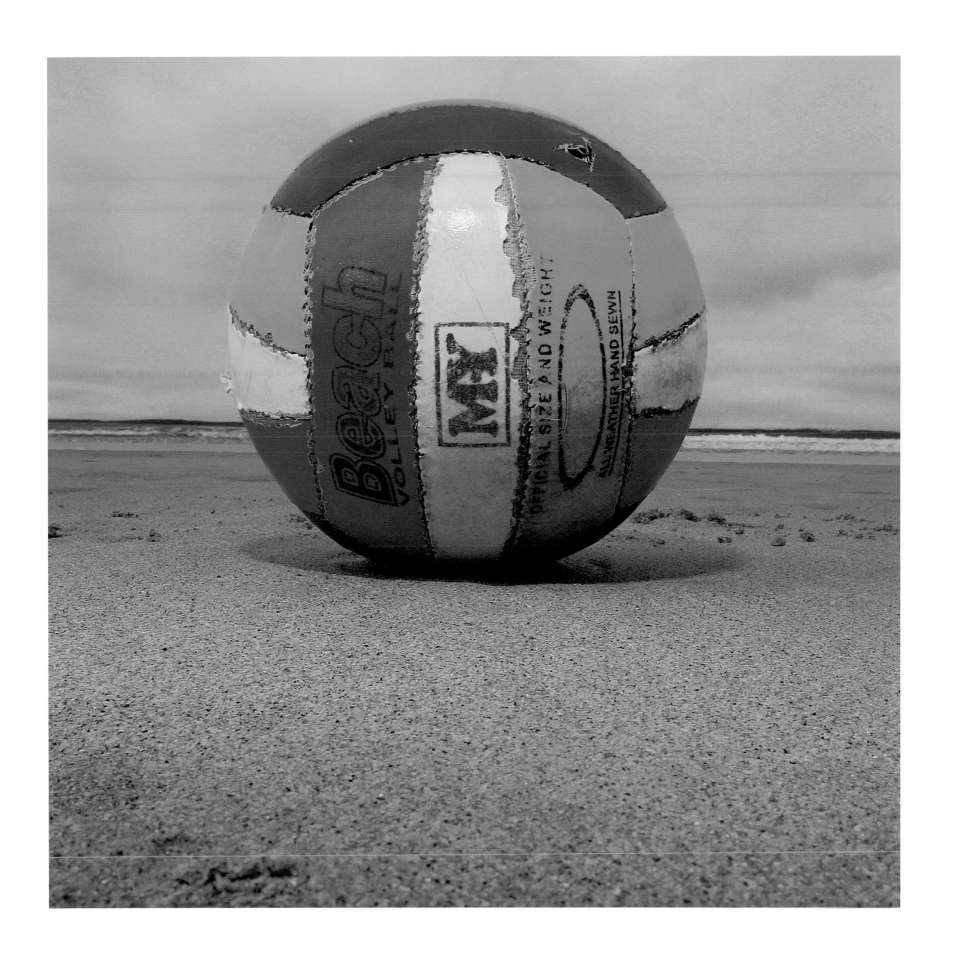

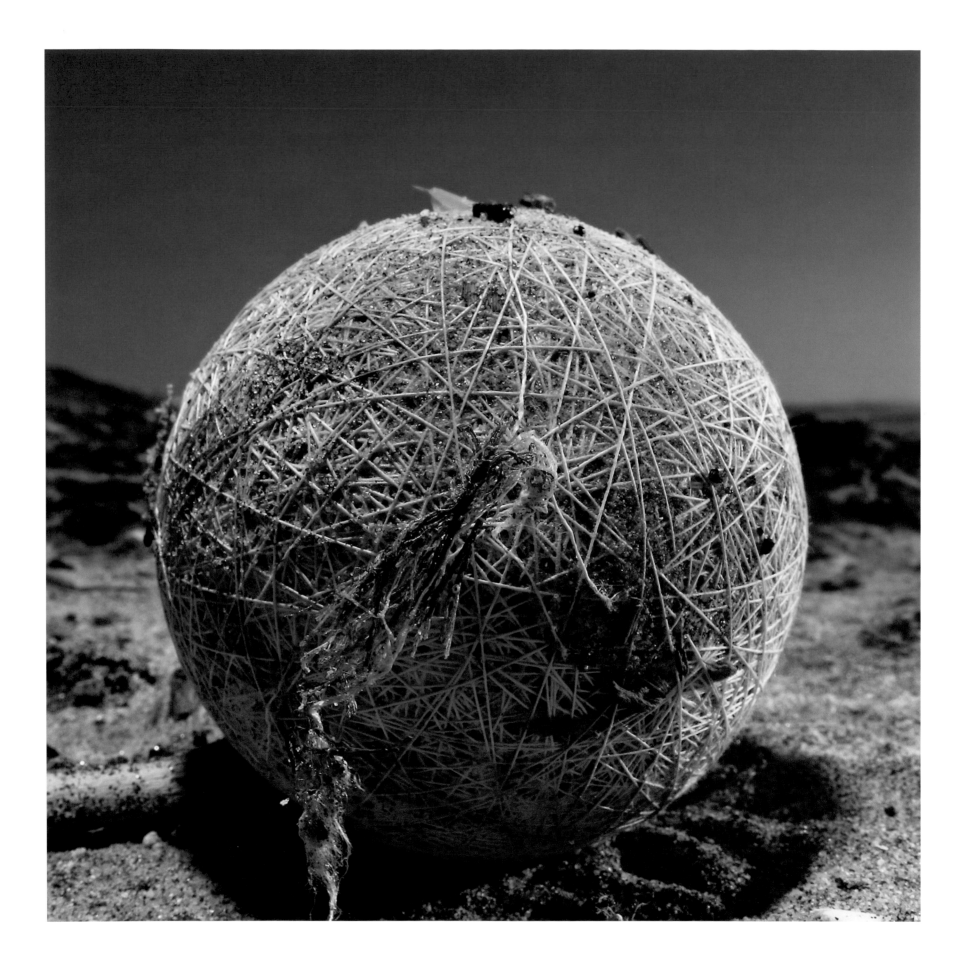

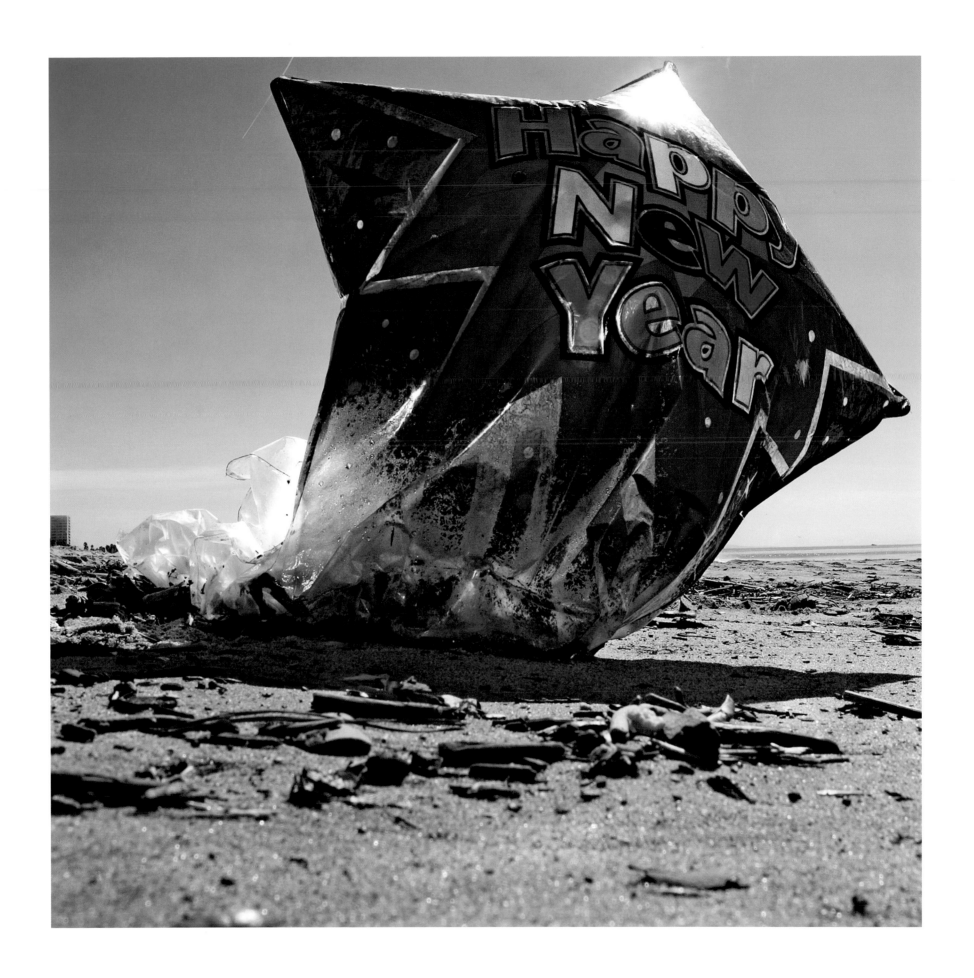

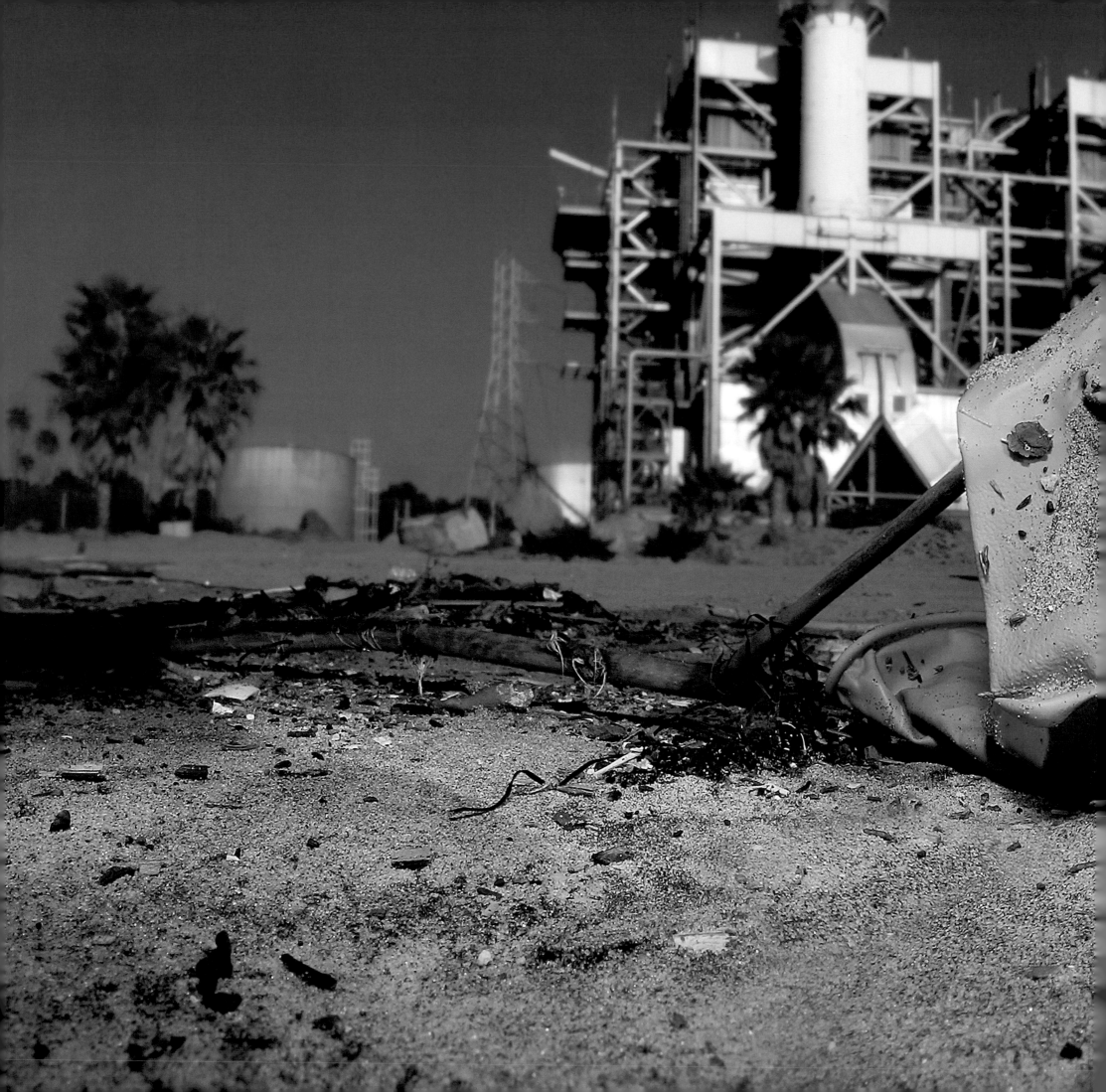

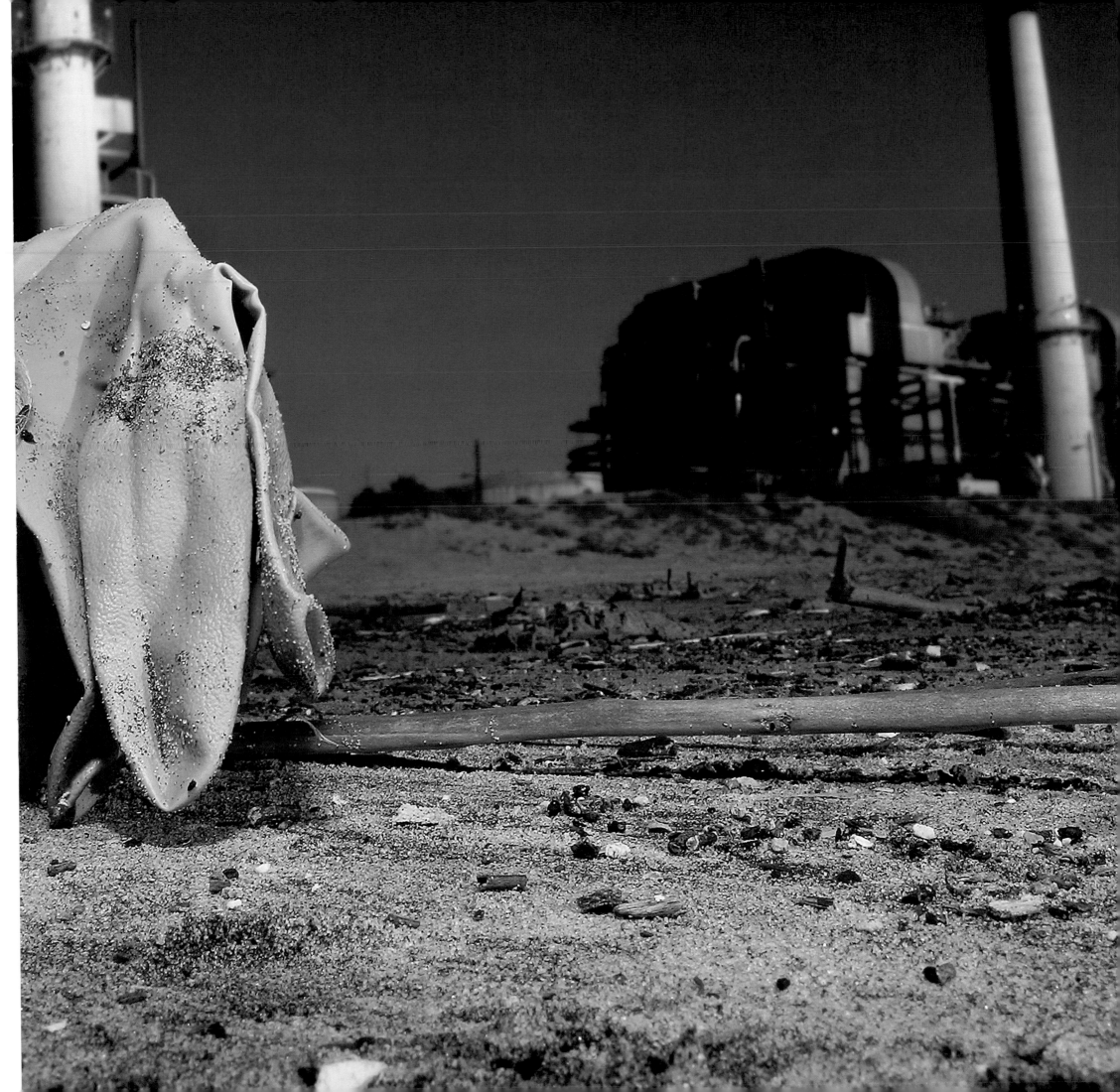

the problem of marine debris, we need to reduce pollution at the source and create less waste in the first place. This can be accomplished in many ways, ranging from greater public awareness, to retooling our industries, making them cleaner and greener. It means moving away from fossil fuels which are the building blocks for many of the plastics polluting our seas. It also means moving towards clean, renewable energy and bioplastics such as corn. The technology is there – it is a matter of harnessing it.

This effect, while noble, is not enough. To truly address the problem of marine debris, we need to reduce pollution at the source and create less waste in the first place.

But just imagine for a moment… the red balloon floats into the sky. Eventually, it deflates and lands in the sea. Then, because it is a biodegradable balloon, it disintegrates before a seal could swallow and choke on it or before it washes up on the beach…before Andrew Hughes has a chance to photograph it.

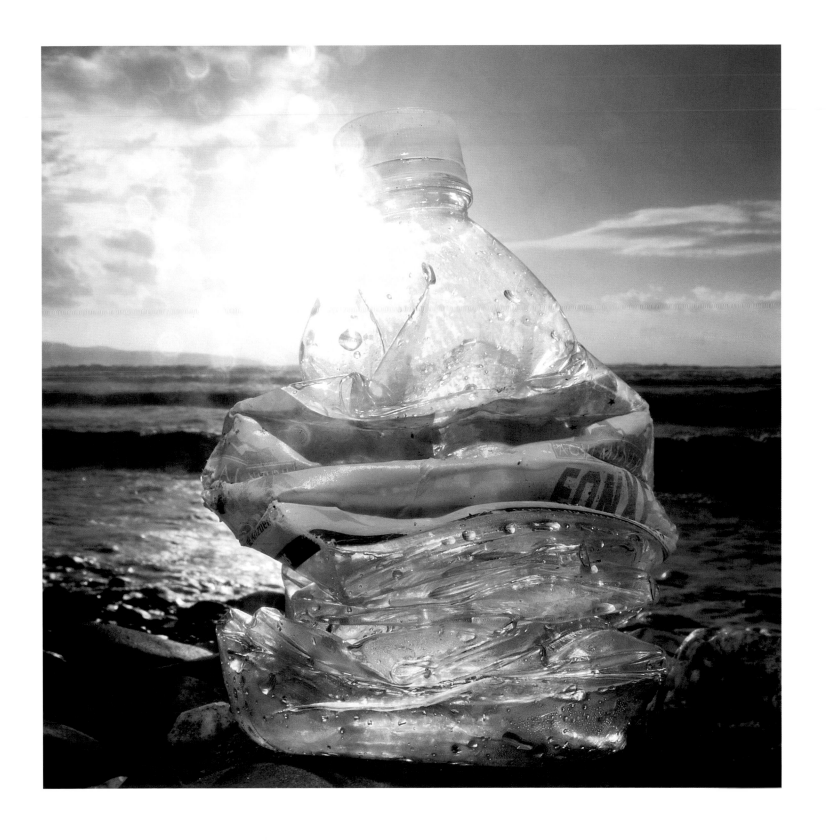

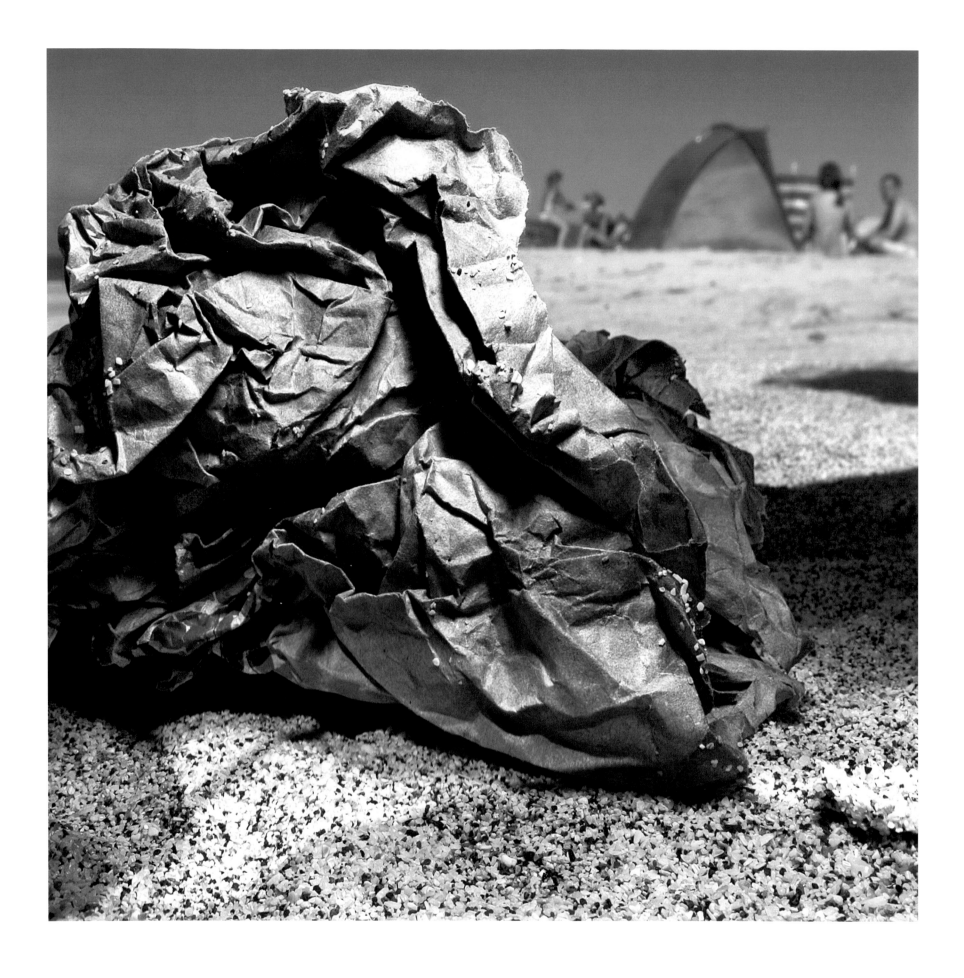

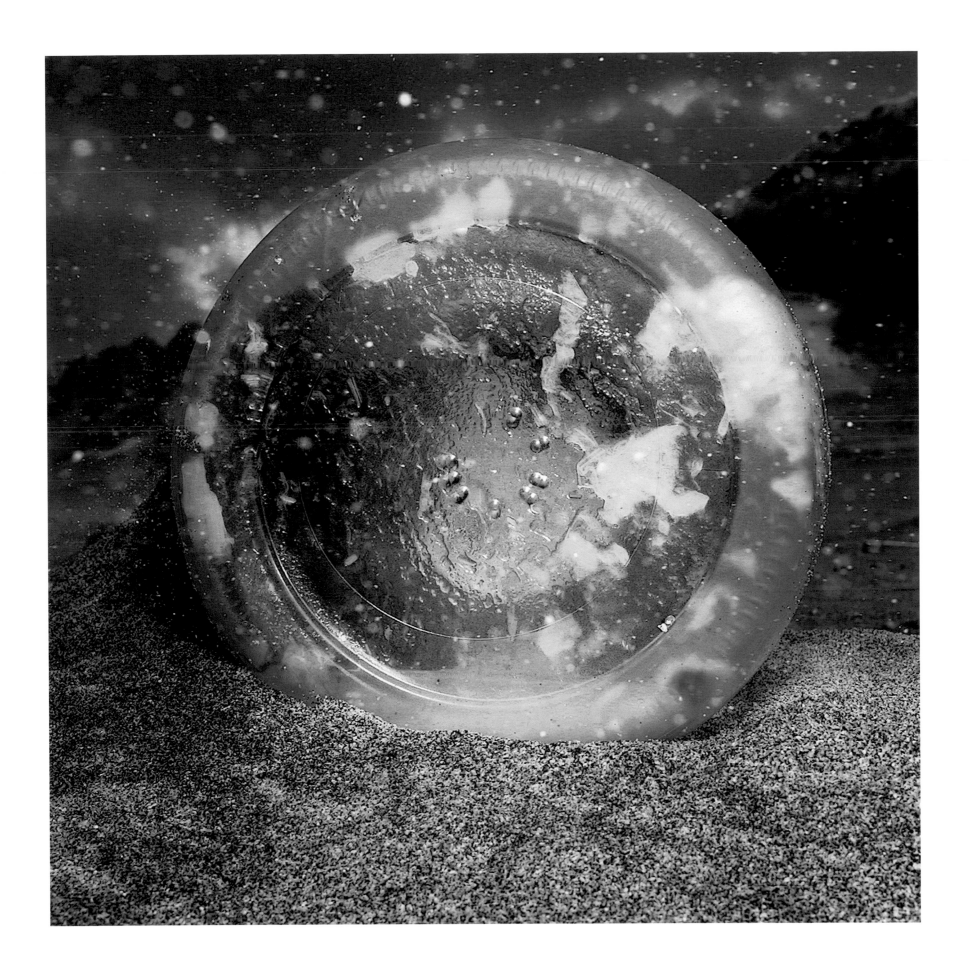

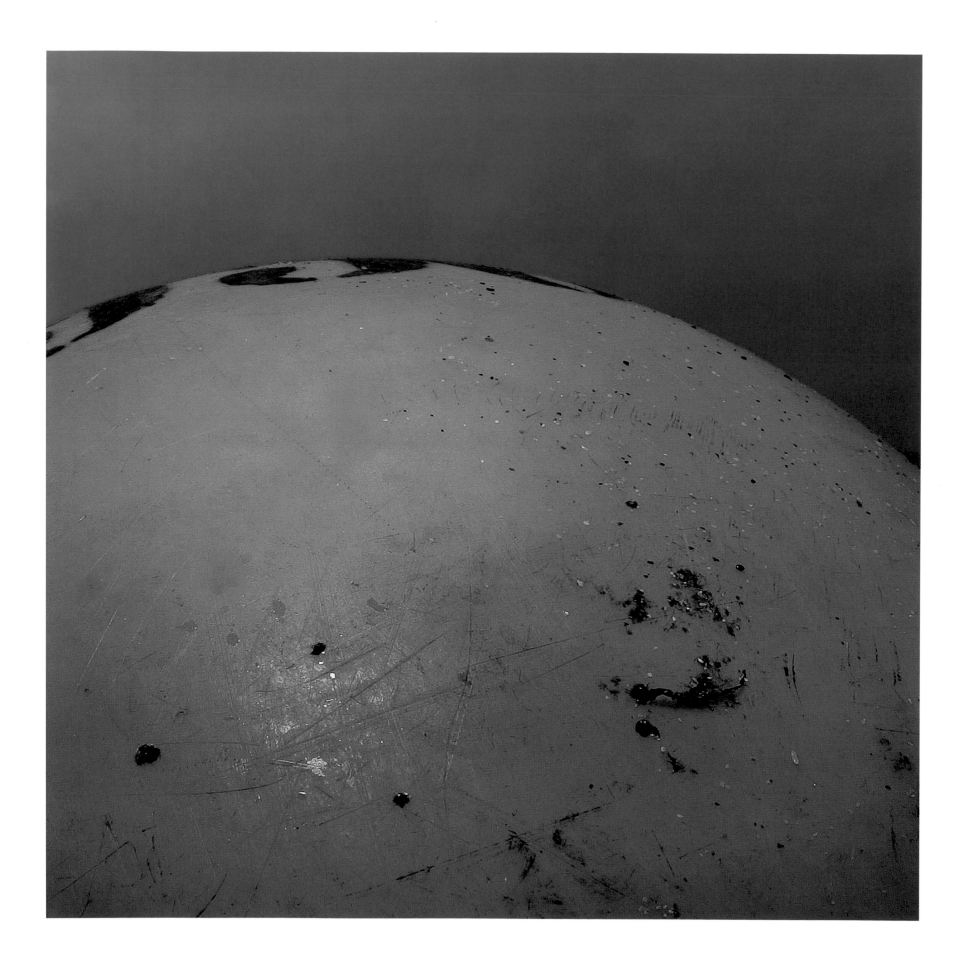

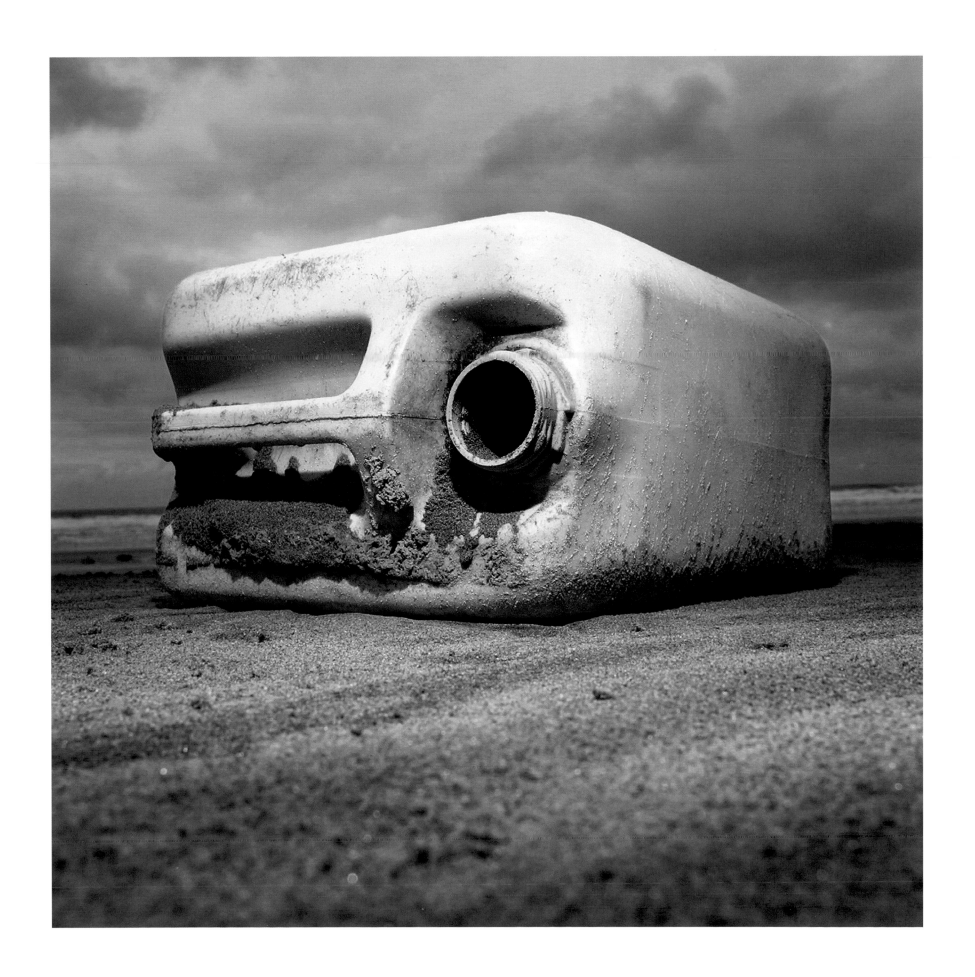

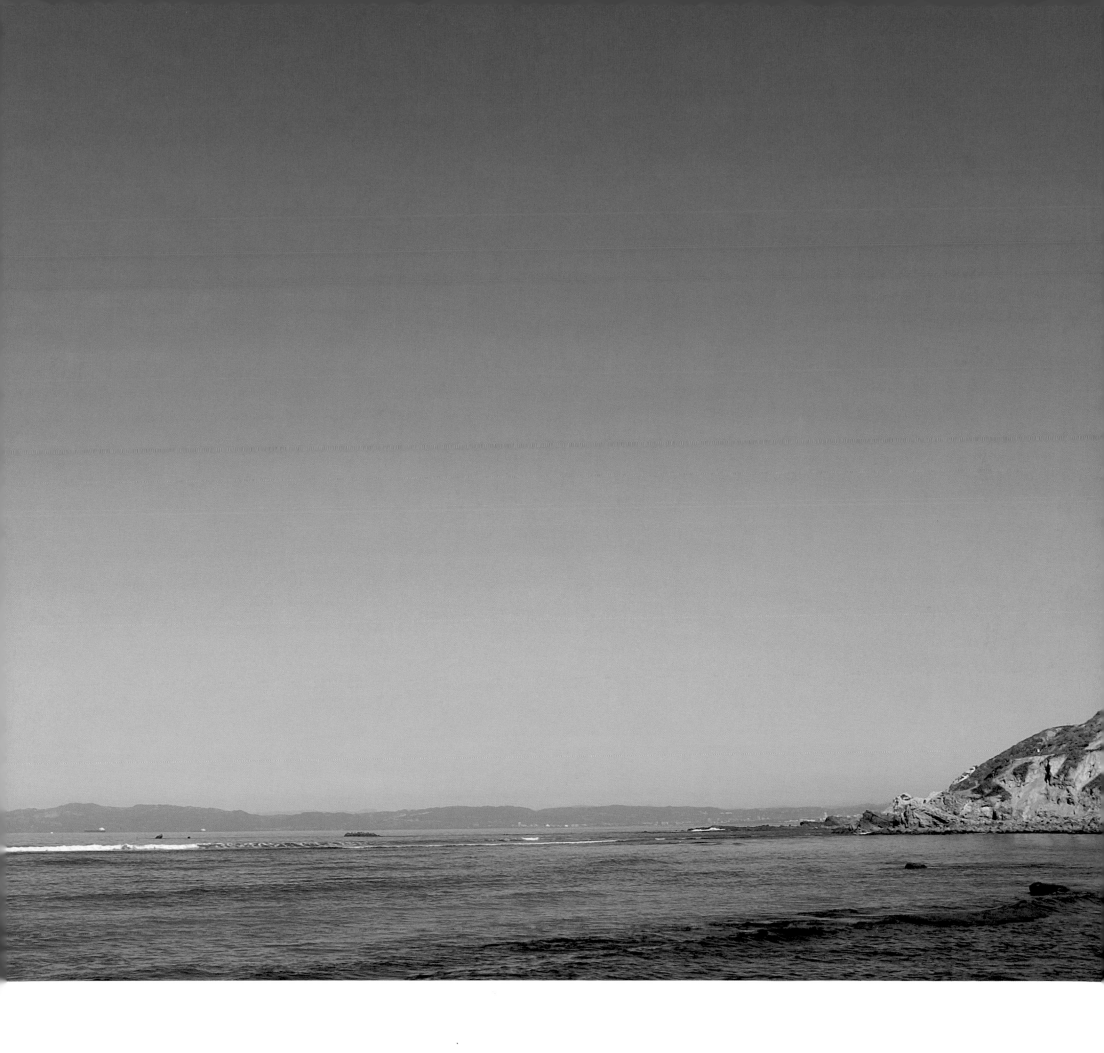

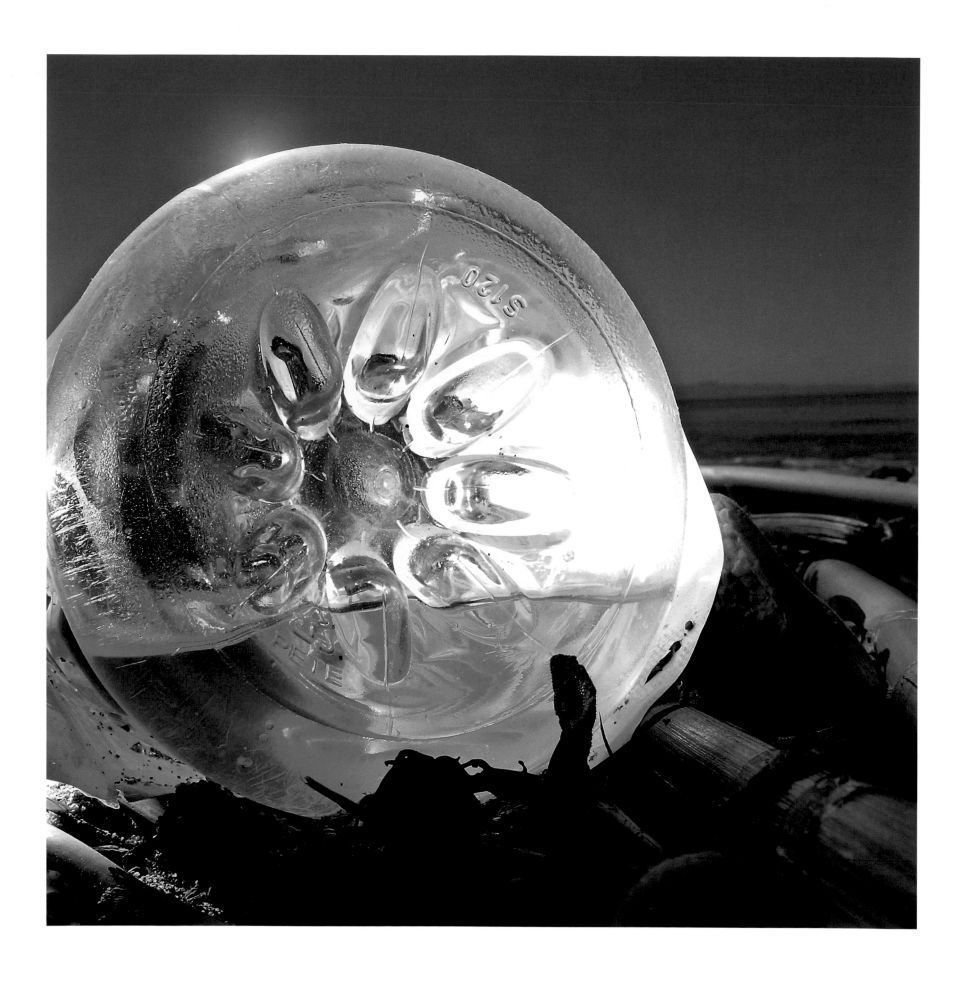

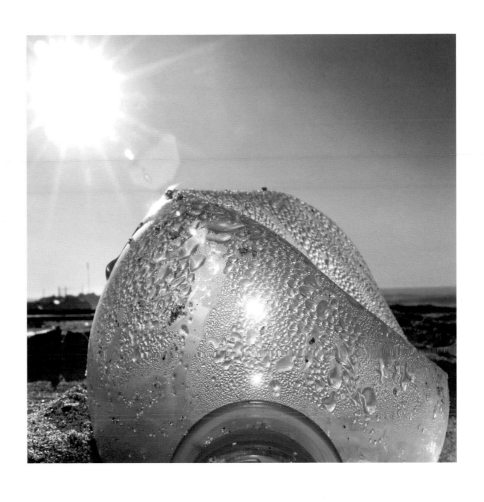

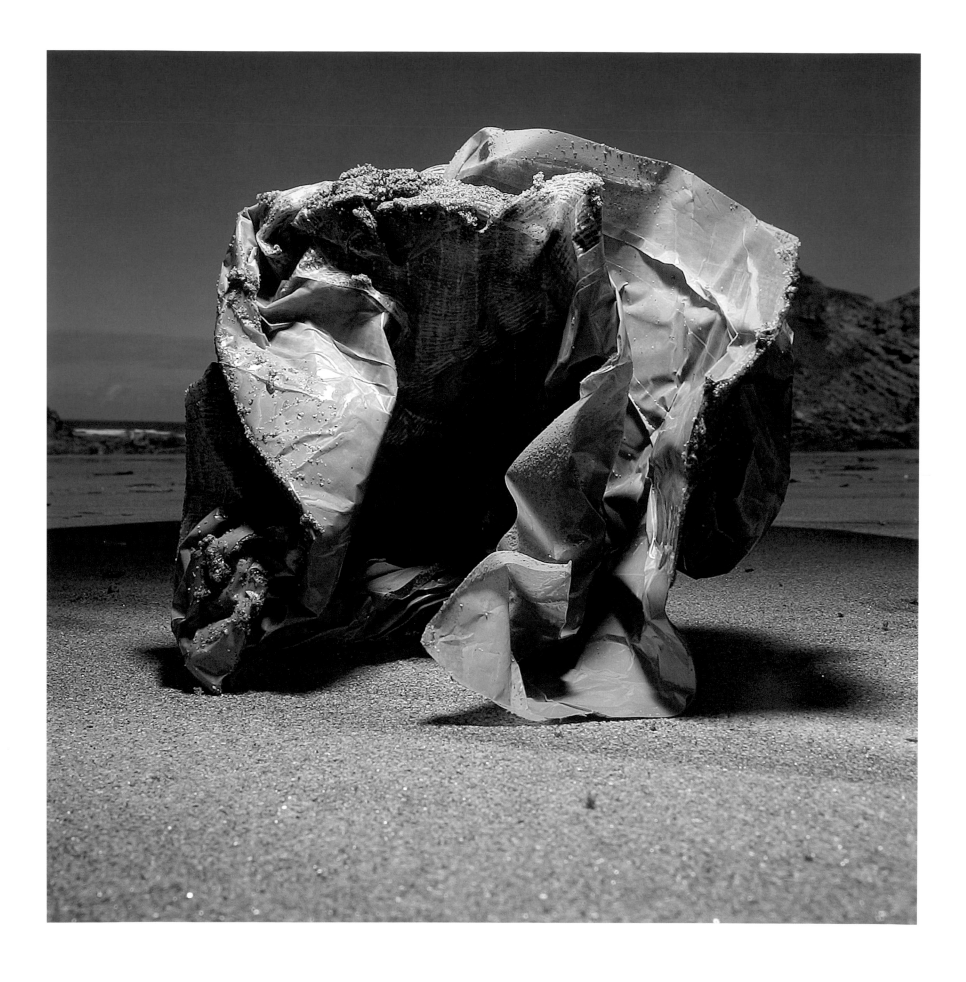

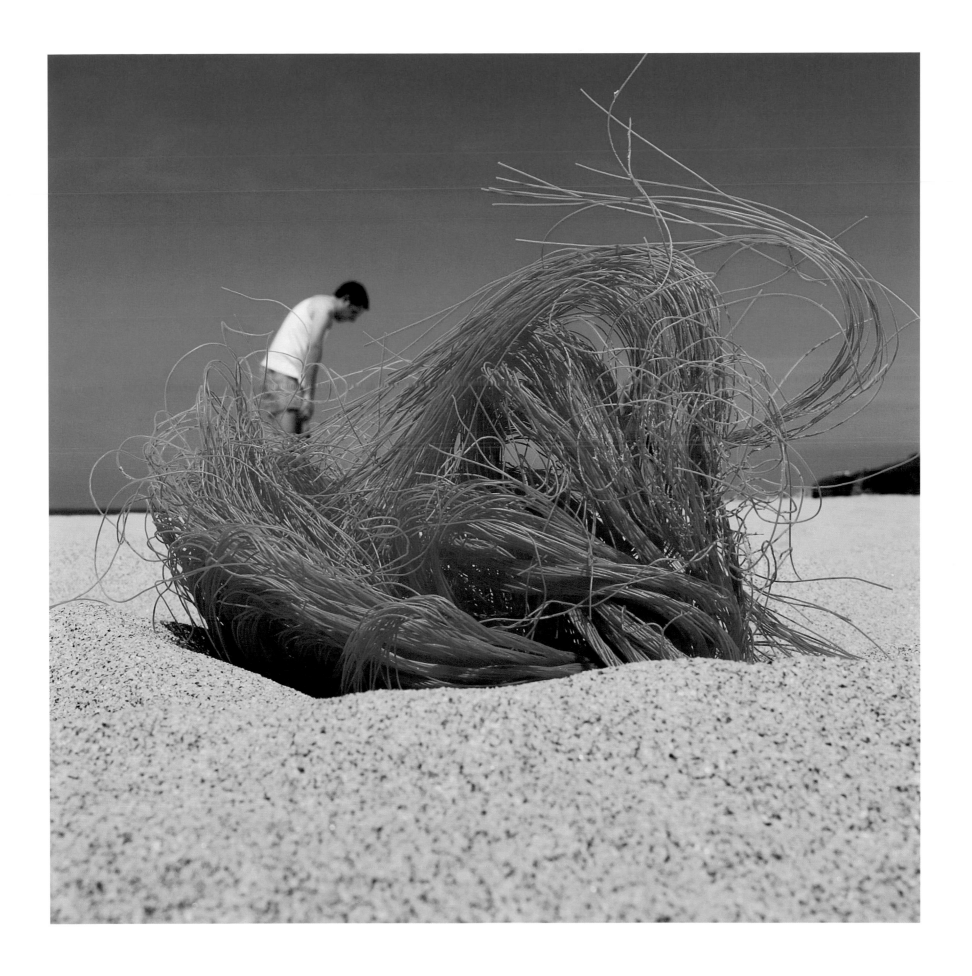

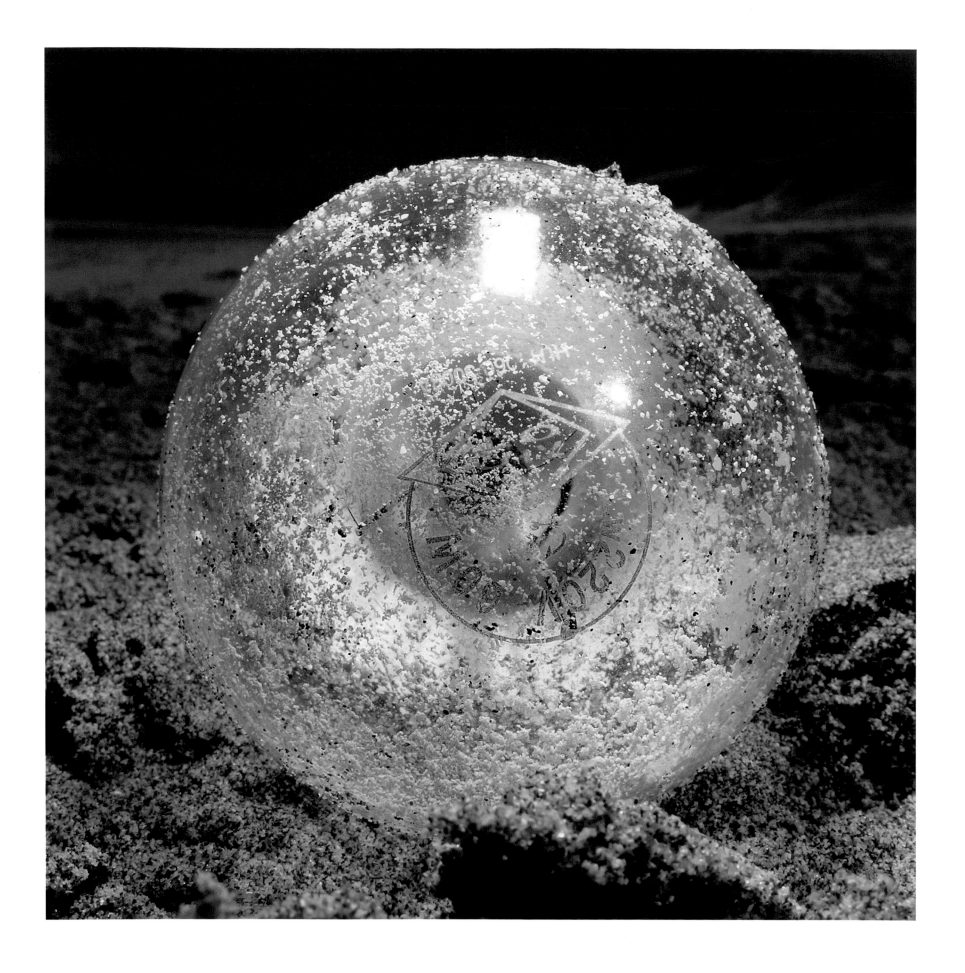

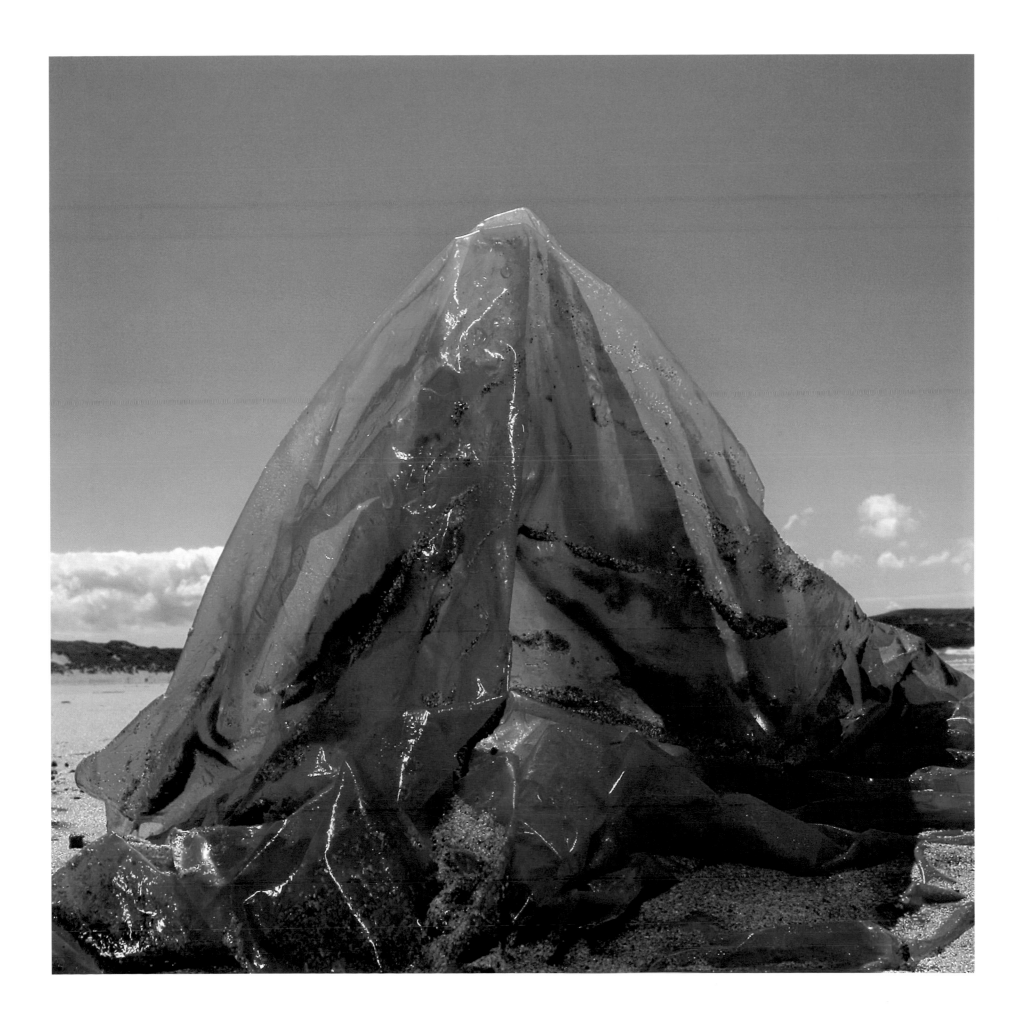

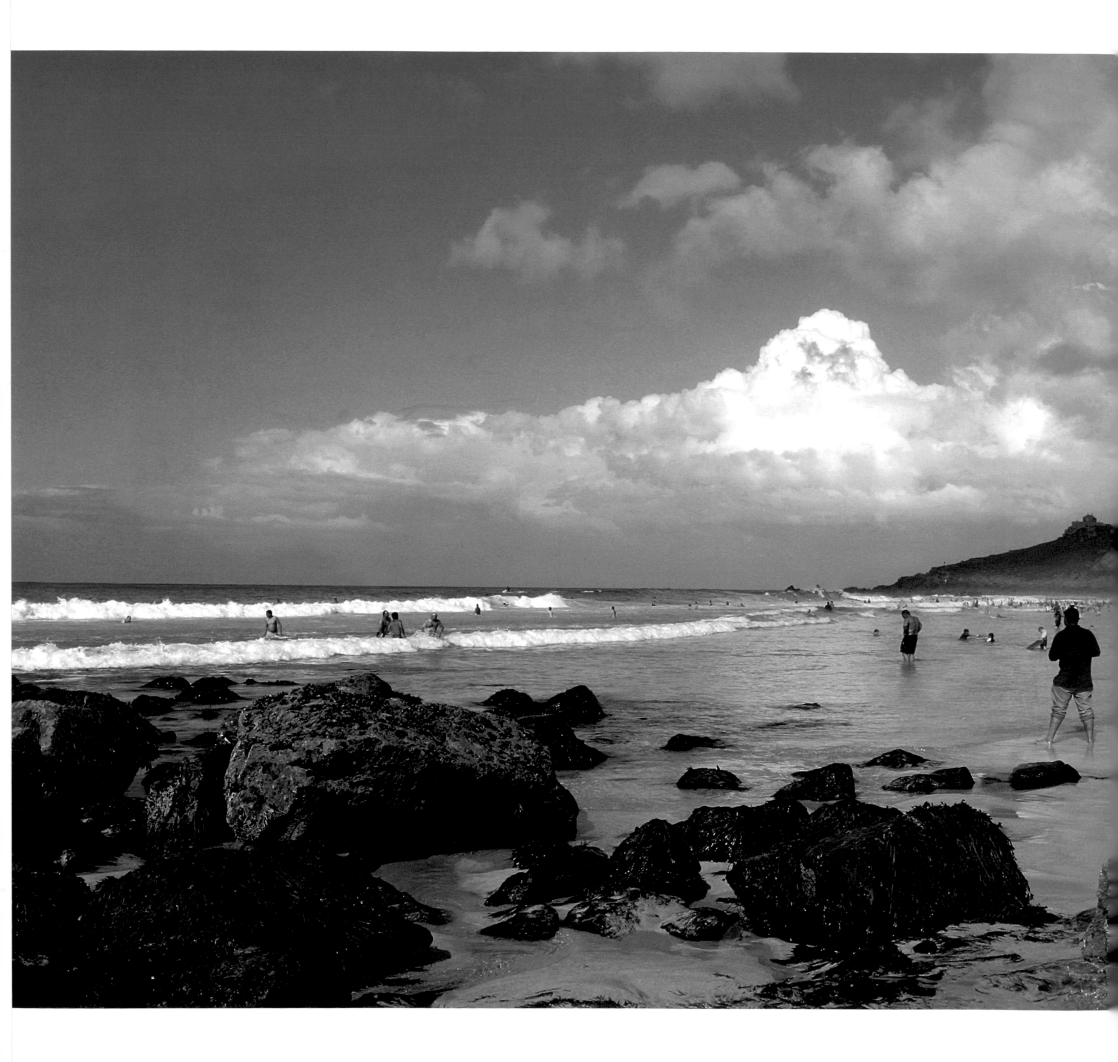

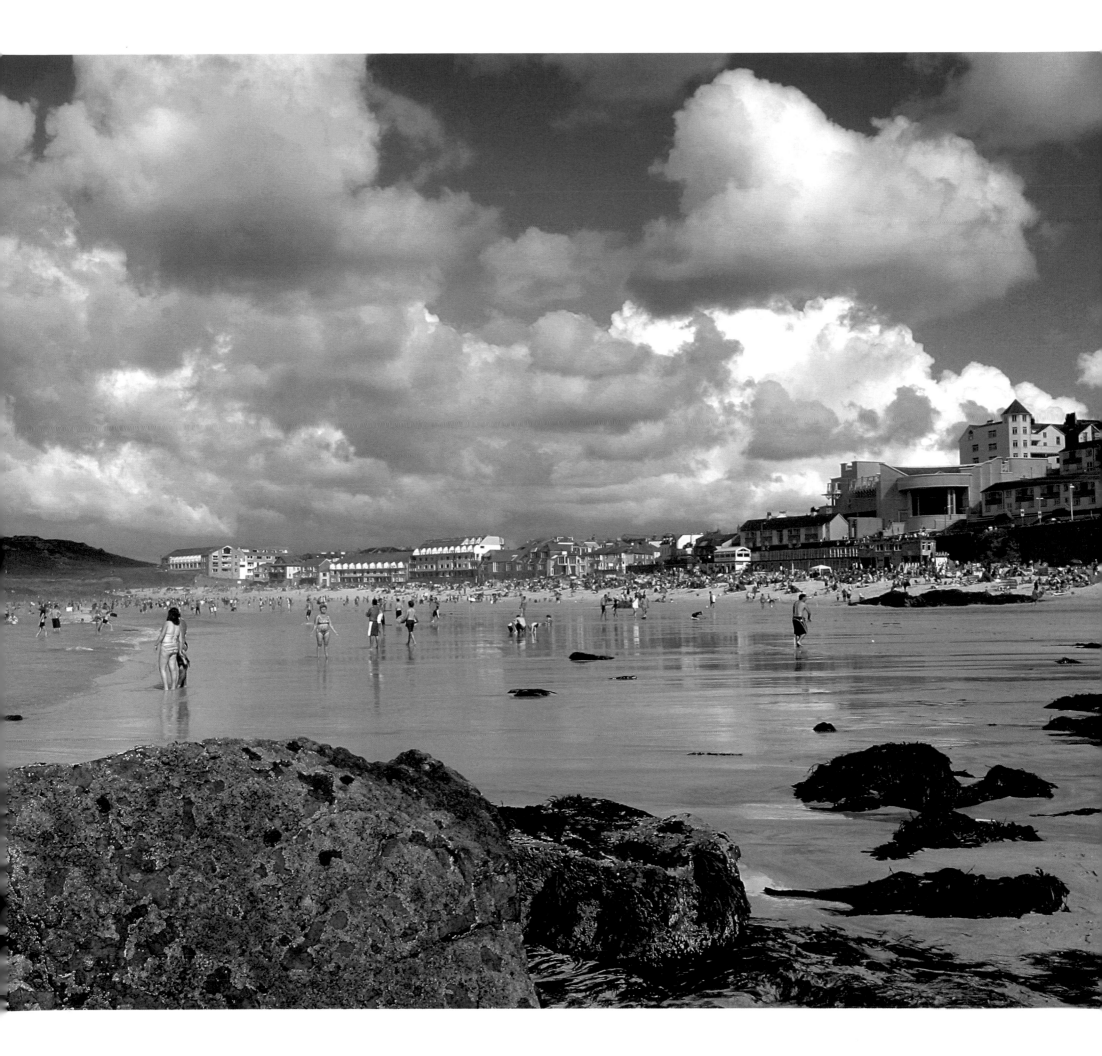

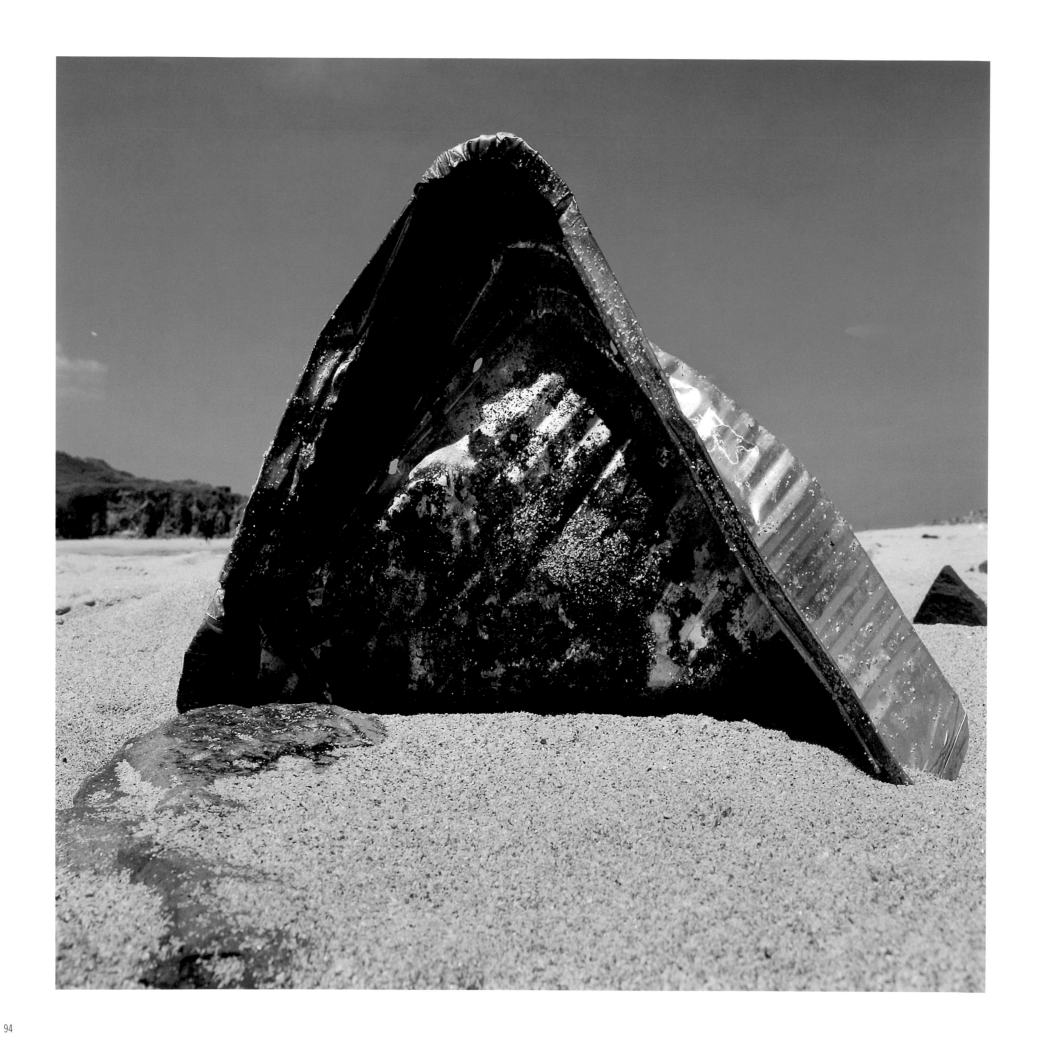

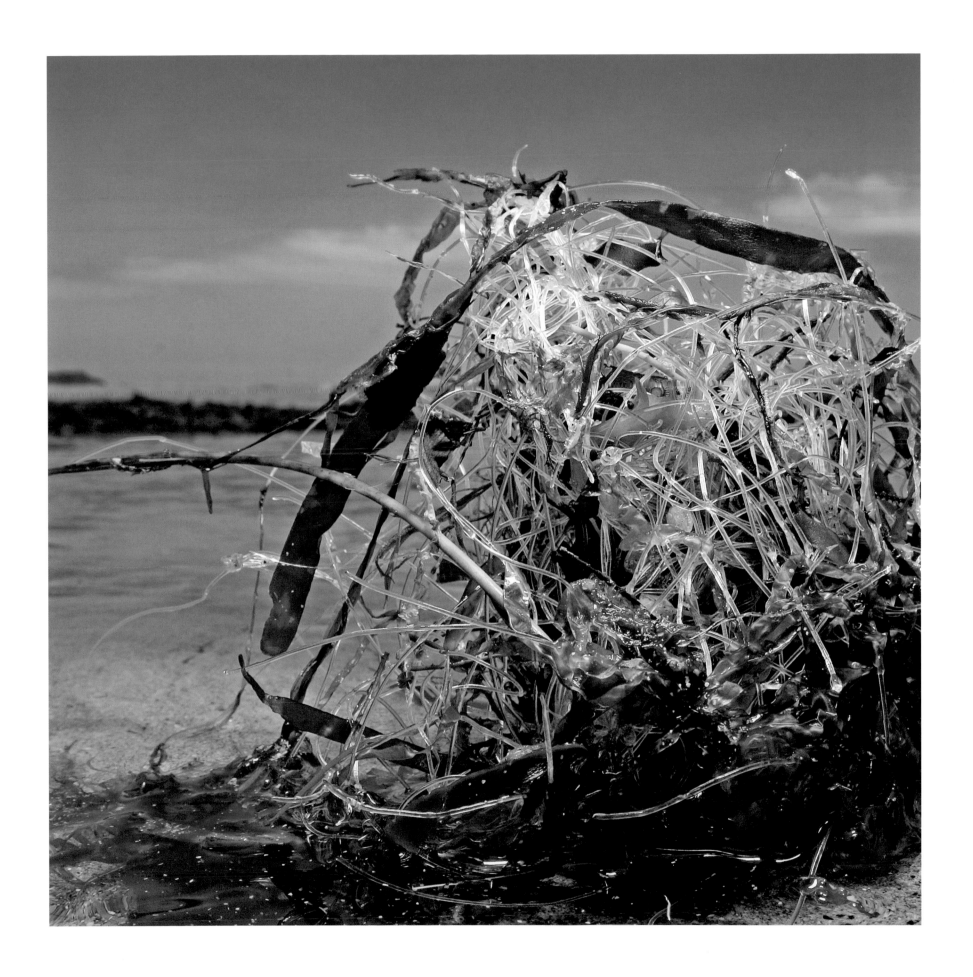

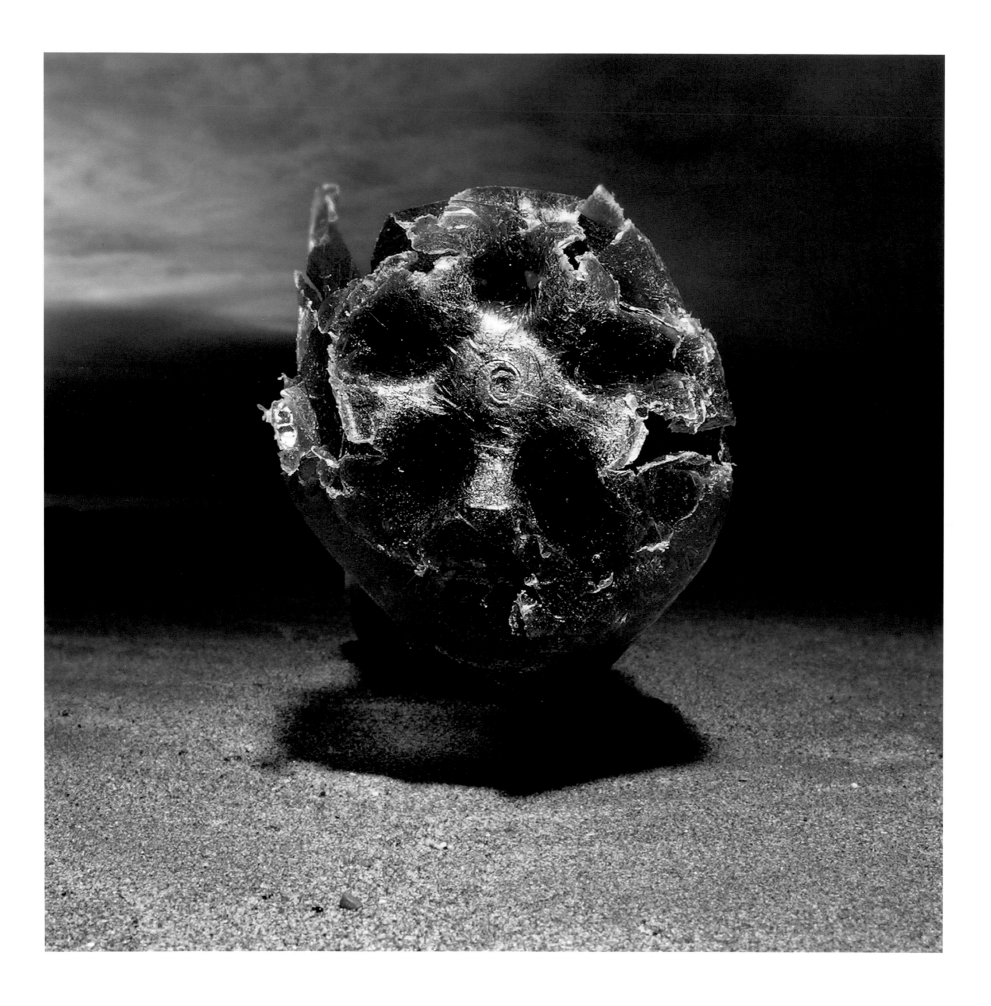

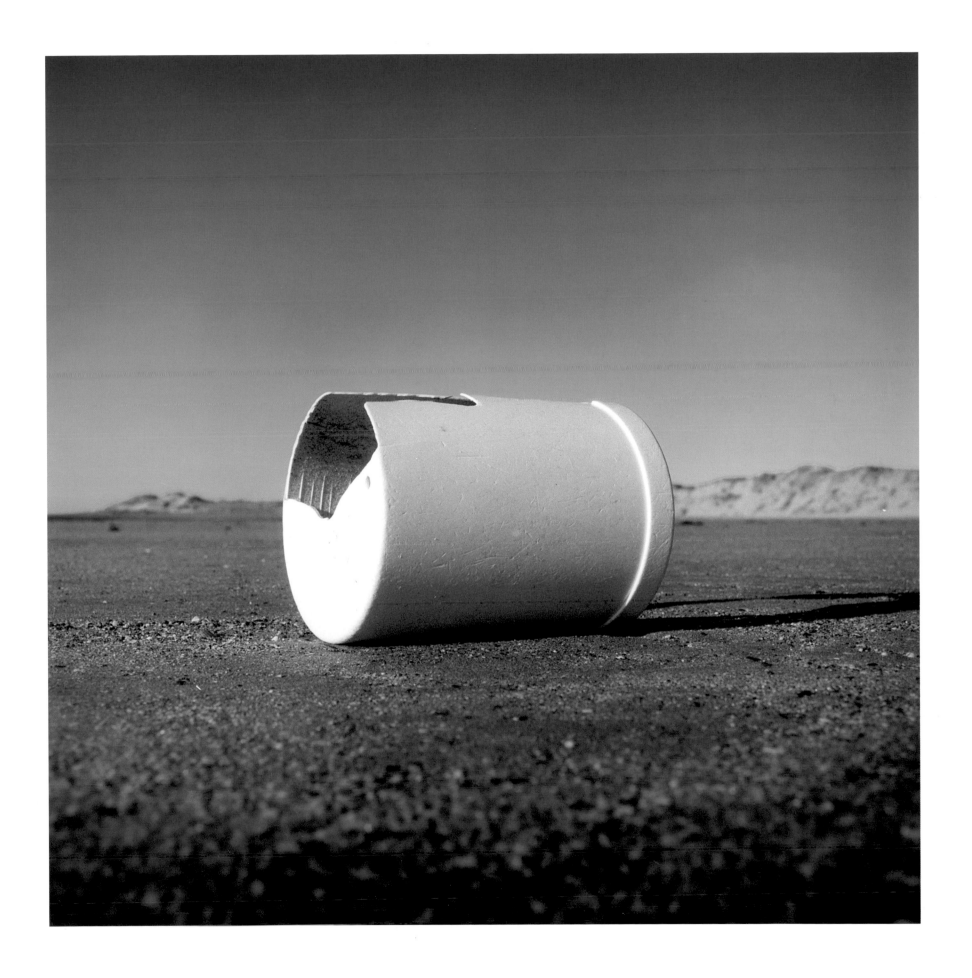

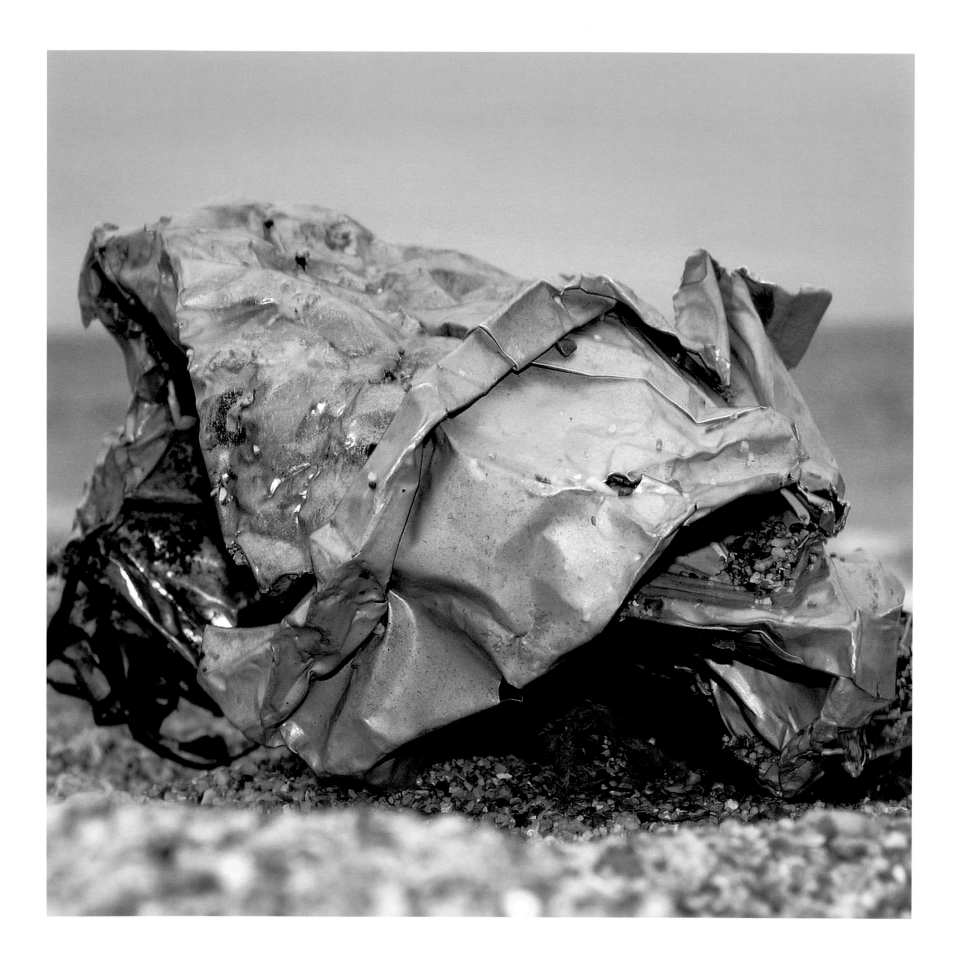

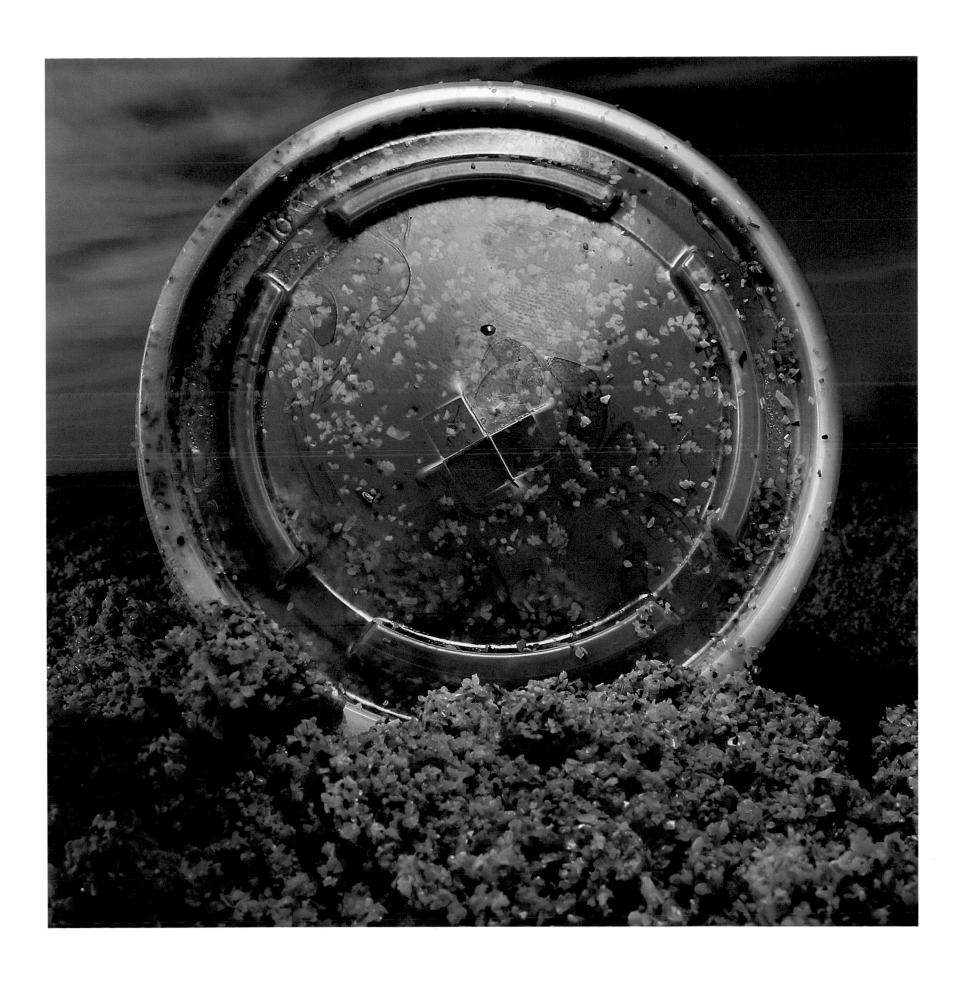

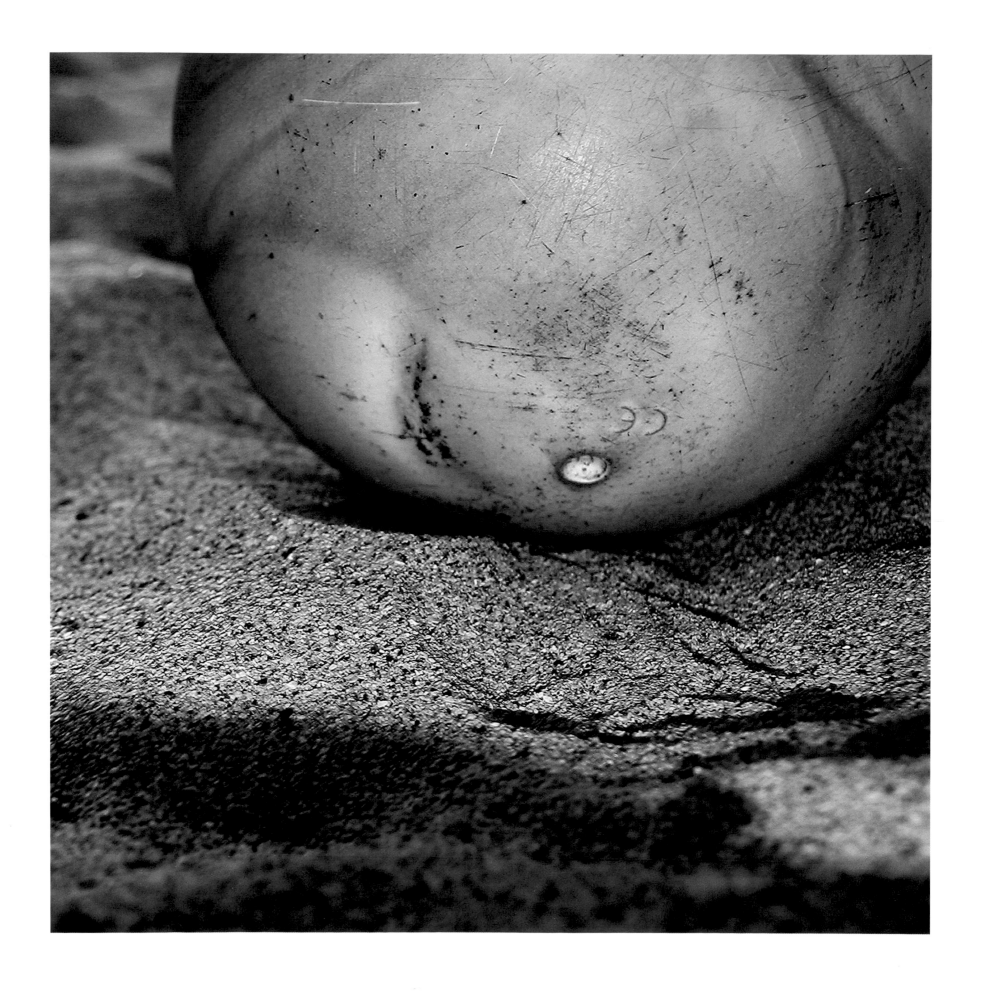

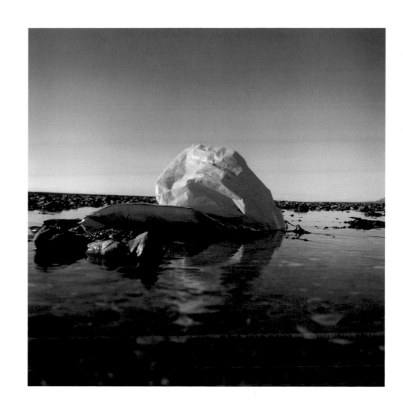

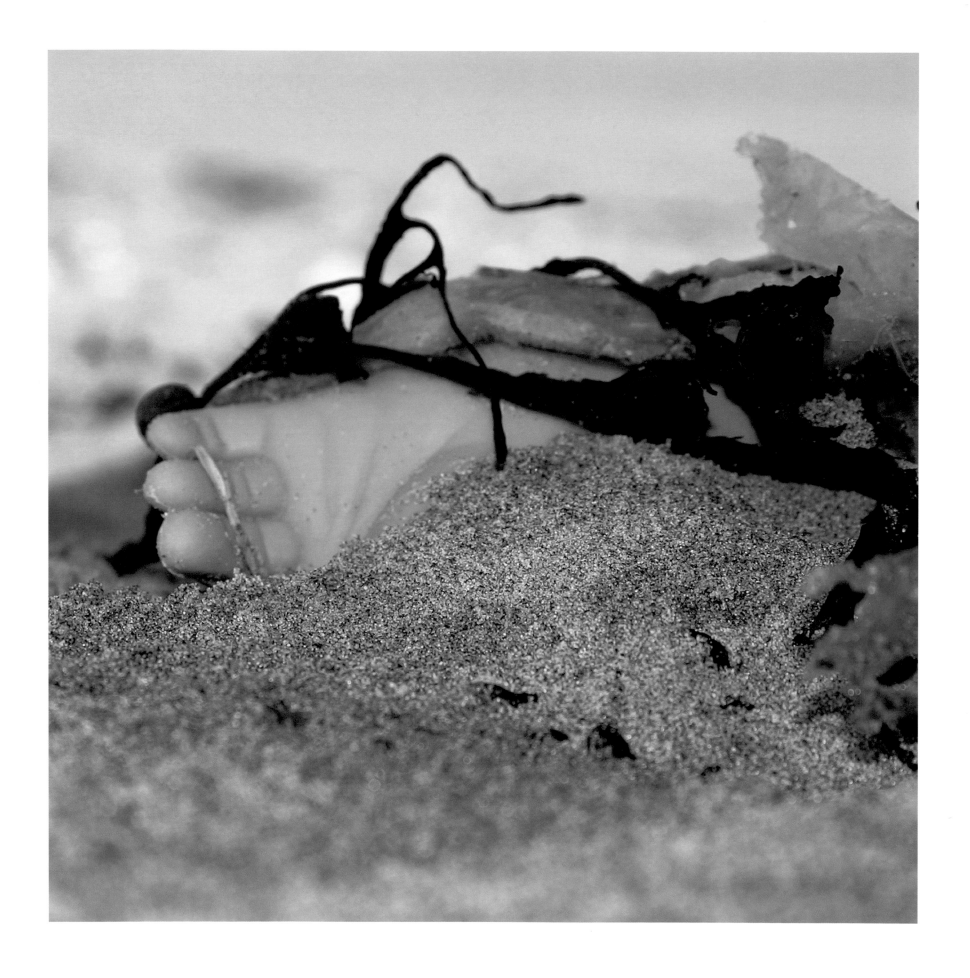

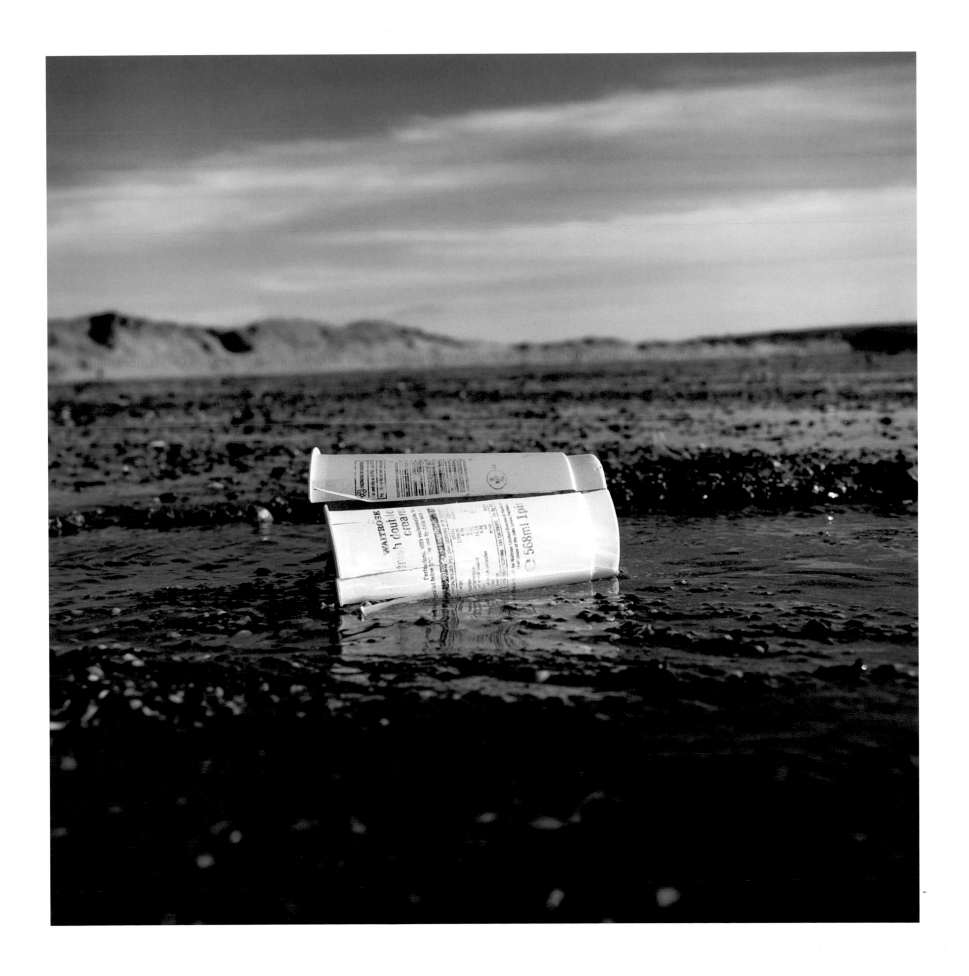

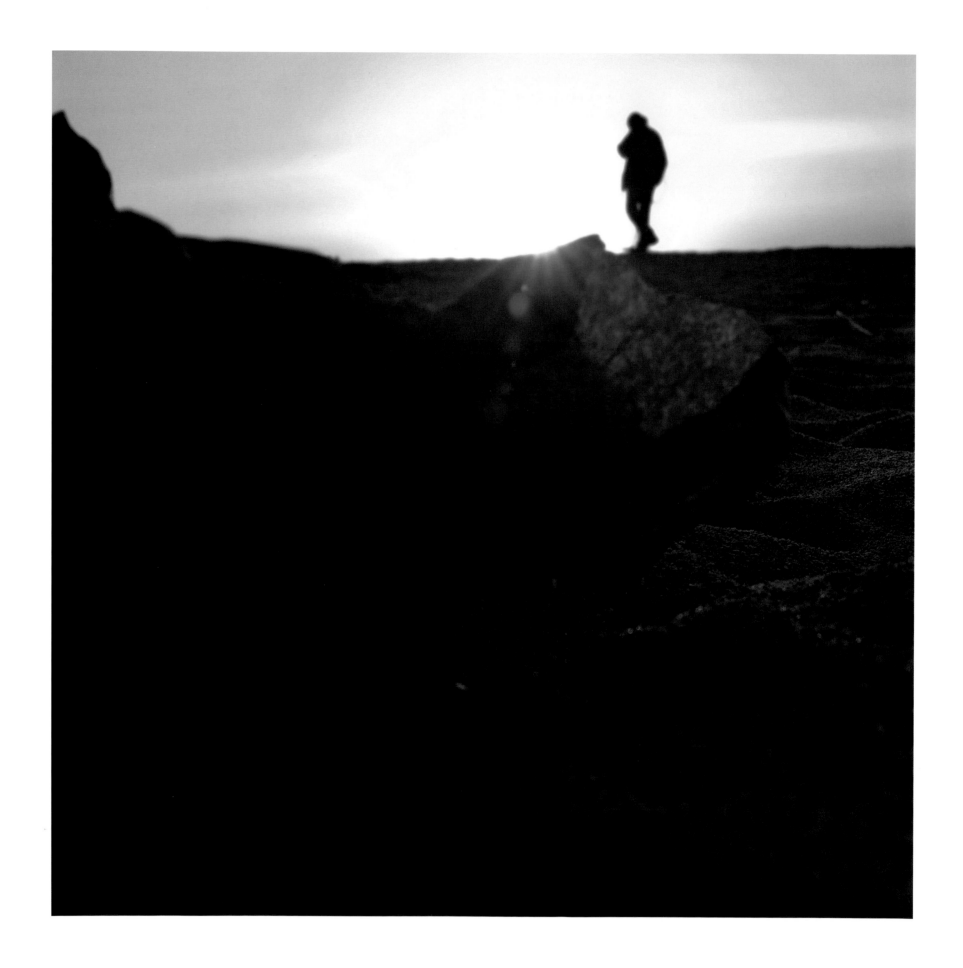

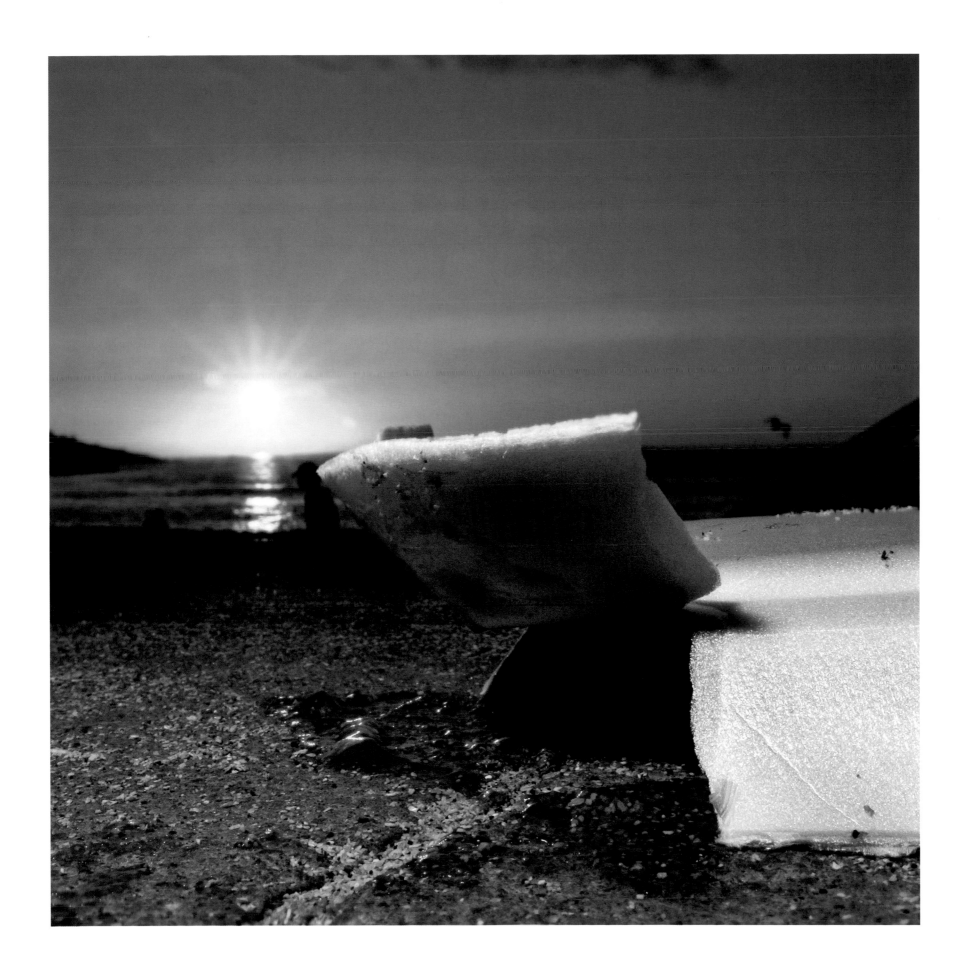

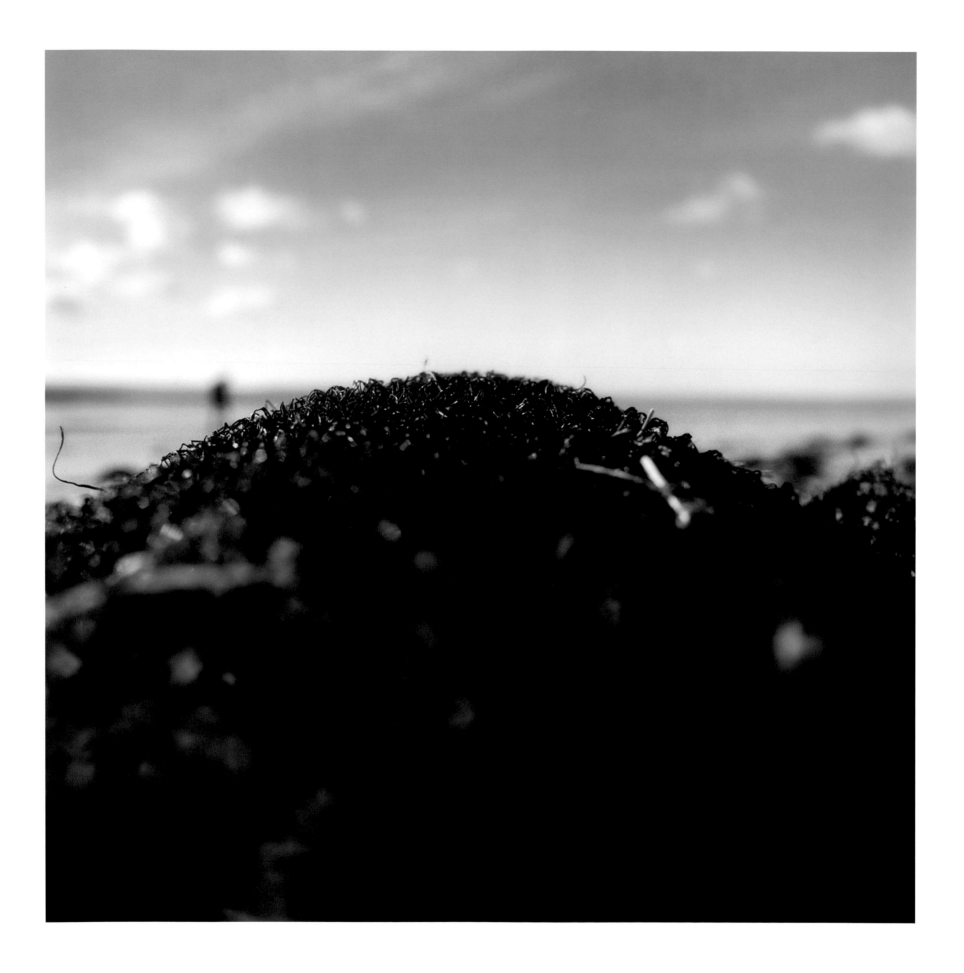

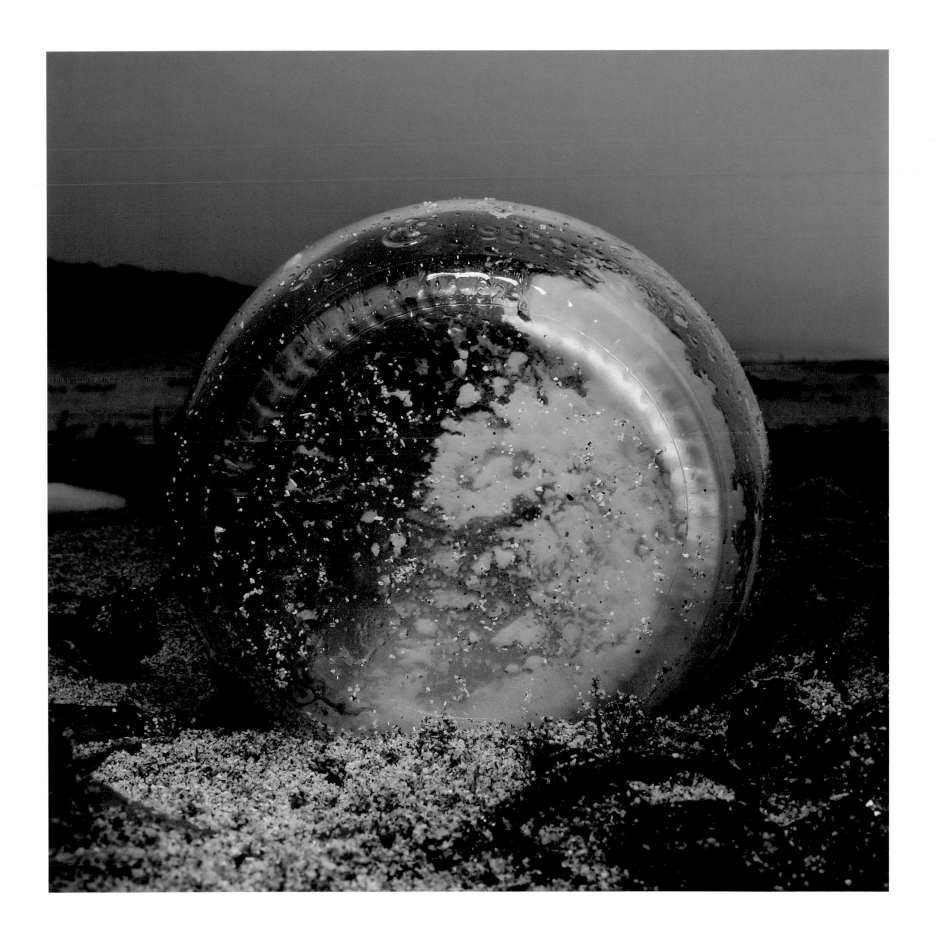

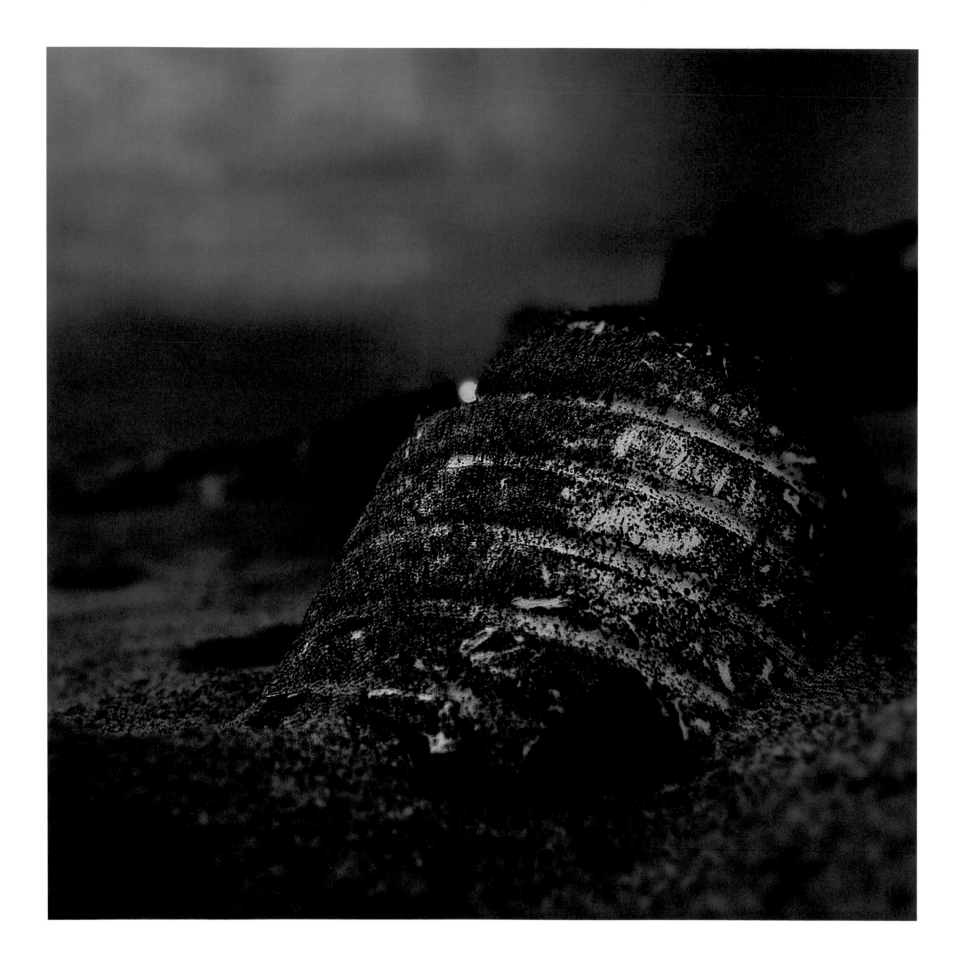

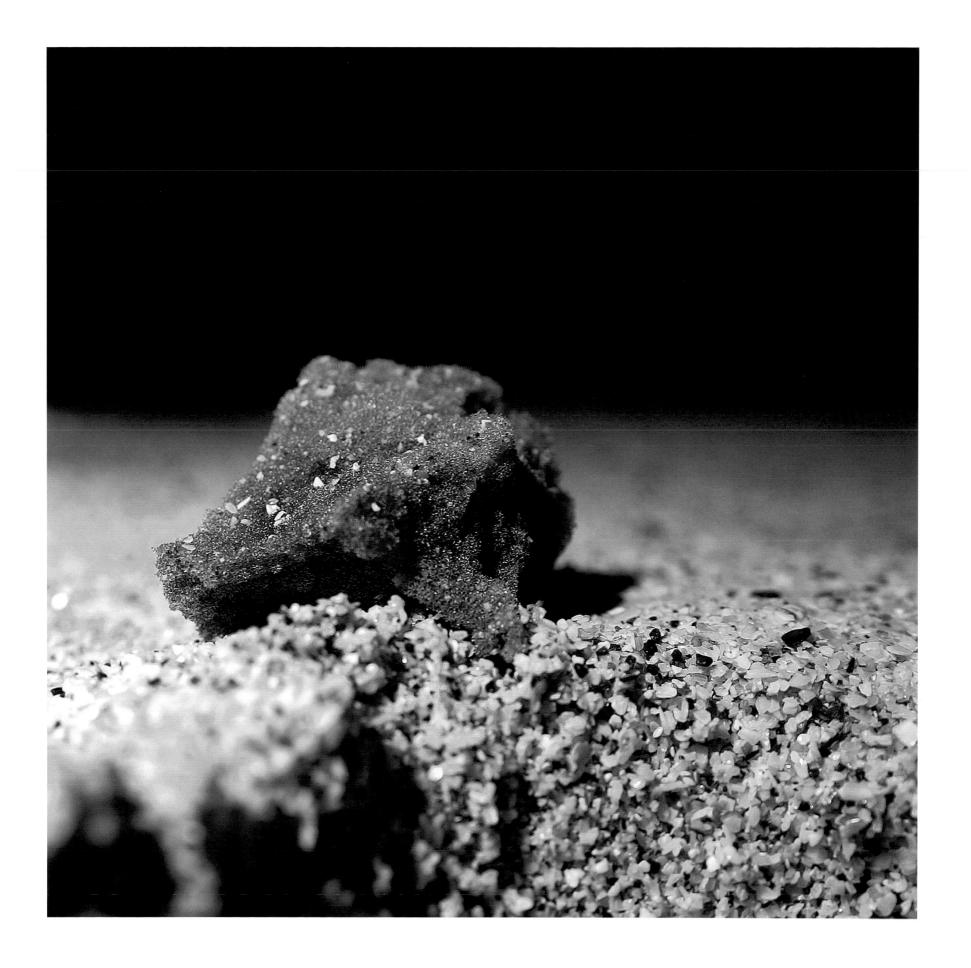

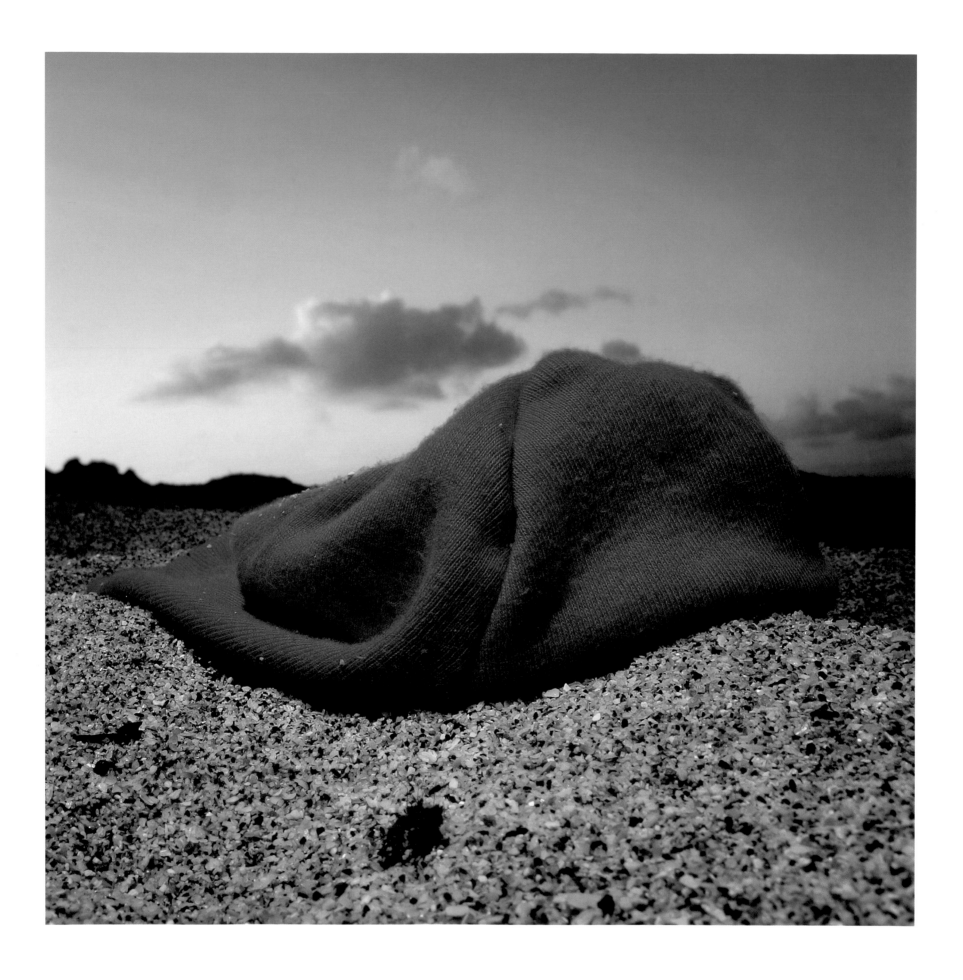

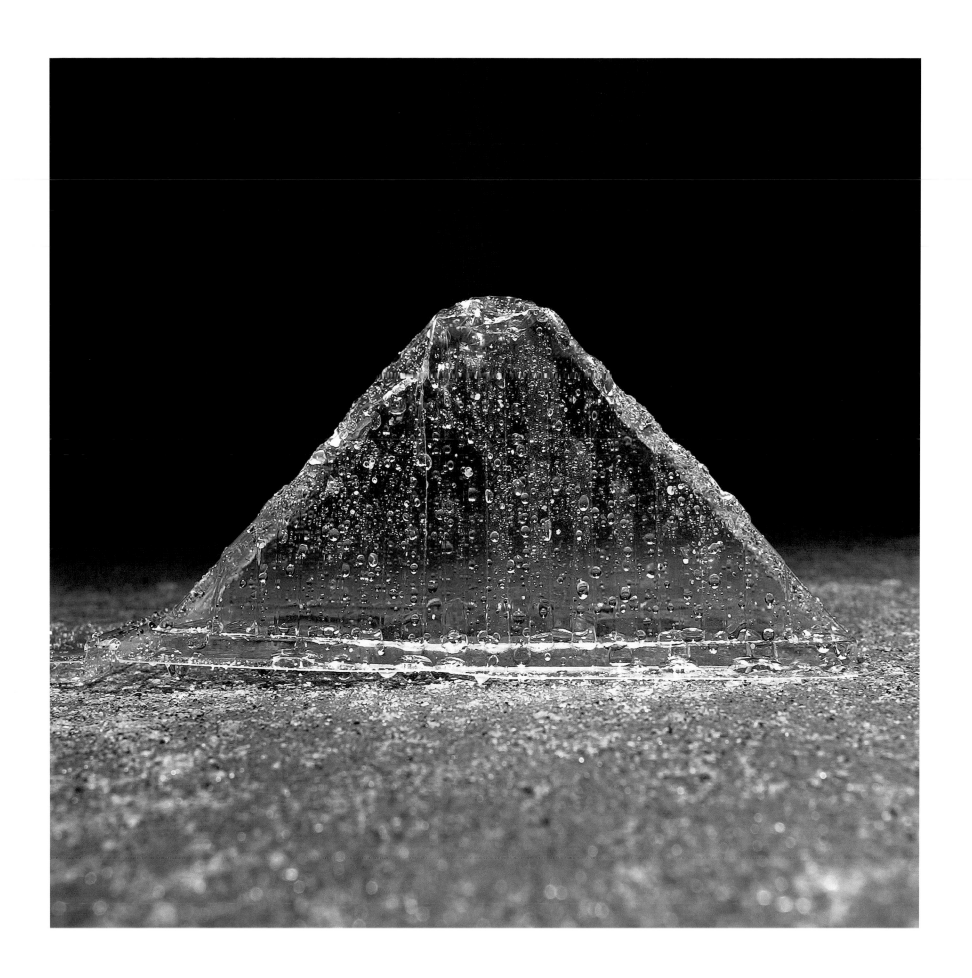

Plastic Debris

Dr.Richard Thompson-

Plastic debris now litters the globe from the deep sea to some of the highest mountains. Millions of tonnes of plastic items are now present in the marine environment, most are buoyant and are accumulating at the sea surface or are washed up on the shore. From the poles to the equator, it is now hard to walk along even the remotest shorelines without encountering plastic debris.

Within just a few decades plastics have become part of daily life for almost all of us. They are durable, lightweight, versatile and inexpensive. A pen, a phone, a television, a toothbrush, a steering wheel, a seat cover, an item of clothing - these and other plastic objects are almost always within an arm's reach. As a consequence of their mass production in the past 50 years, plastic usage has increased exponentially. Worldwide production has grown from around five million tonnes per year in the 1950s to over 100 million tonnes today, and the diversity of plastic products is now so extensive that it seems almost impossible to imagine life without them. Together with plastic building materials and car components that have a long service life are numerous types of disposable wrapping and packaging which have much more transient uses. Once used, a large proportion of the resultant plastic debris will go to landfill, some will be recycled or reused, but a significant amount will be discarded into the environment. We still know relatively little about the longevity of plastics in the natural environment or in landfill; some estimates suggest plastics will last for hundreds of years while others indicate that thousands of years is a more appropriate timescale. However, we do know that durability, coupled with increasing levels of global production, presents a major waste management problem.

The accumulation of plastic debris in the marine environment has been well documented and the frequency of accounts has increased markedly since the early 1970s. There have been reports of debris on shorelines from Antarctica, Australasia, South America, North America, the Pacific Islands, the Caribbean, China and many other locations worldwide. Some of the worst affected beaches can have over 10,000 items of small plastic debris per square meter. Plastic is also accumulating in the oceans, floating at the surface and on the seabed. Prevailing winds and ocean currents redistribute and concentrate this floating debris to such an extent that some areas of the Pacific are reported to have in excess of 300,000 items of plastic per square kilometre. Even the deep sea is now strewn with plastic debris that has lost its original buoyancy because of the steady accumulation of marine organisms colonising its surface. Little has been done to quantify plastic debris on the seabed but one of the most detailed surveys so far has indicated that in some areas the abundance of debris can be as substantial as at the sea surface.

More concerning are the challenges that plastic debris presents to marine life, causing feeding deficiencies, suffocation and death. A wide range of creatures mistake plastic debris for food: to a turtle, for instance, a floating plastic bag may appear strikingly similar to the jellyfish it would typically eat. Over 80 species of sea birds, 26 species of marine mammals, including whales and manatees, and numerous fish species are also known to mistake small items of floating plastic for their prey. Such encounters with plastic obstruct the digestive tract, reducing the capability for further feeding. Unlike natural prey, plastics are resistant to digestion and can remain within the guts of marine creatures. For example, the post mortem of a pygmy whale which died after stranding on a beach in Texas, revealed plastic bags, wrappers and sheeting that had completely blocked its digestive tract. Recently, it has been shown that over 95% of fulmars washed up dead on beaches in the North Sea had plastic in their guts.

As well as problems deriving from eating plastics, fish, birds and marine mammals frequently become entangled in plastic twine, rope and netting, invariably leading to severe injures or death. Entanglement repre-

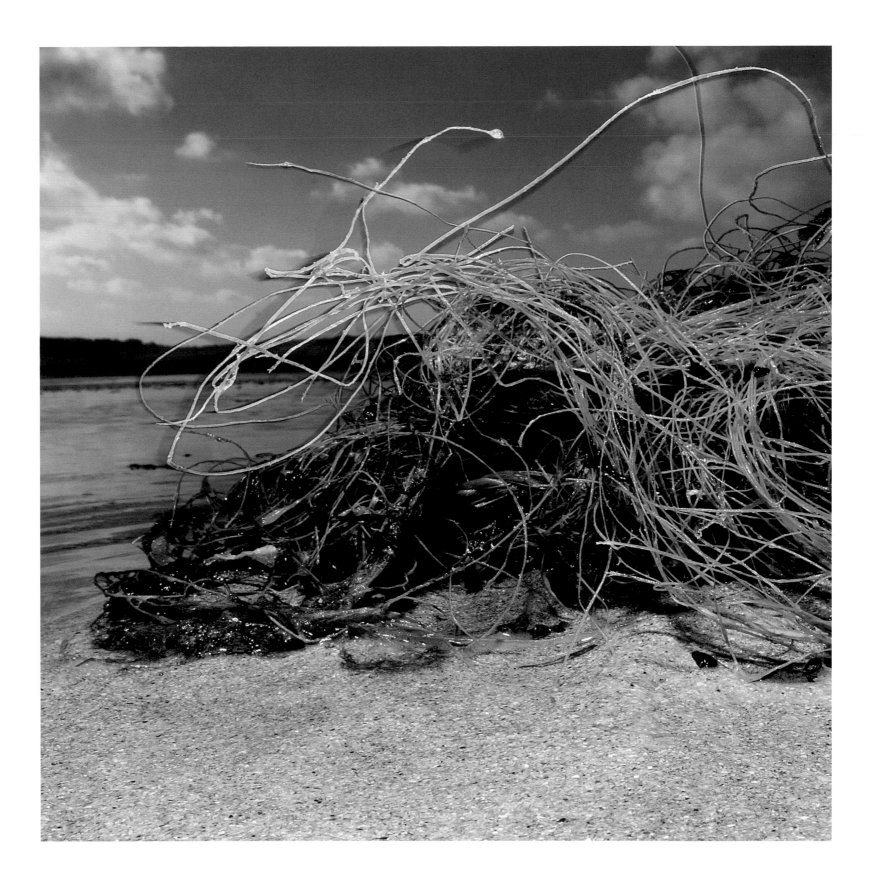

sents one of the most serious threats to marine animals: it is believed to be responsible for over 10% of the mortality in gannets off the German coast and is a particular problem for seals that play with floating debris only to become caught in loops or netting. Seal pups sometimes become tangled in plastic debris around their neck; as they grow older this will slowly strangle them and eventually cut their arteries.

Recently, work by my group at the University of Plymouth has shown that microscopic fragments of plastic have also accumulated in the oceans over the past 40 years. These fragments, many smaller than the diameter of a human hair, are now common in the water column and in marine sediments around the British Isles. Some of the fragments are likely to have formed by the mechanical and chemical breakdown of larger items. In addition, tiny plastic fragments are now used as abrasives for shot blasting and as scrubbers in hand cleaners, make-up removers, toothpastes and household cleaning fluids. Tiny fragments such as these are likely to pass directly into aquatic habitats with wastewater. Owing to their size, these particles are eaten by a wide range of organisms. The environmental consequences of these tiny fragments are only just becoming apparent. Apart from the problems of physical obstruction to feeding, small plastic fragments also have the potential to transfer toxic chemicals to the food chain. A range of potentially harmful chemicals, such as colourings, flame-retardants, biocides and plasticizers, are used in plastic manufacture. Plastics can accumulate and concentrate toxic chemicals that have entered the environment from other sources. In particular, hydrophobic contaminants that are concentrated at the sea surface readily latch on to floating debris adding to the potential for plastics to transfer chemicals to marine life. Work is now ongoing to quantify the full extent of these potential hazards.

What can be done? Despite the scale of the problem this is an issue we can all help redress. The majority of plastic debris enters the sea after careless disposal of everyday objects, so unlike chemical contaminants that can seep insidiously into the environment in water-borne discharges, most plastic debris is accumulating as a consequence of irresponsible littering by all of us. The most significant step in reducing marine contamination is to dispose of our litter properly. Furthermore, we can all reduce our use of disposable plastic products. In some countries, incentives to encourage consumers to reuse bags rather than throw them away after each shopping trip have achieved a significant reduction in the number of plastic carrier bags produced. Manufacturers and suppliers should focus on using the minimum amount of packaging required to get goods safely to their customers. Sorting glass according to colour before recycling is something that is familiar to most consumers - why not apply the same approach and give different kinds of polymers different colour coding to help make recycling simpler?

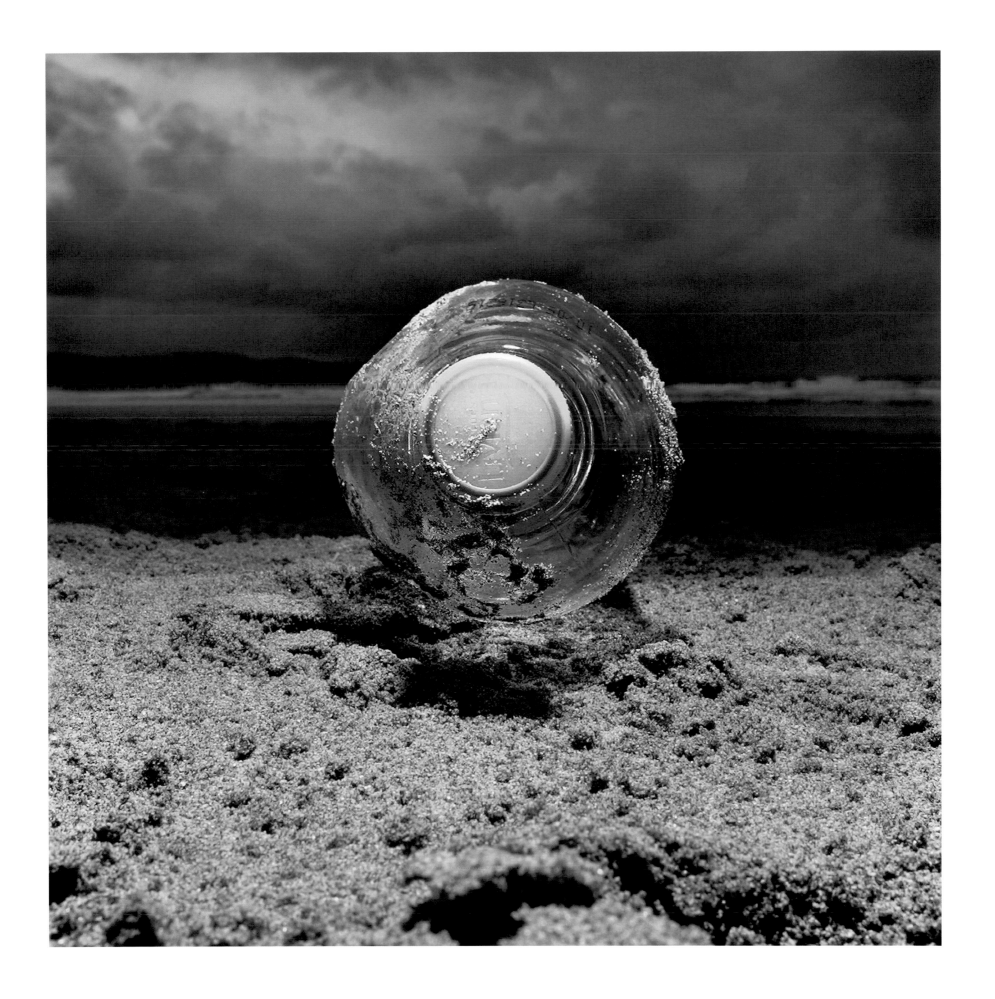

An alternative approach is the use of biodegradable plastics. However, the term 'biodegradable' can be misleading: most consumers would assume this to mean a complete and environmentally harmless breakdown. This is frequently not the case as most biodegradable plastics require specific conditions to degrade whilst others disintegrate into thousands of tiny non-degradable parts. There are concerns that biodegradable packaging could in fact be adding to, rather than reducing, the impact of plastic in the environment. To help resolve this conflict we need standardization of the term 'biodegradable' on an international scale.

This book gives an insightful perspective to the ubiquity and durability of plastic objects. It serves to catalogue just a small part of a non-degradable legacy from our convenience-driven era but, unfortunately, the debris illustrated on these pages is likely to remain long after we have departed. The stranded, solitary objects that Hughes photographs are becoming harder to find, not because the amount of plastic debris is declining, quite the opposite: many shorelines are now so contaminated that solitary items of debris are seldom found. Working together as consumers, suppliers, manufacturers, scientific advisors and legislators, we can find solutions but we must act on it straight away.

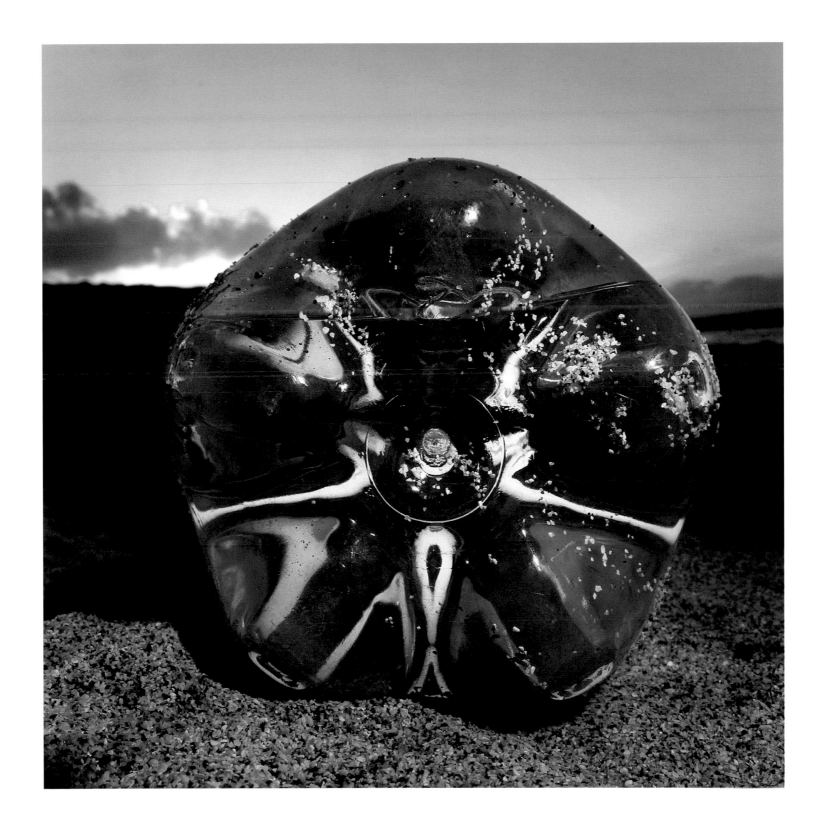

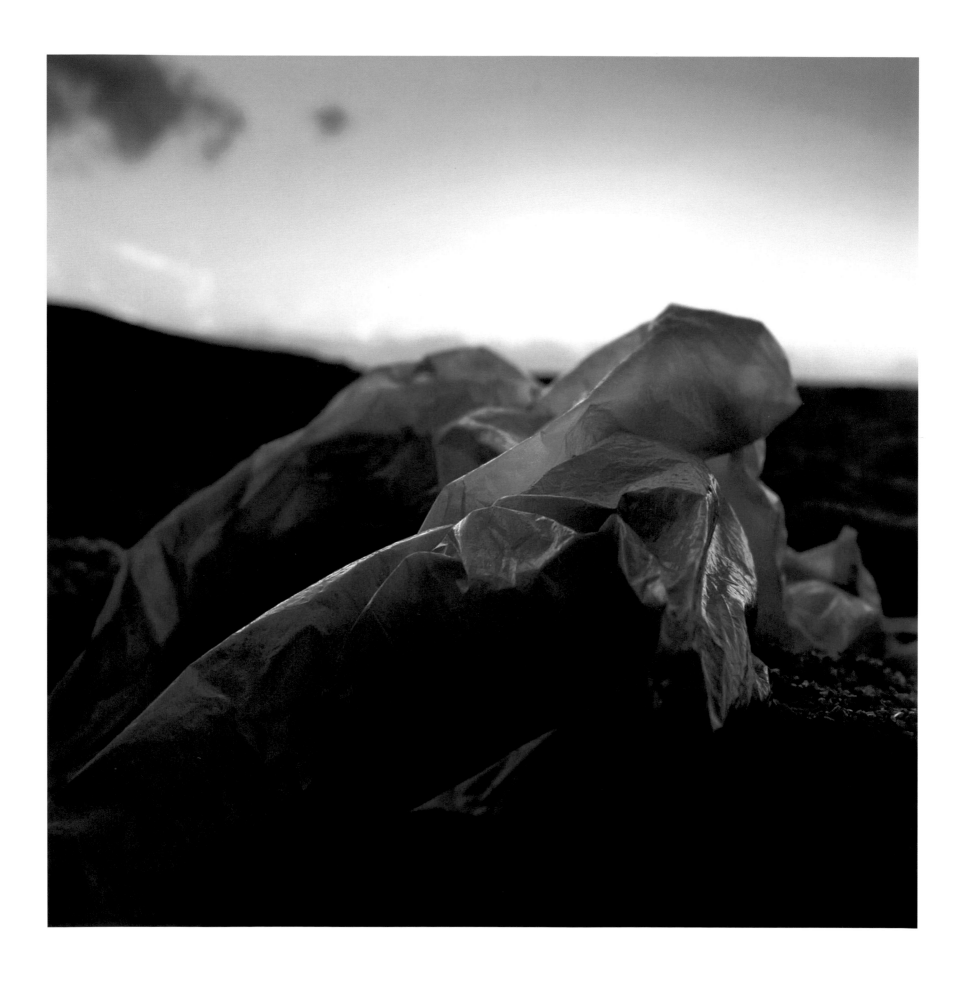

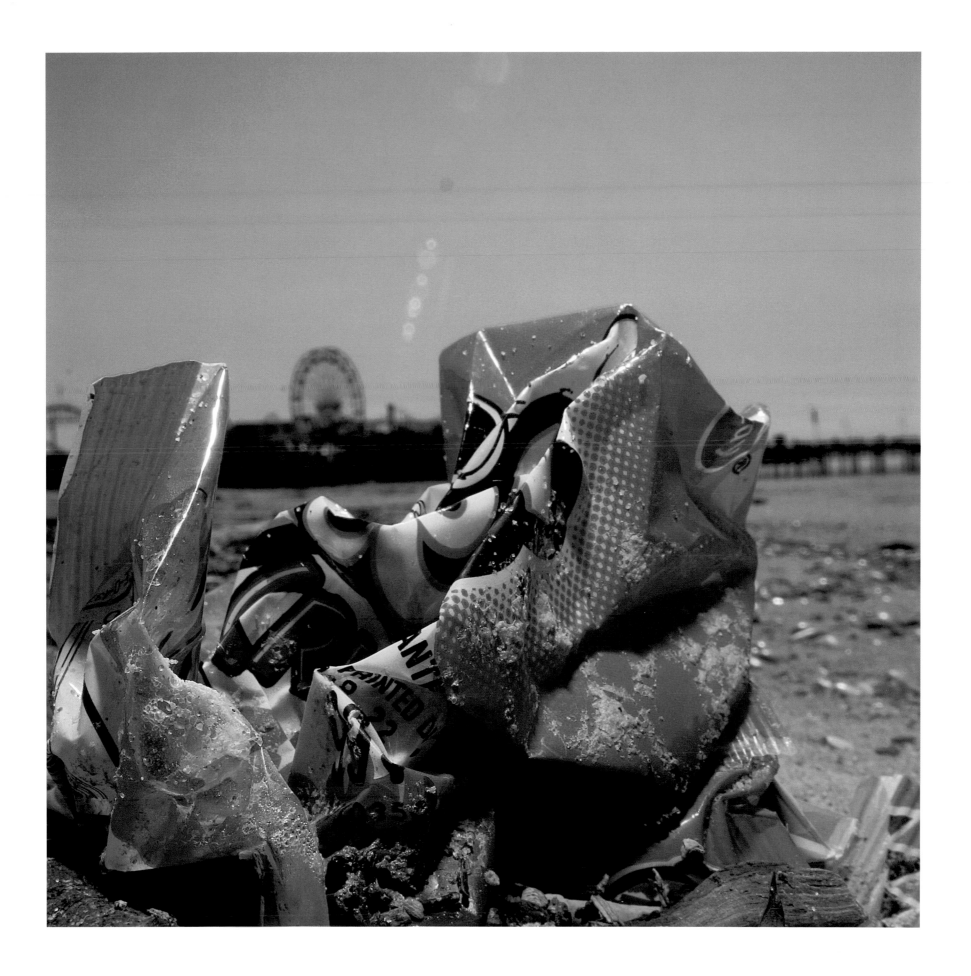

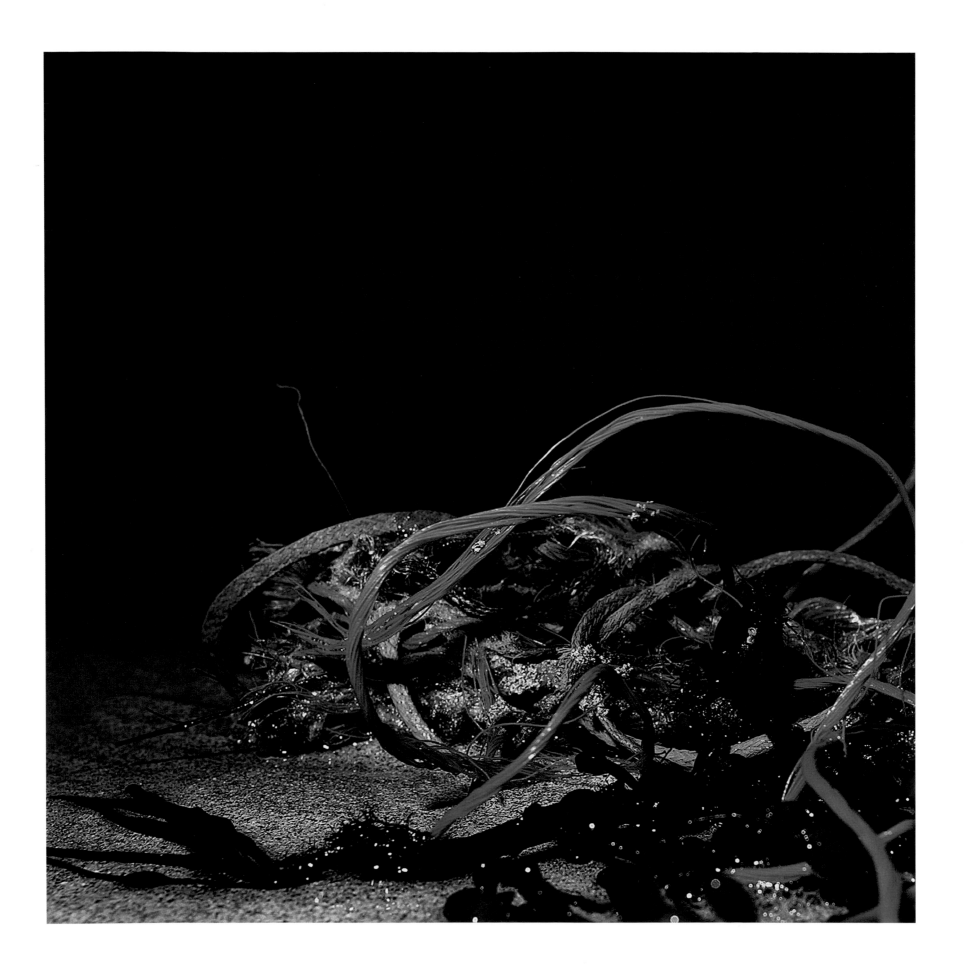

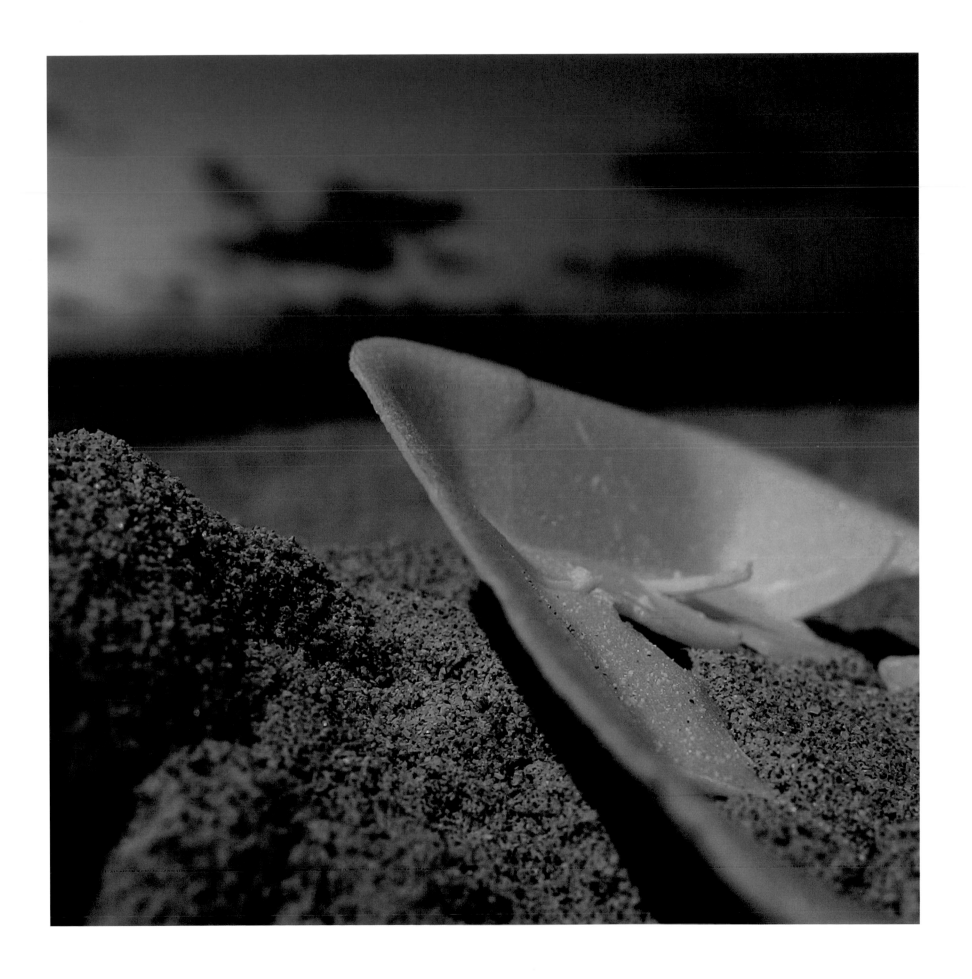

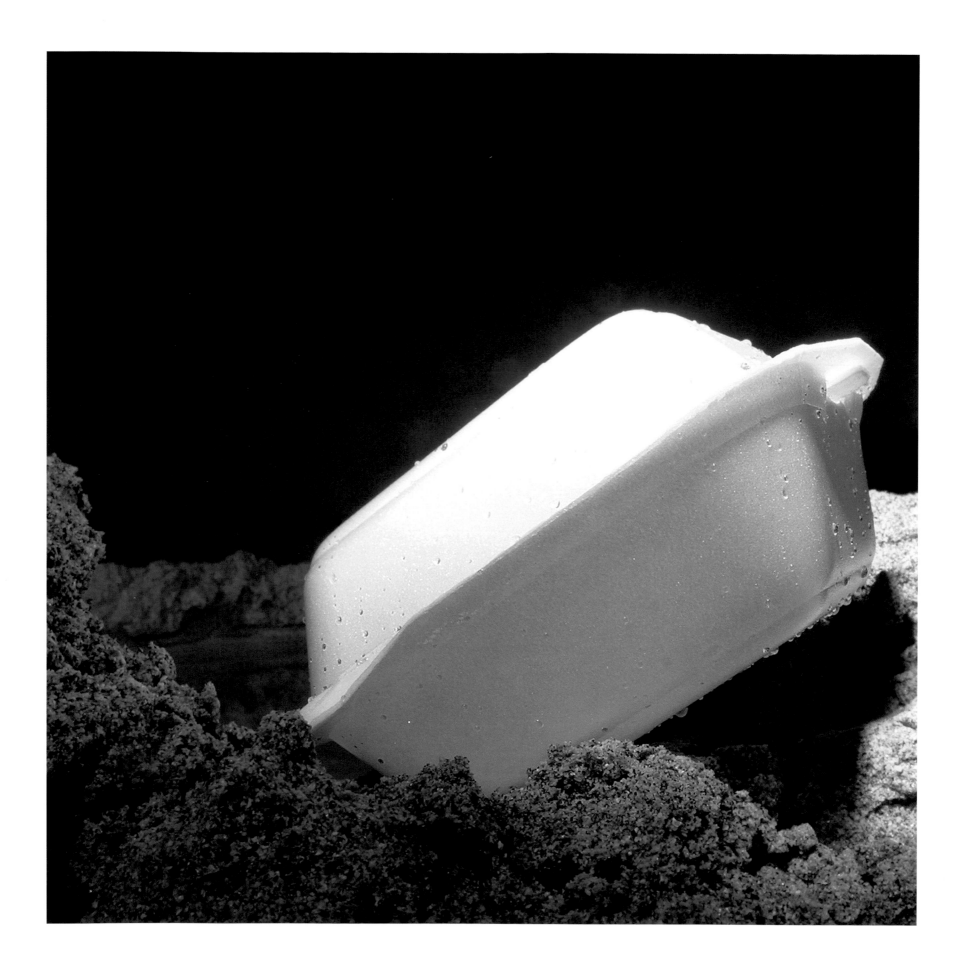

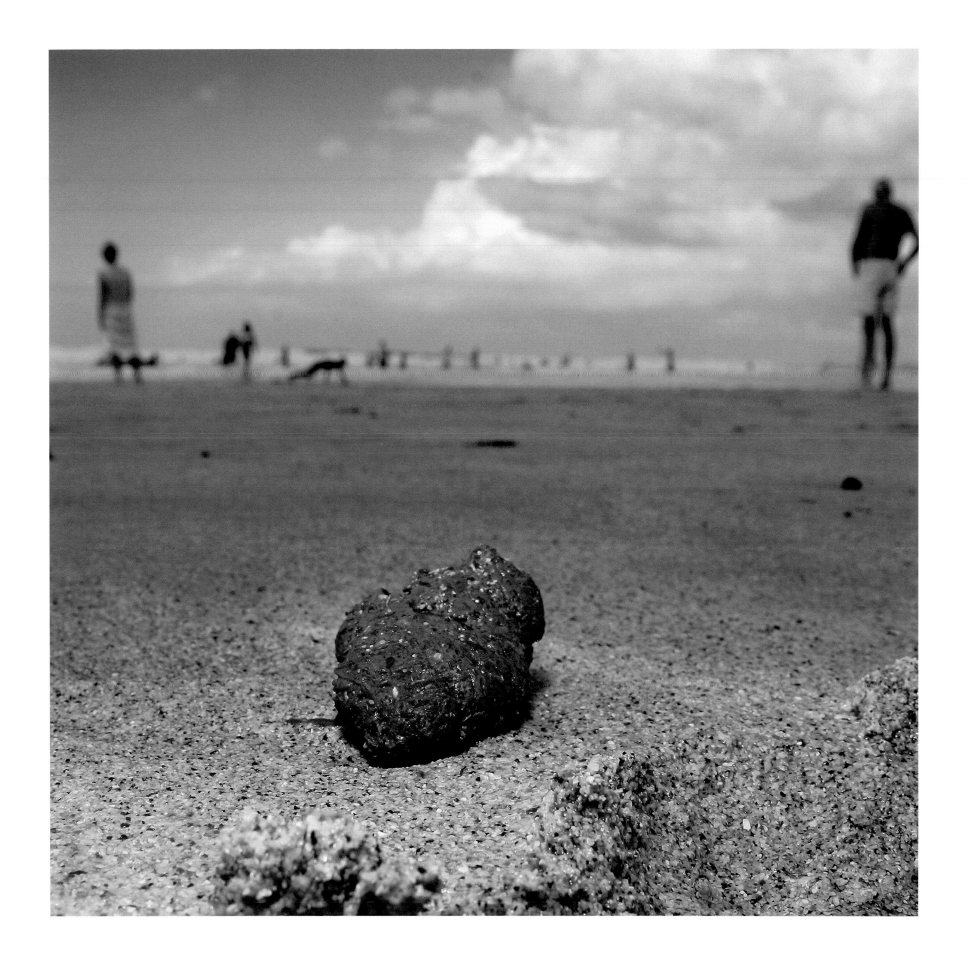

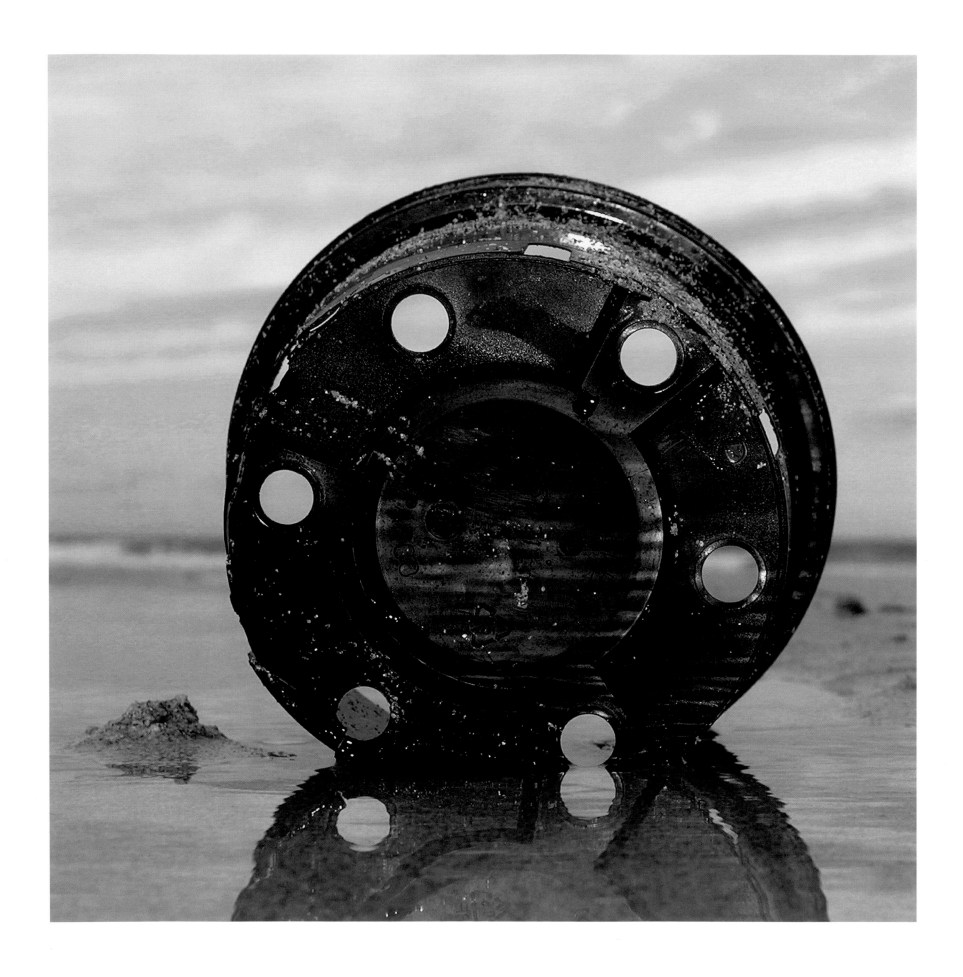

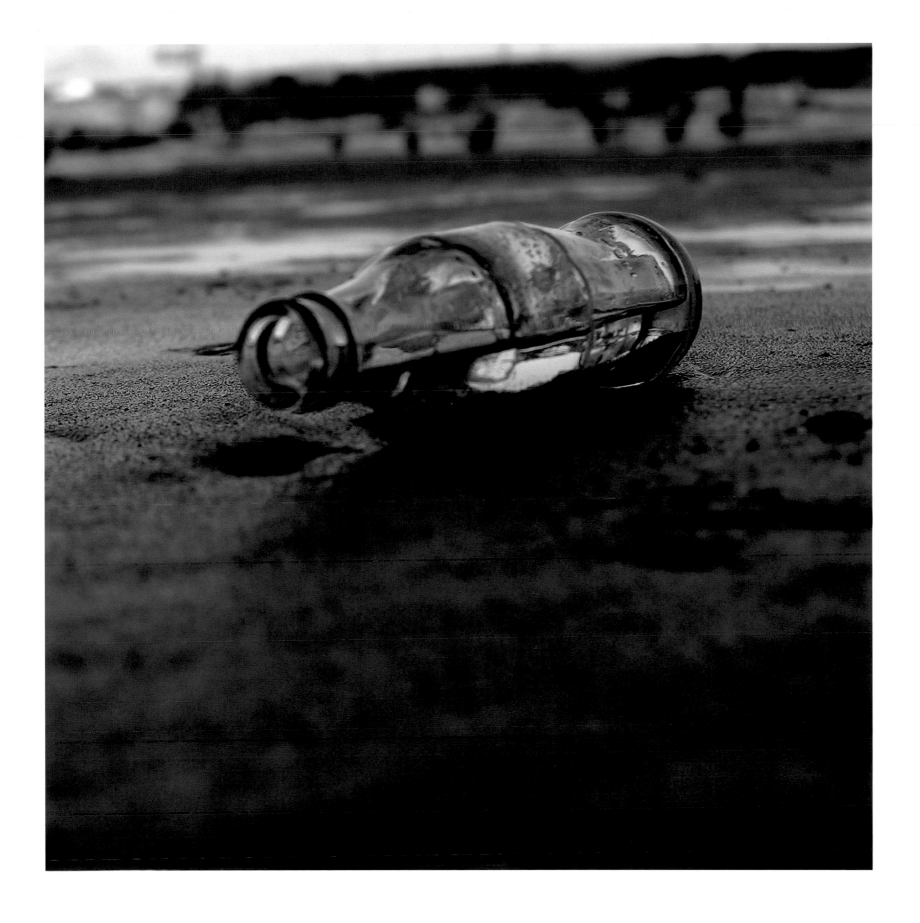

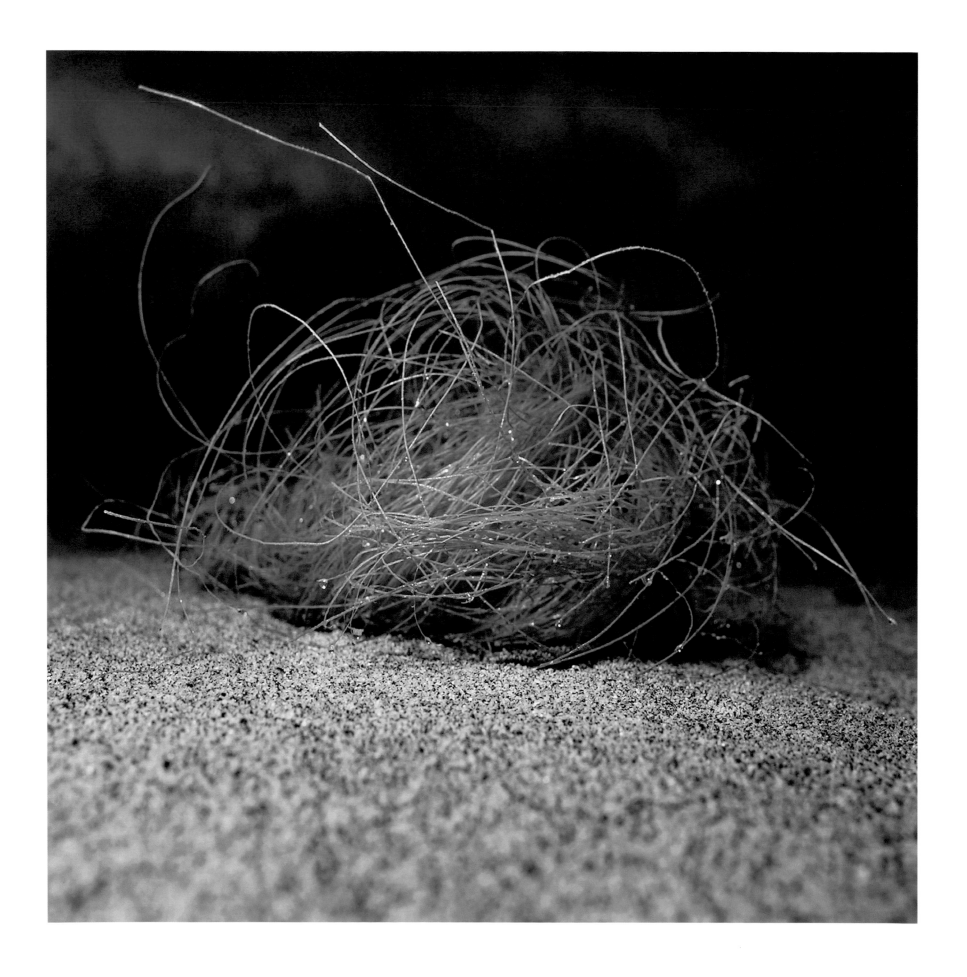

126

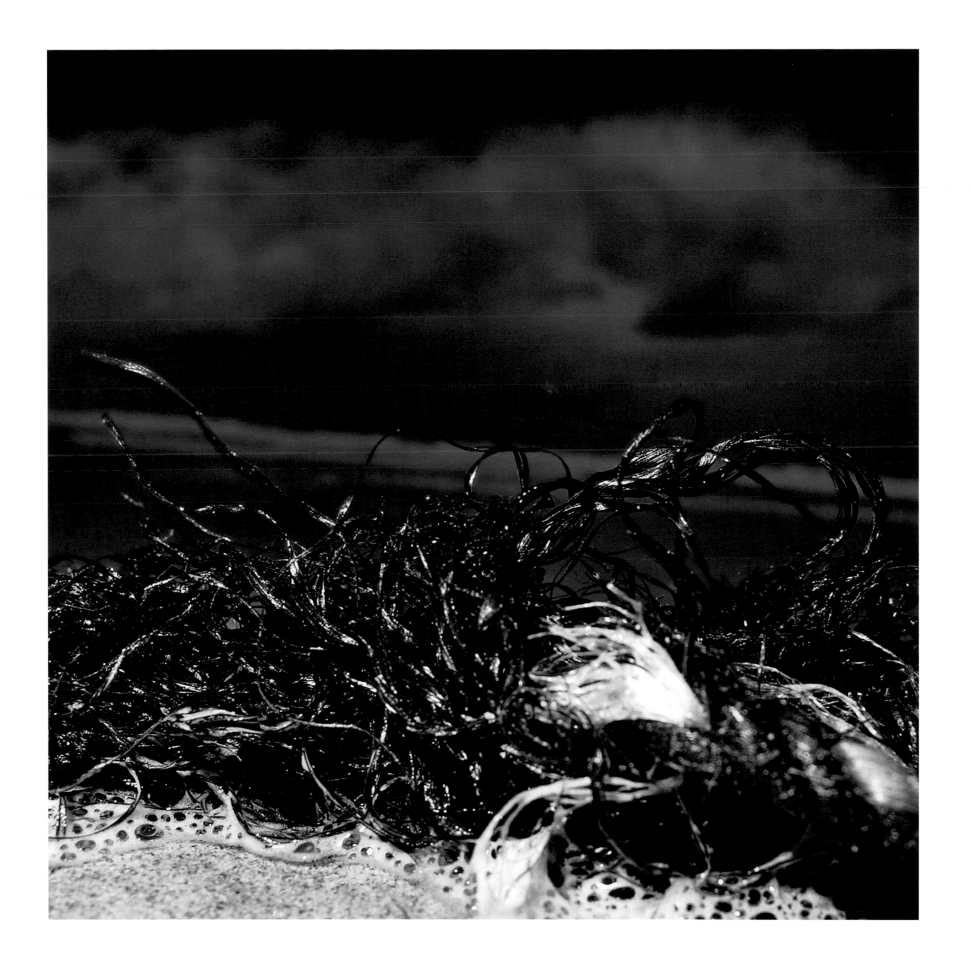

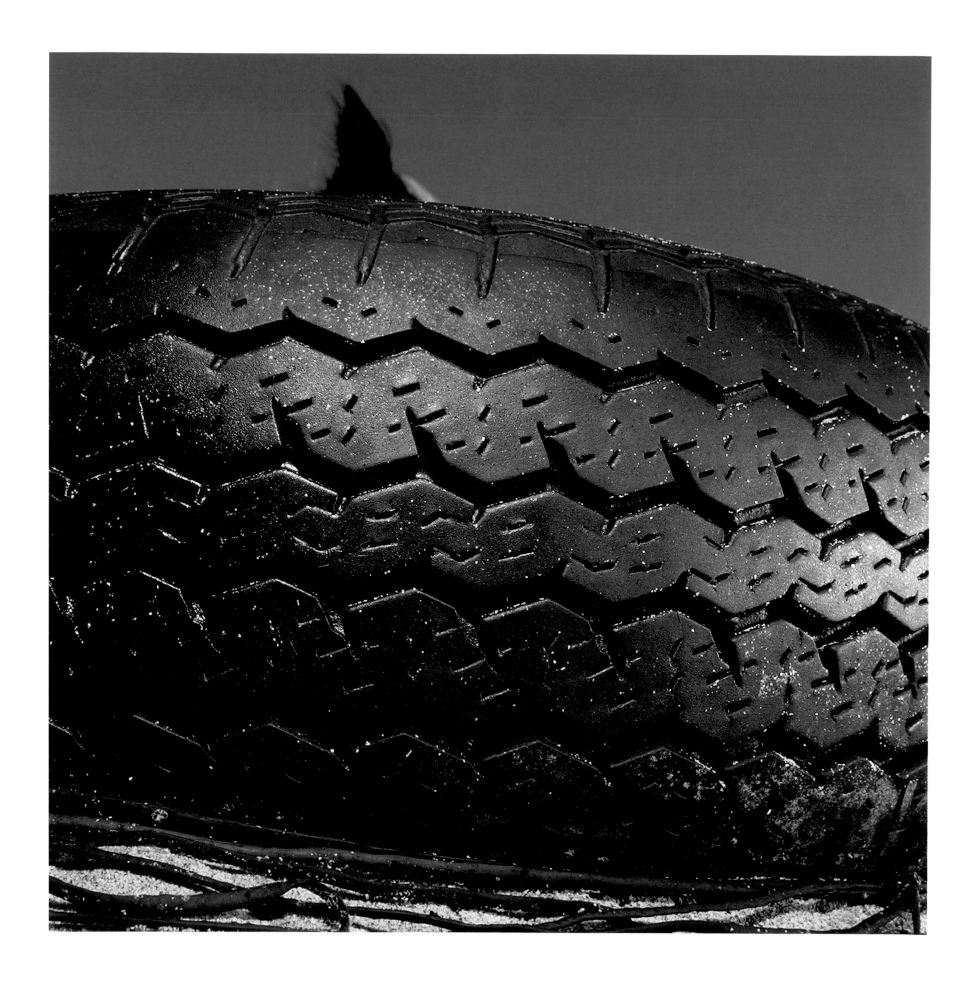

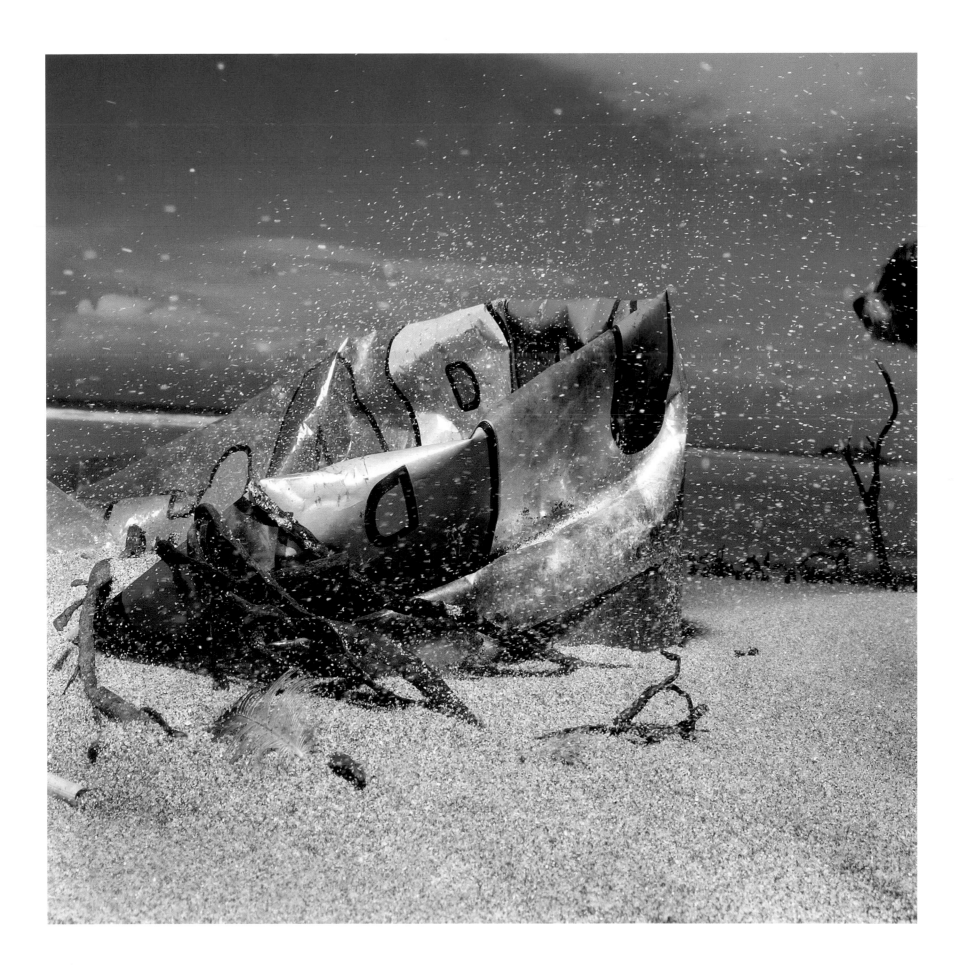

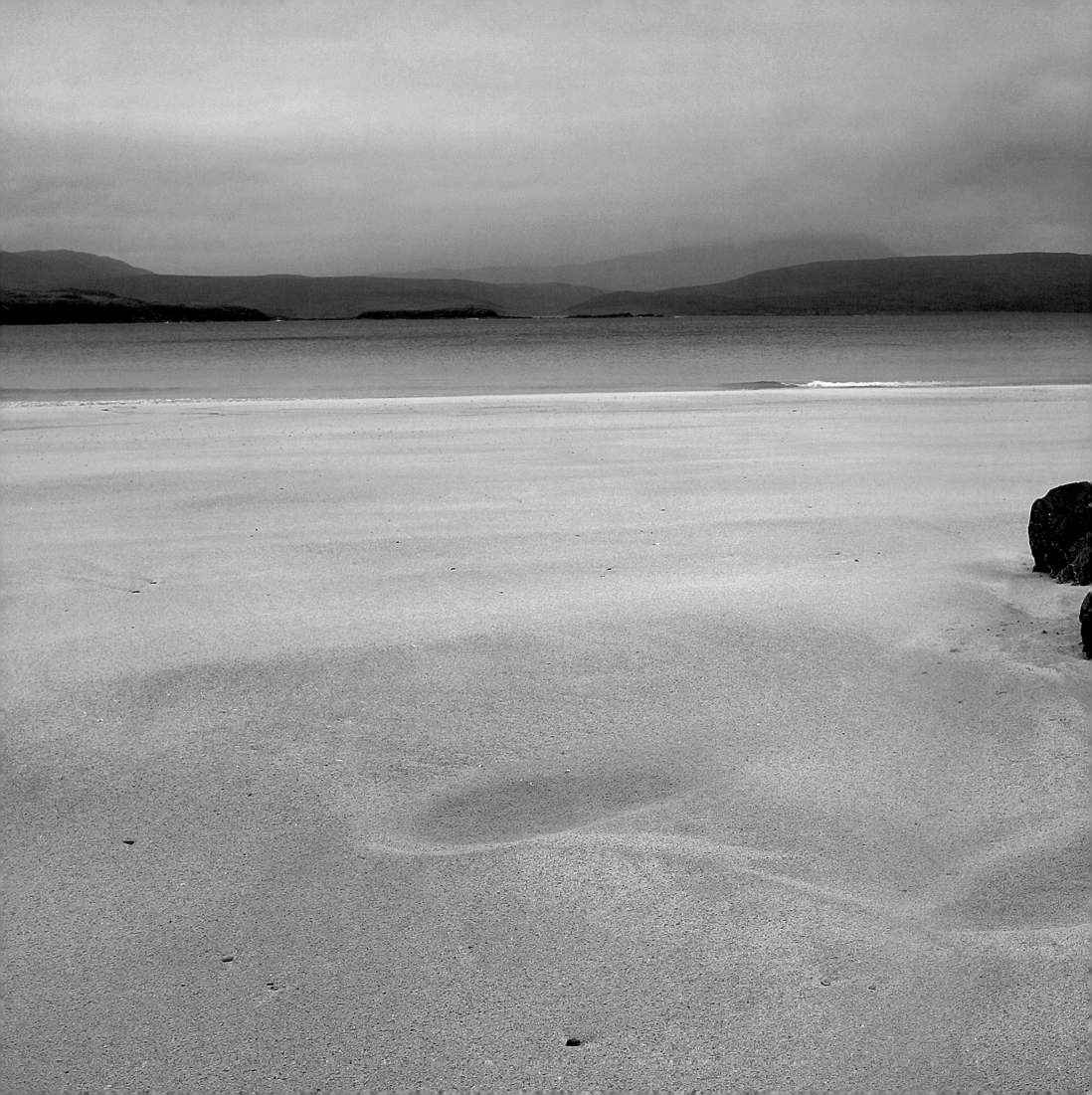

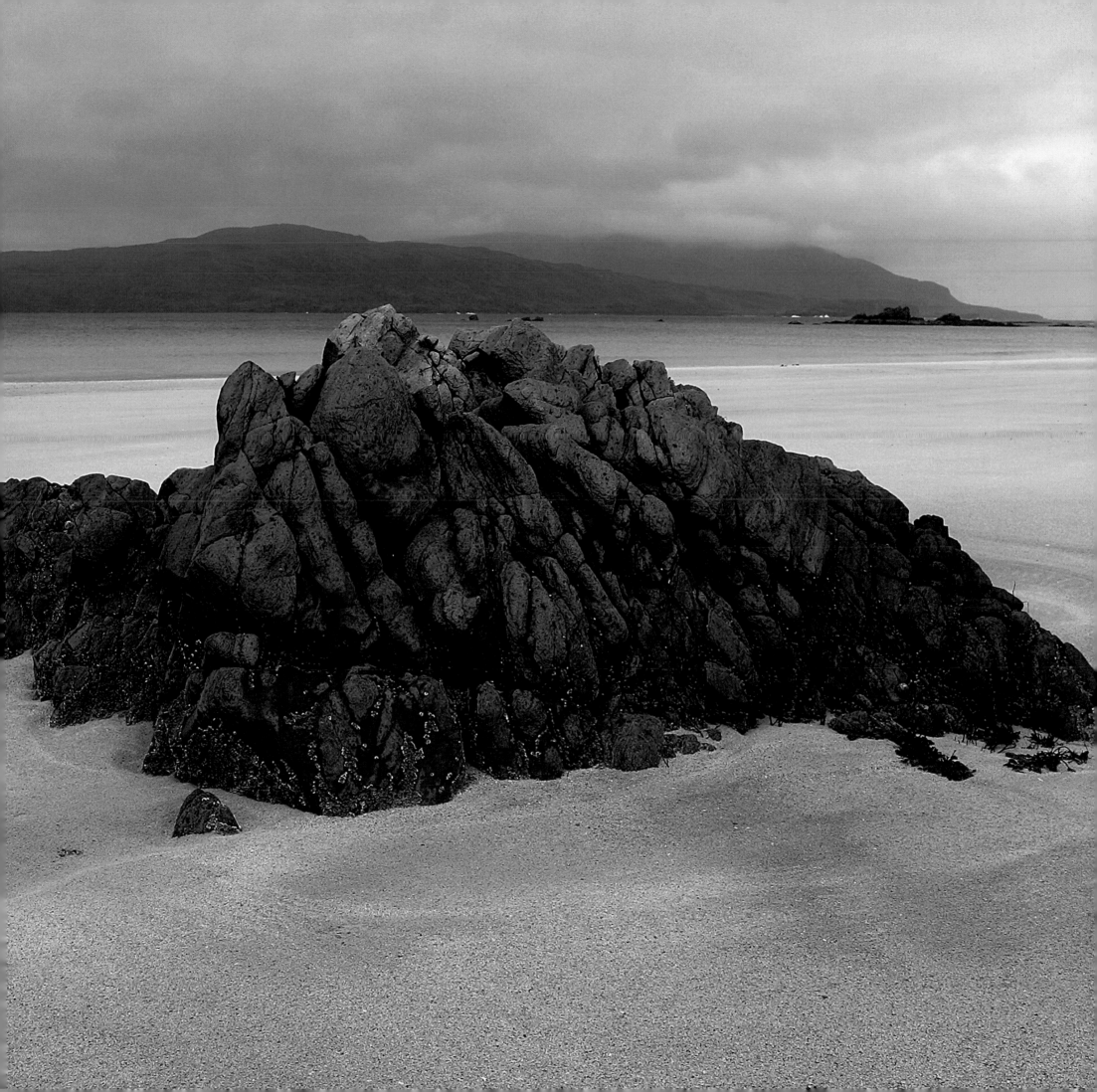

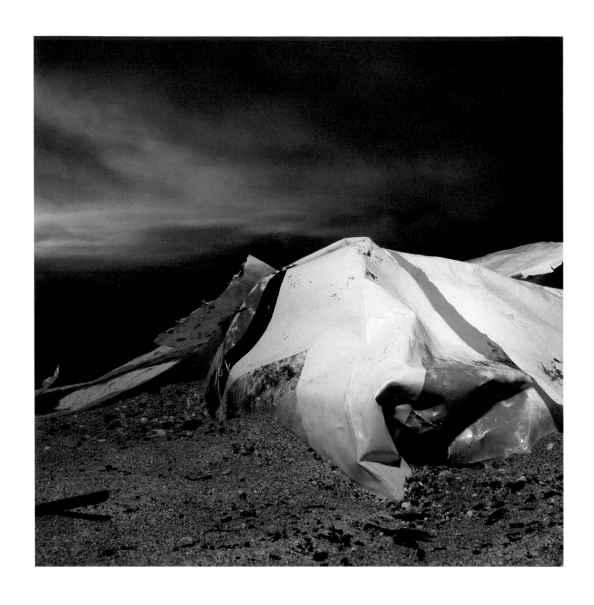

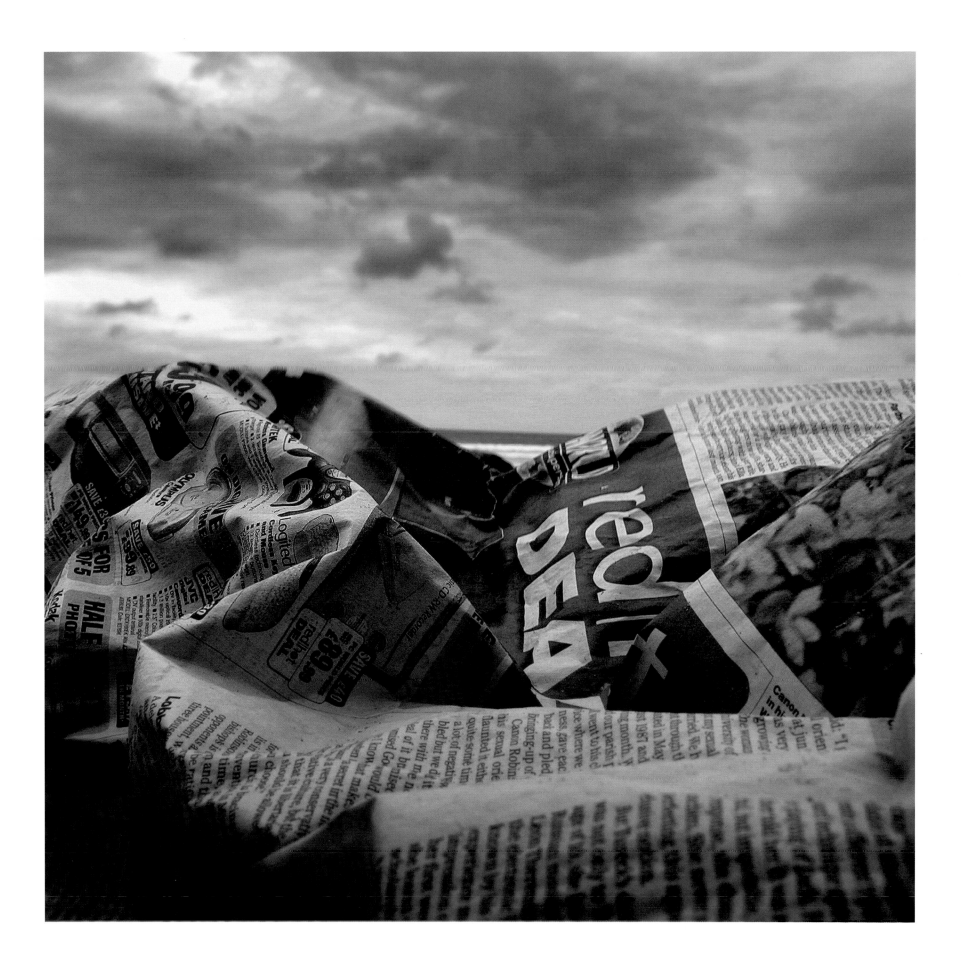

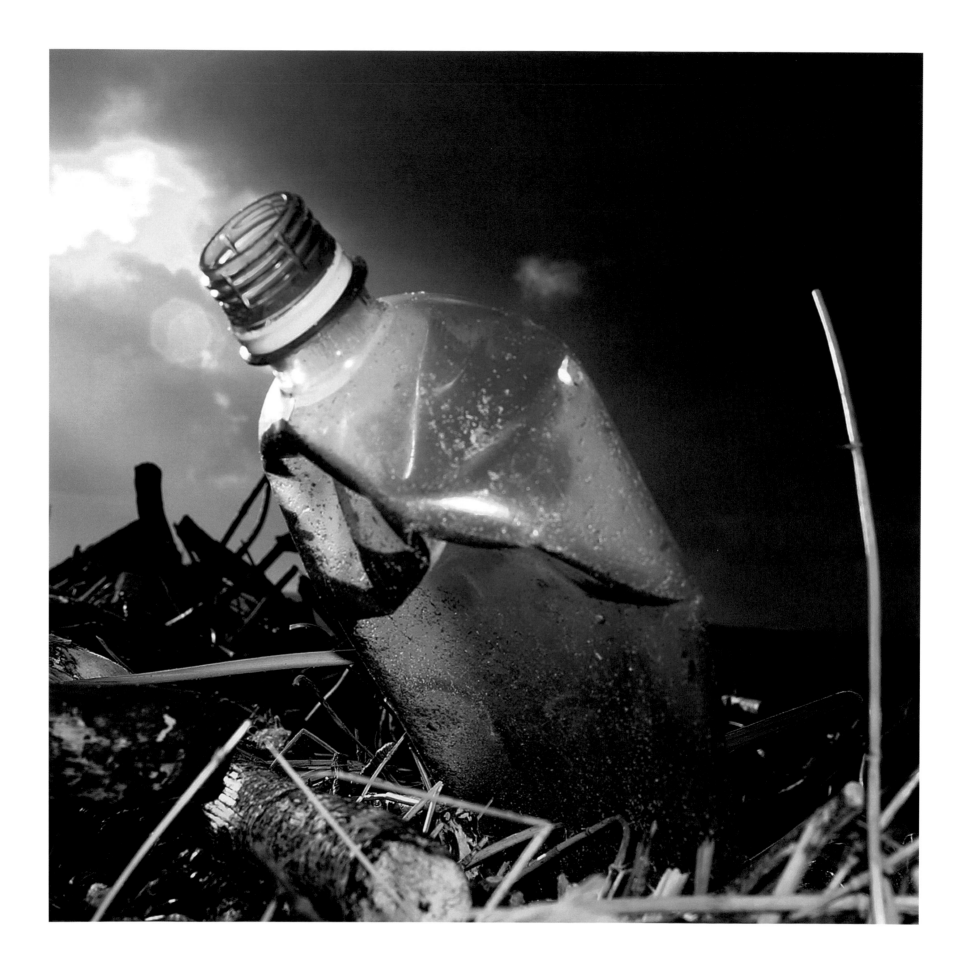

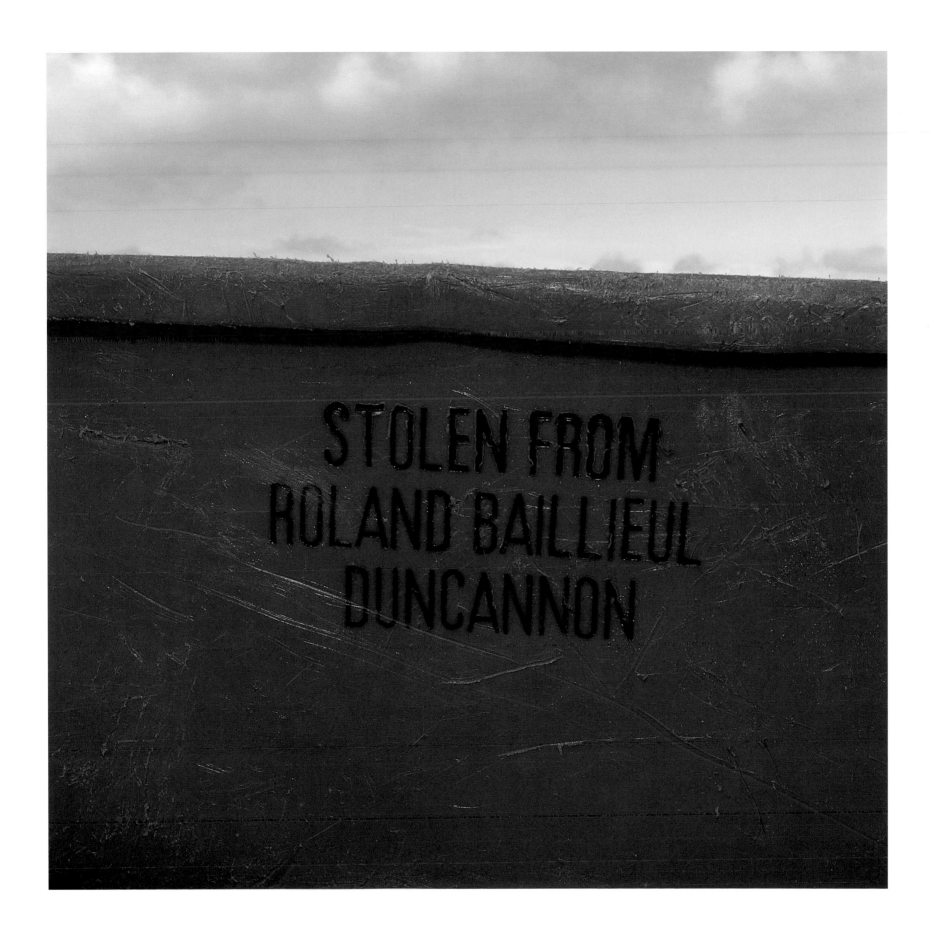

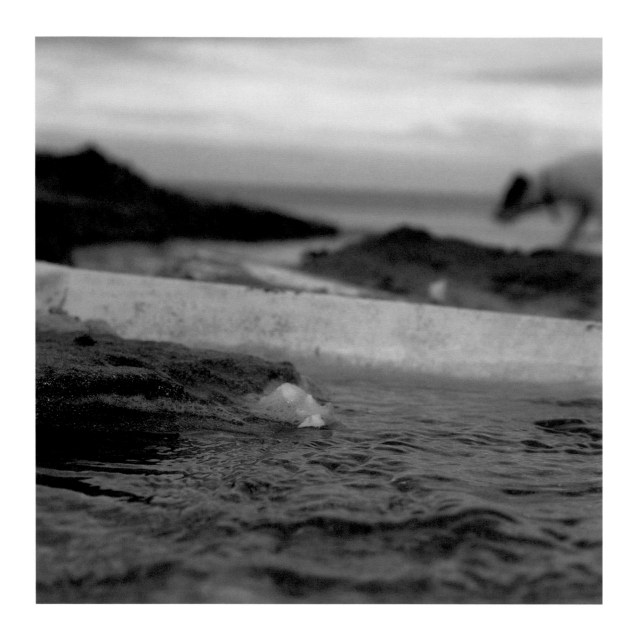

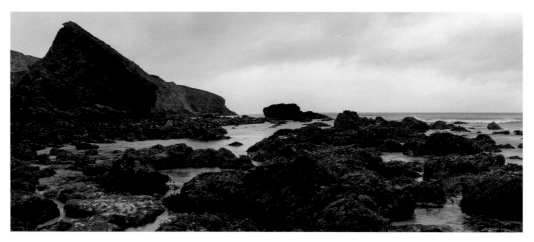

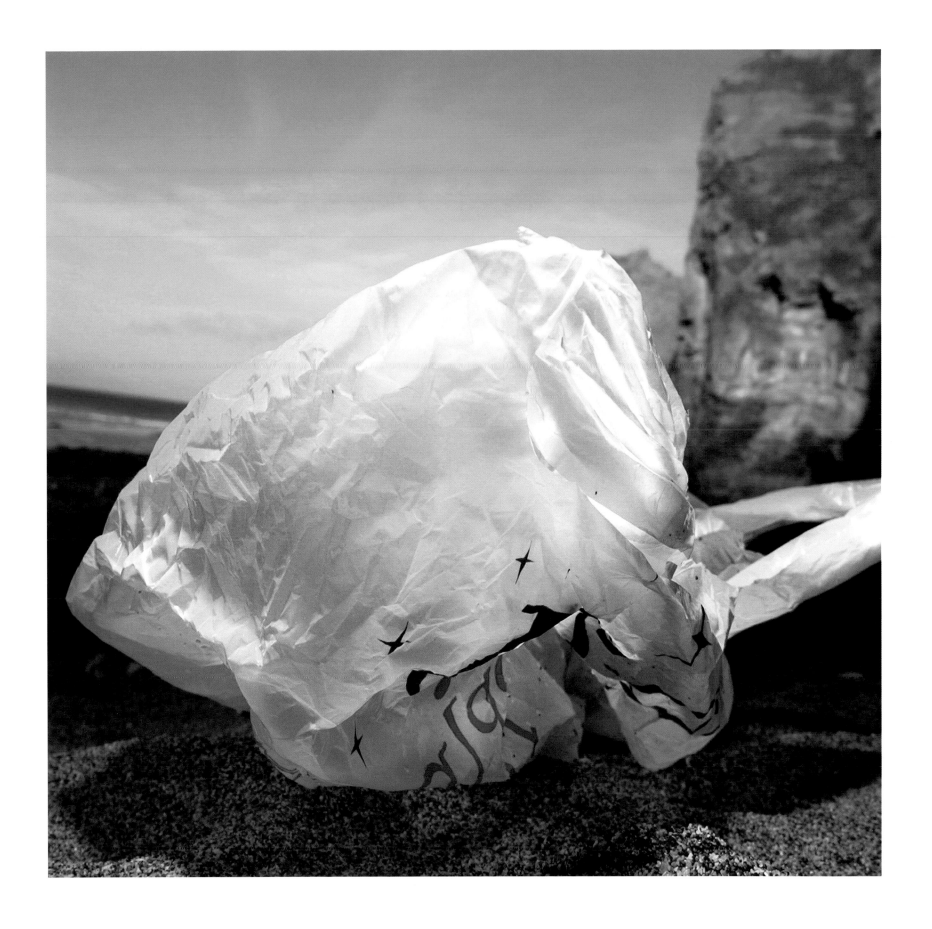

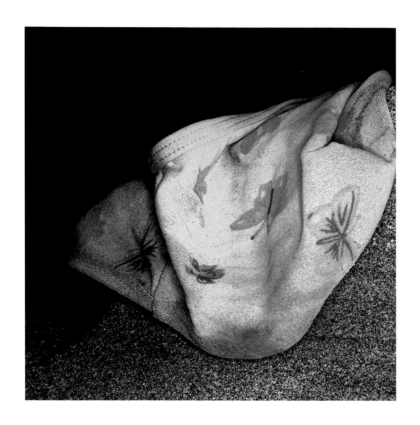

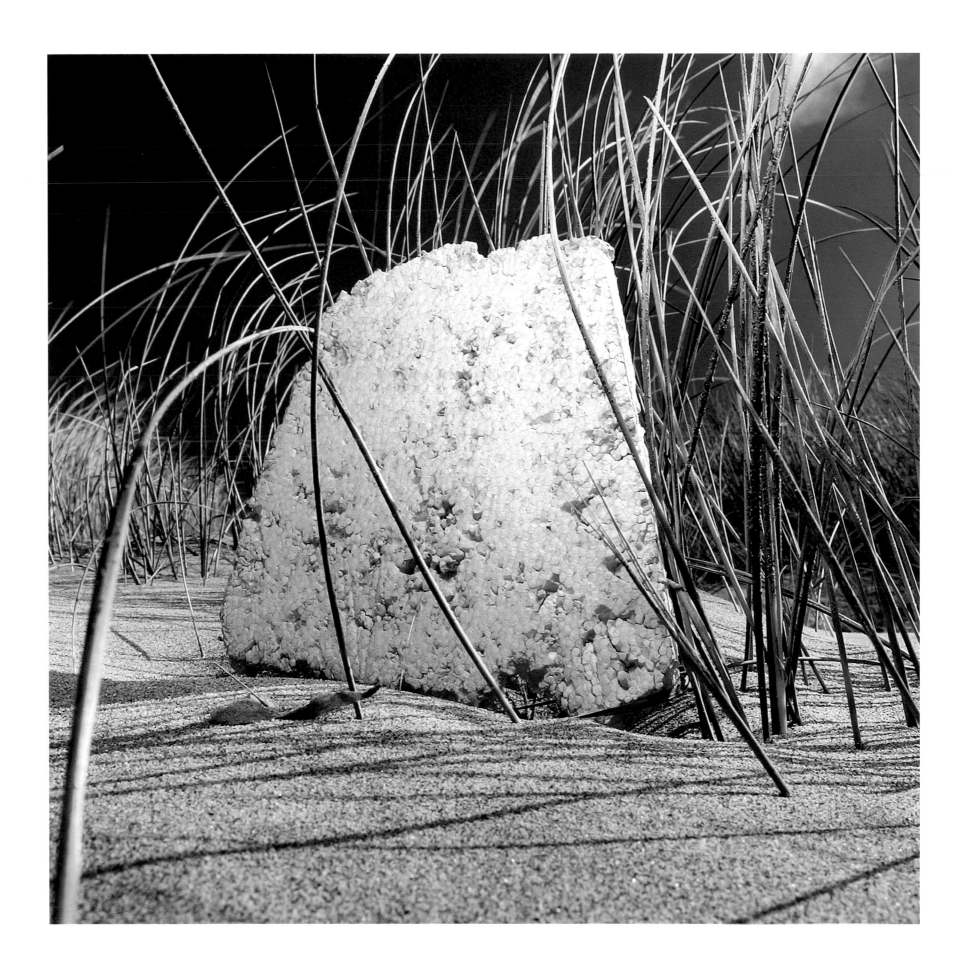

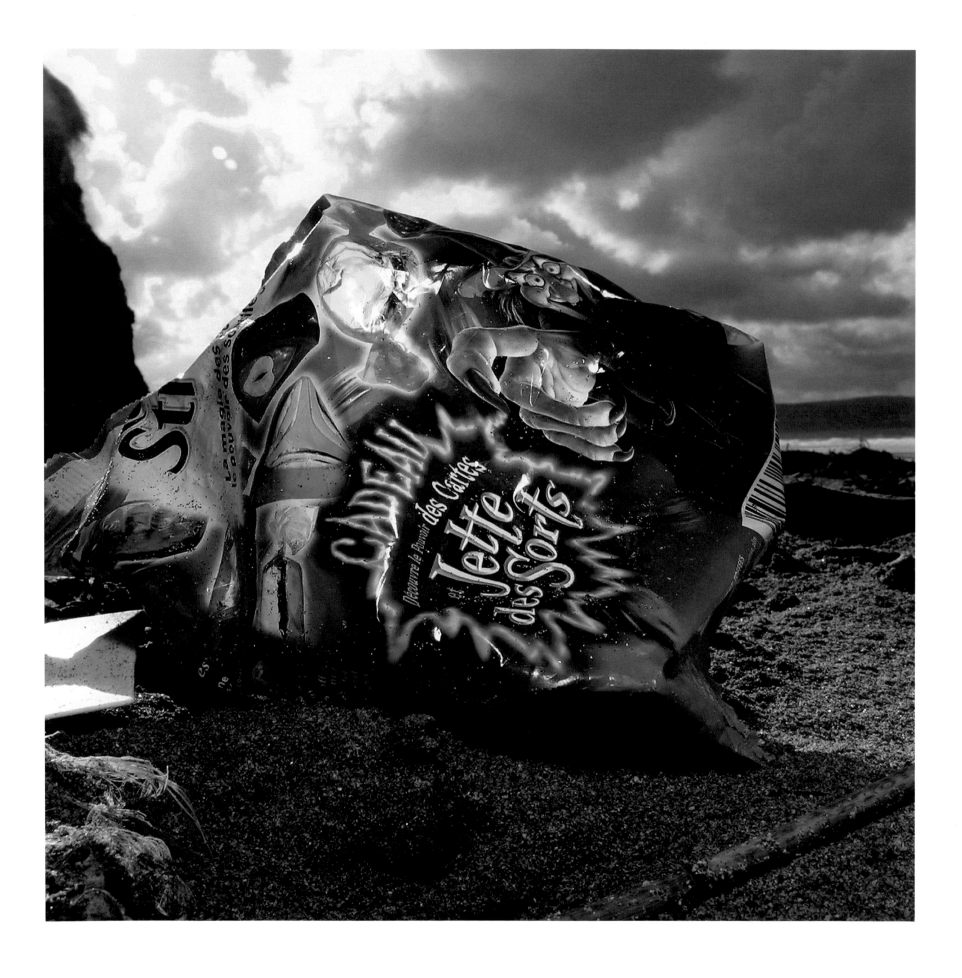

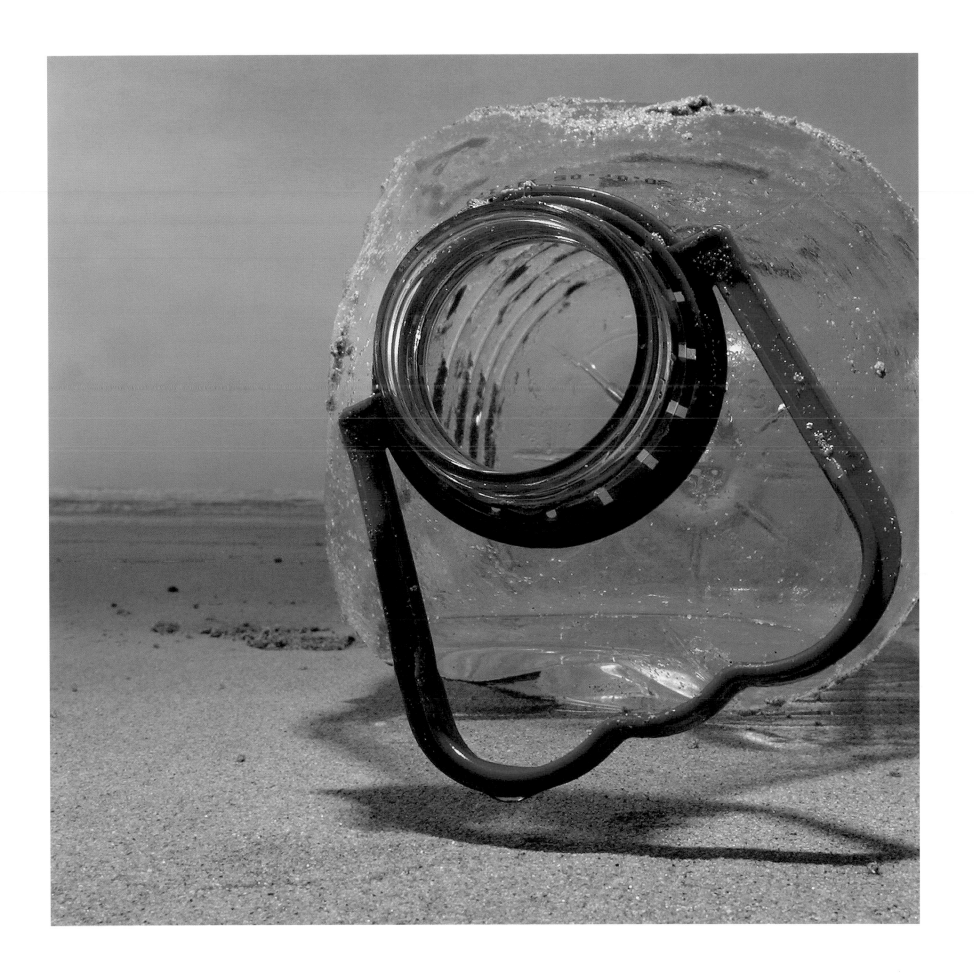

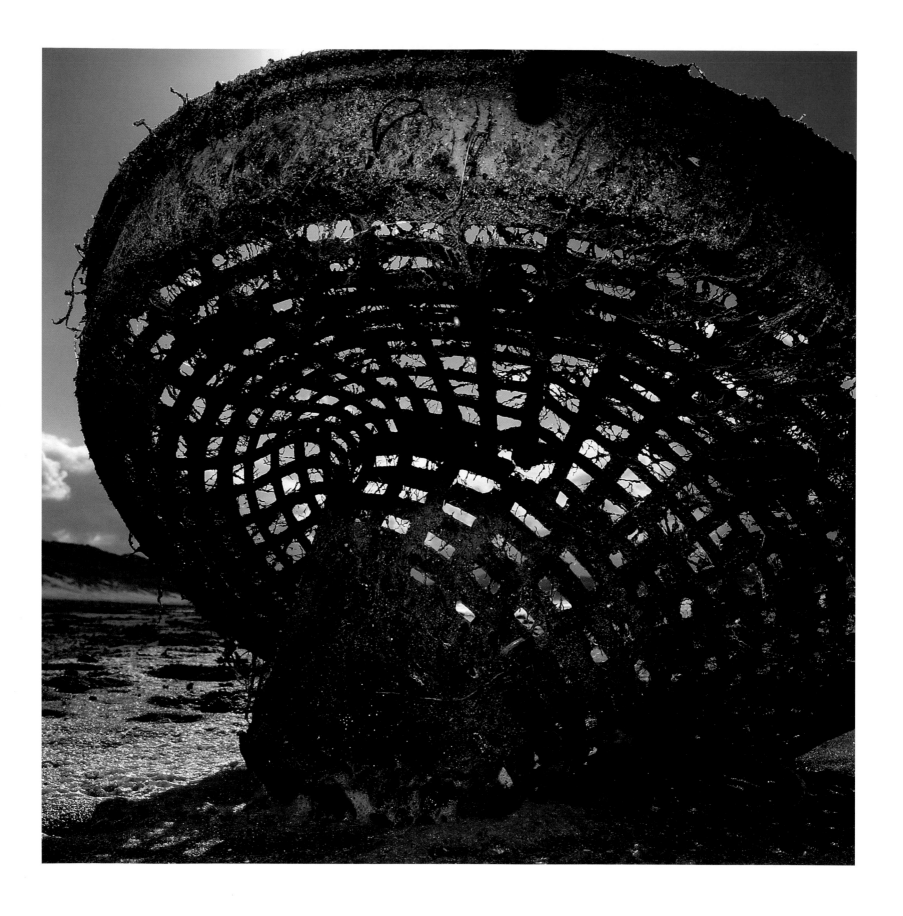

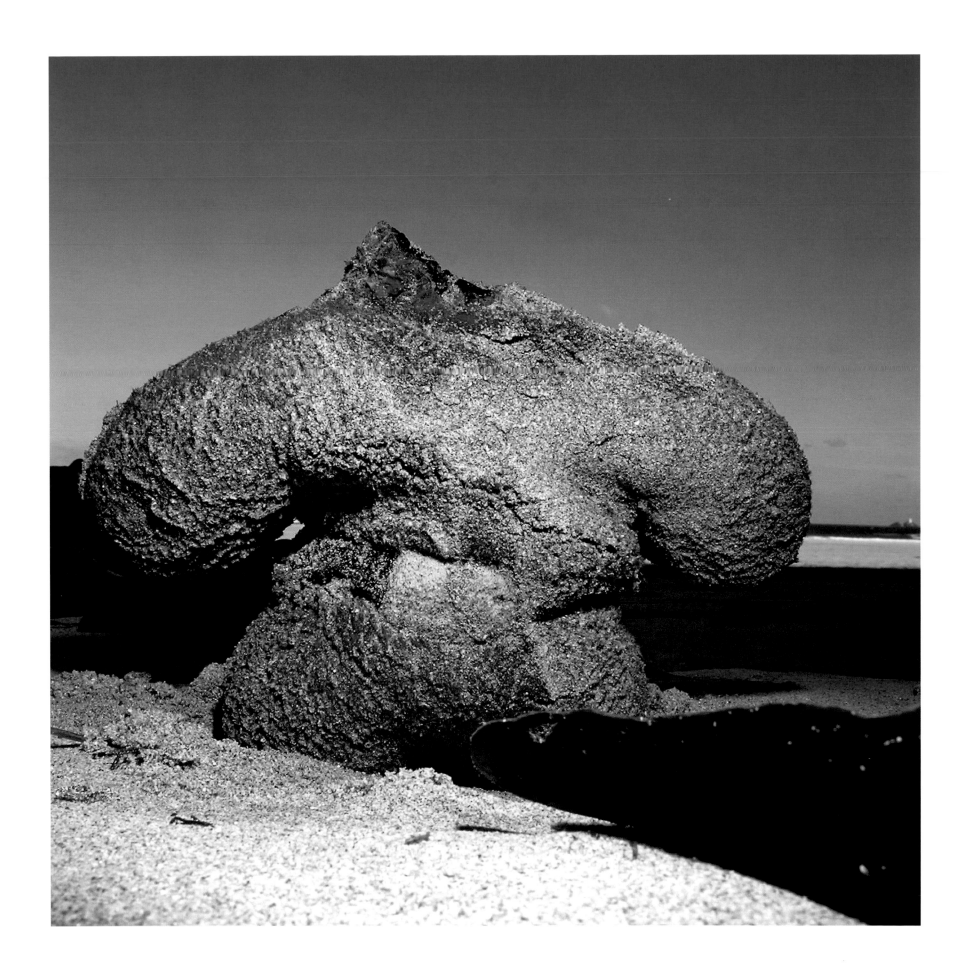

The Beach as Ruin

Lena M. Lencek-

Roughly six thousand miles west of St Ives in Cornwall, I walk the beach at Neahkahnie, Oregon. Its seven miles of sand stretch between the brittle cliffs at the base of Neahkahnie Mountain to the north, and, to the south, the estuary of the Nehalem River, where fat seals sprawl on snags and boulders. Tucked beyond the dunes are parallel lanes of cottages sheltered by beach pines, escalonia, blackberry vines and salal, and, beyond them still, to the east, islands of second and third growth fir sprouting from vast tracts of scarred clear cuts. The tide is out, exposing a half-mile of ocean floor littered with crab, sand dollars, jellyfish and starfish. Beach gulls step high around them, tearing at the feast like tourists at an all-you-can-eat buffet. Here and there the tip of a wave nudges up a dead cormorant. The yellow sea foam advances and recedes on the dark sand. I see no dog droppings, no cigarette butts, no spent condoms, no beer cans, no bottle caps, no charred firecracker fuses, no cellophane wrappers or plastic bags - in short, none of the conventional markers of licit and illicit pleasures that distinguish Andrew Hughes' staggering photographs of the beach at St Ives.

If my word picture of the beach is idyllic, Hughes' images are anti-idylls premised on the view that the beach is a ruin of both nature and culture. His version of the tainted, blighted, violated beach participates in a ruinology reaching back to the biblical narrative of the seashore as the topographical trace of divine wrath. The Garden of Eden, we recall from Genesis, had no seashore, no riverbanks, no coastline: instead, the primordial place was as seamless as the navel-free abdomen of Adam and Eve, perfect and complete, concealing nothing and exposing in its unbroken surface the fluid harmony of creation with creator. The violent collision of turbulent waters and earth came later, after humankind struck out on its own mulish and thorny path, provoking the Creator, as the authors of the Bible tell us, to unleash a great Flood of waters as an instrument of punishment. Forever more, since that catastrophic deluge, 'the beach' haunts Judeo-Christian cosmogony as the remnant of disaster, the ruin of a once perfect creation. As Thomas Burnet, the influential 17th century British theorist, interpreted the scripture in Telluris Theoria Sacra (The Sacred Theory of the Earth), when the Flood waters had retreated into internal caverns, the earth had become "a gigantic and hideous ruin [...] a broke and confused heap of bodies." And nowhere was the earth more monstrously horrid than in its mountain ranges and the rocky, fractured shores of its heaving seas.

Modern geologists, setting aside the lenses of theology, ethics, and aesthetics, 'read' the seashore as a kind of utilitarian ruin, a margin of land engineered - by its position at the intersection of antithetical elements - to serve as a buffer zone. Call it 'location as destiny.' Rocky or sandy, the beach is that perpetually mobile zone where earth accommodates itself to the assault of water, wind and tectonic tremors. The surface of this flexible seam bears a constantly updated chronicle of geological triumphs and defeats traced in the organic calligraphy of the intertidal zone - seaweed, the exoskeletons of arthropods and molluscs, fish bones, feathers - and in the monumental record of tumbling rock faces and shifting dunes.

Archaeologists, too, approach the beach as a trash heap. These rag-pickers and scavengers of the humanities prowl the intertidal zone and littoral shallows for the remnants of dead civilizations. Sifting the sands and shales of coastal waters, they scout for ingots, amphoras, statues, weapons, stone blocks, mosaics, and body ornaments that are markers of once vibrant trade routes, commercial centres, cultural monuments, and human habitations dating far back to the Bronze Age. What they miss, the fingers of tourists idly sifting beach sands identify as a lucky find: the time-smoothed edges of a shard, a frieze, a fibula. And though we call them 'artefacts' and **give them value and accession numbers in museum catalogues, we must acknowledge them for what they are: the wreckage of once-cherished cultural ambitions.**

Of all the stuff that washes up on beaches, the manmade strata are the most telling as inventories of the values and priorities of the cultures that produced them. Sir Francis Bacon said with respect to antiquities, that ruins are "history defaced, or some remnants of history which casually have escaped the shipwreck of Time." The military hardware - bunkers, rusting tanks, propellers - on the beaches of Normandy, the South Pacific, Vietnam, are monuments to what Sigmund Freud identified as the death drive fundamental to the human psyche. The wreckage left behind in the wake of the tsunami of January 2005 stands as a testament to the First World's insatiable appetite for leisure in Third World tourist resorts. In the same year, on the opposite side of the globe, Hurricane Katrina ploughed through the Gulf Coast and the Mississippi River basin, leaving behind a landscape of broken power grids, oil rigs, and ruptured chemical depots in a wash of shingles, cars and corpses. The chronic deposits of catastrophe, man-made or natural, stand as massive 'vanitas' installations, reminding us that in the face of time and nature, all that is human is transitory and ephemeral. "In ruins movement is halted and Time is suspended, " writes Christopher Woodward in his

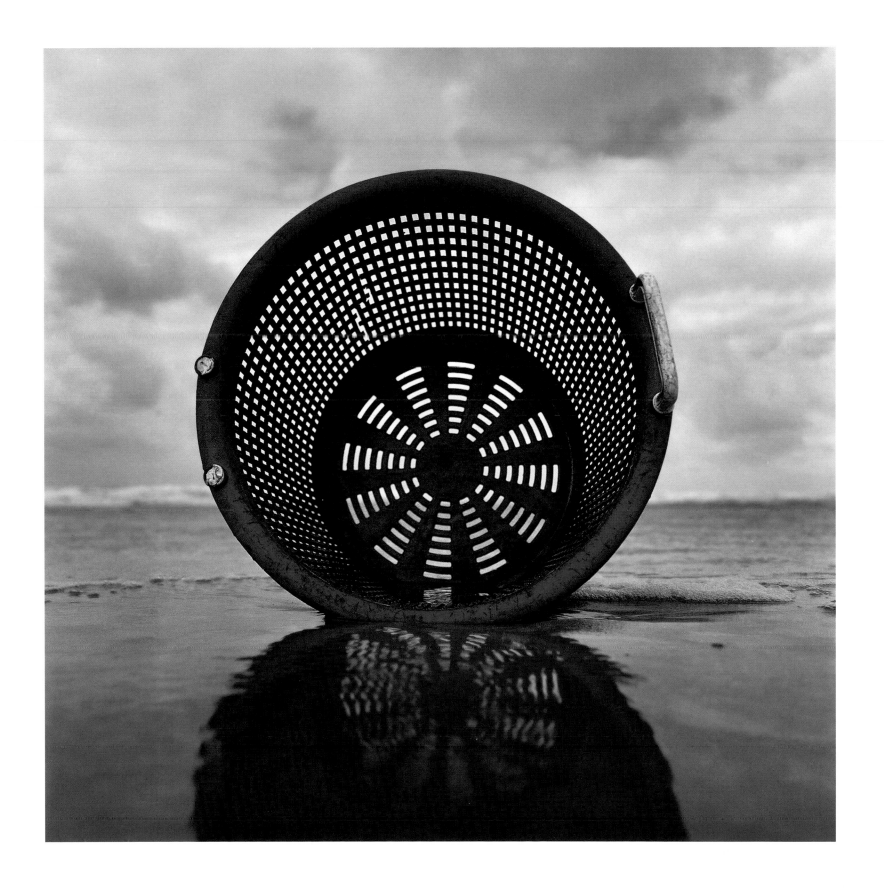

reflection *In Ruins*.

The one, saving grace of these landscapes of devastation is the promise of decay and, following hard on its heels, renewal. For all its tragic toll on human lives and suffering, the spectacle of destroyed artefacts on the beach has had its inspiring, hopeful interface. The tsunami, the hurricane, the winter storm, after all, scrub clean the beaches on which Western entrepreneurs have spot welded clones of Western recreational modules. They sweep away the factories of pleasure tourism whose raw material is the fatigued, overweight, jaded, spiritually exhausted techno worker, and whose product is the tanned, satiated tourist. All the improvisational, shabby construction of the recreational Id is subject to instant erasure at the stroke of a hyperbolic surge.

Garbage, as Elizabeth Royte tells us in Garbage Land has a tendency to move downward and to the margins. No matter how much one might groom a beach, the dynamism of tides and winds guarantees that one will always find some piece of rubbish washed up at the high tide mark. It is this invariantly dynamic and mutable conjunction of natural stage and cultural prop that makes each piece of beach trash a memento mori telegraphing the elegiac message "Et in Arcadia Ego" - "I too am in Arcadia," that reminder of death's omnivorous inevitability in our lives. What remains, as Denis Diderot reflected while looking at the ruin paintings of 18th century artist Robert Hubert, is a profoundly reassuring confidence in an infinitely renewable nature, "The ideas aroused within me by ruins are lofty, " Diderot wrote in 1767. " Everything vanishes everything perishes, everything passes away; the world alone remains, time alone continues. How old this world is! I walk between these two eternities [...] What is my ephemeral existence compared to that of this crumbling stone?"

Interestingly, however, when it comes to the "message" transmitted by the "medium" of trash, not all beach rubbish is created equal. Archaeological artefact aside, there is a class of beach trash that is disturbing in a way unprecedented in human experience. This is the burgeoning flood of feculence and rejectamenta produced by contemporary technology, consumerism and demographics, that generates a dread of apocalyptic proportions. The secret message of industrial, non-biodegradable garbage on the beach is that some things are for keeps, and some mistakes can never be corrected. Promethean man might in fact have reached the point of no return, when the products of human intelligence

have finally surpassed the capacity of nature. A walk on a litter-strewn municipal beach is an excursion into the hellish prophecy of doom by human hubris.

Andrew Hughes' photographs of rubbish at the beach speak to this dread. His monumental photographs of the banal relics of our evermore supersized, disposable lifestyles intimate the hidden depths that lurk beyond the superficial disgust with which beach junk fills us. We are dismayed by the irony that the very beaches we seek out as physically and psychically restorative refuges are as irretrievably polluted as our toxic hinterlands. Andrew Hughes literally rubs our noses in the lethal deluge of trash unleashed by man against man, the toxic flood of polymers, plastics, and contaminants that - another irony - survive our ephemeral pleasures to lead half-lives of reproach, ugliness, and menace.

Burnet, Thomas, *The Sacred Theory of the Earth*, H. Lintot, London, 1734, p.51
Bacon, Francis, *Advancement of Learning*, ed. Joseph Devey, Collier & Son, New York, 1902, p.103
Woodward, Christopher, *In Ruins*, Pantheon, New York, 2001, p.36
Royte, Elizabeth, *Garbage Land. On the Secret Trail of Trash*, Little Brown, New York, 2005, p.4
Diderot, Denis, *Salons*, ed. Jean Seznec and Jean Adhémar, Oxford University Press, Oxford, 1963, pp.228-9

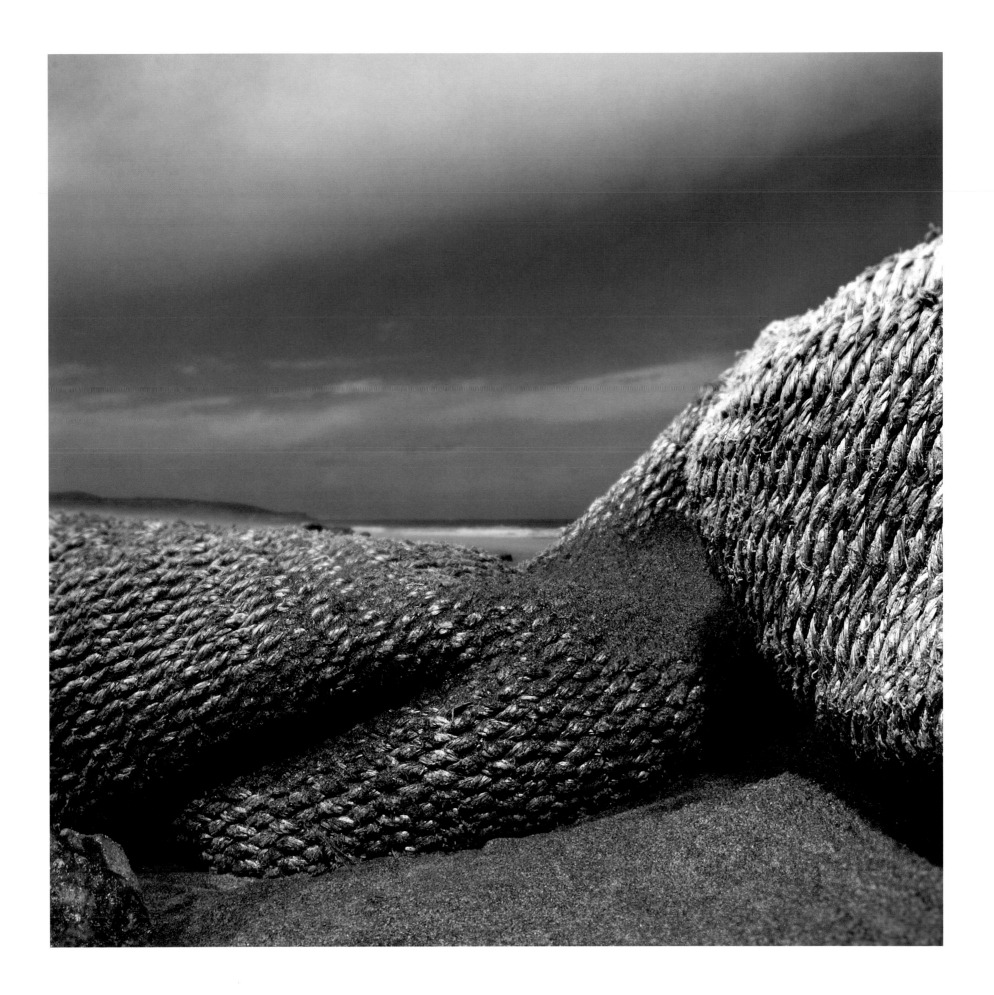

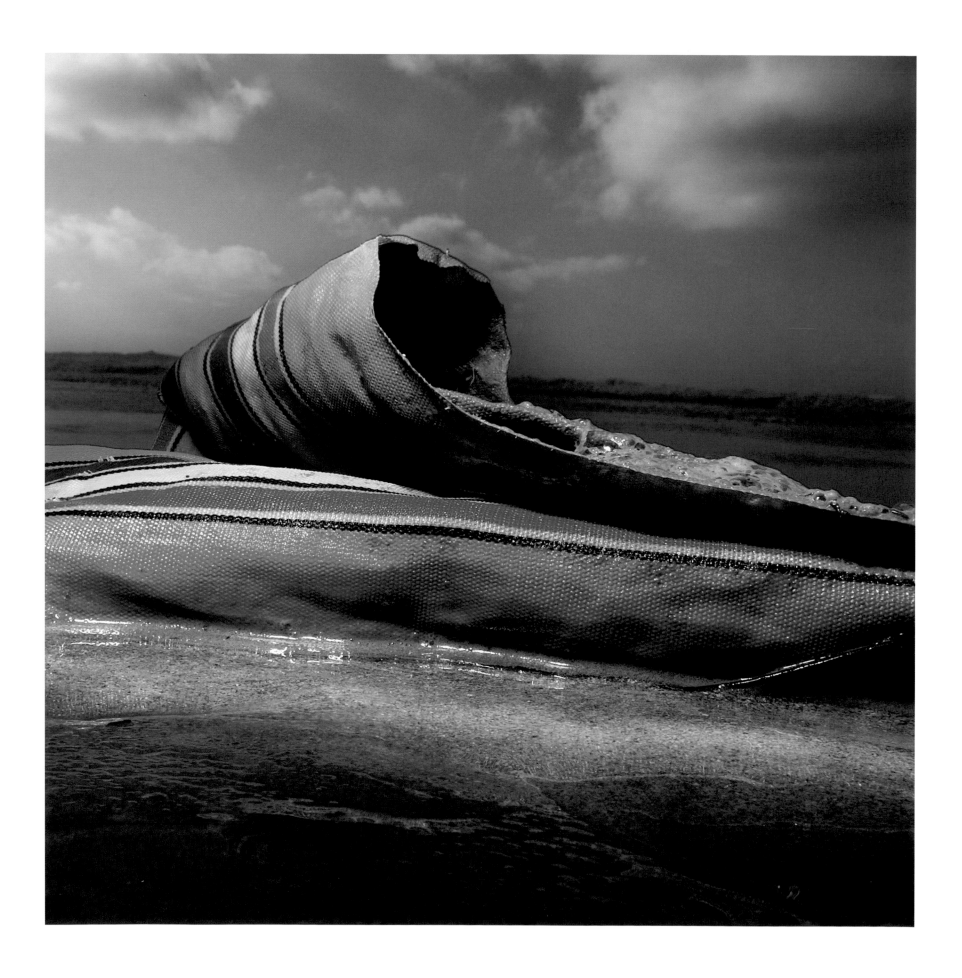

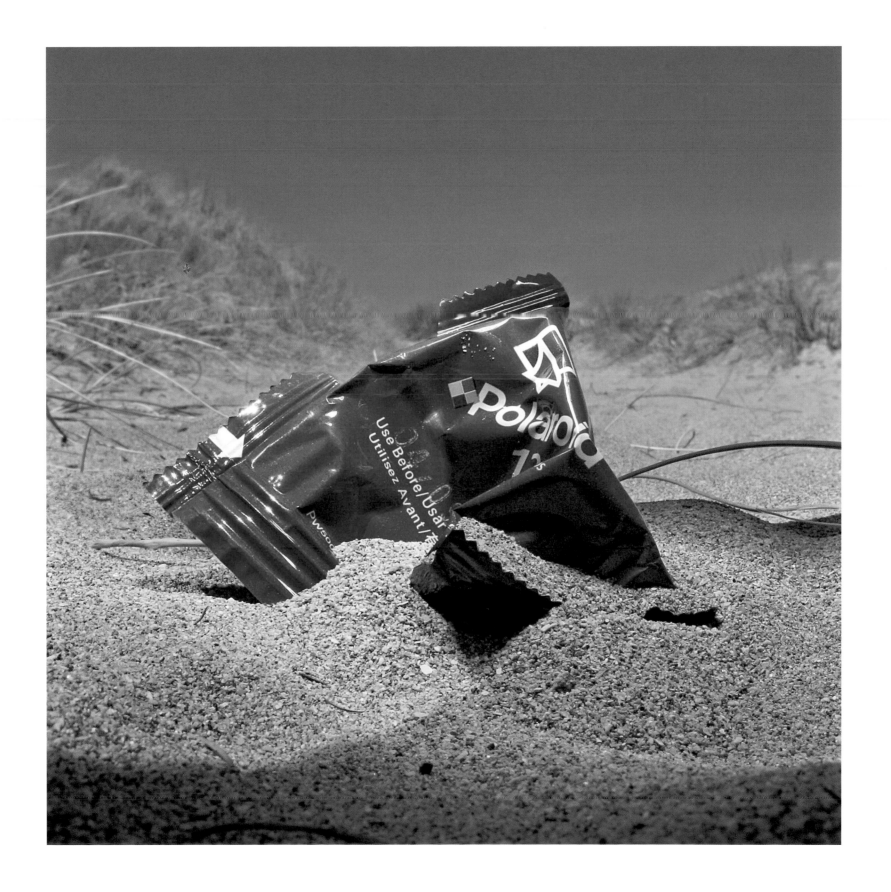

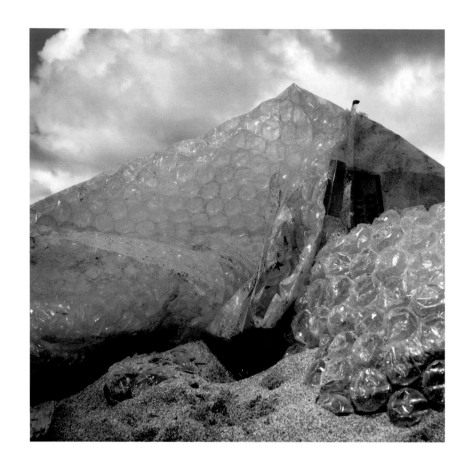

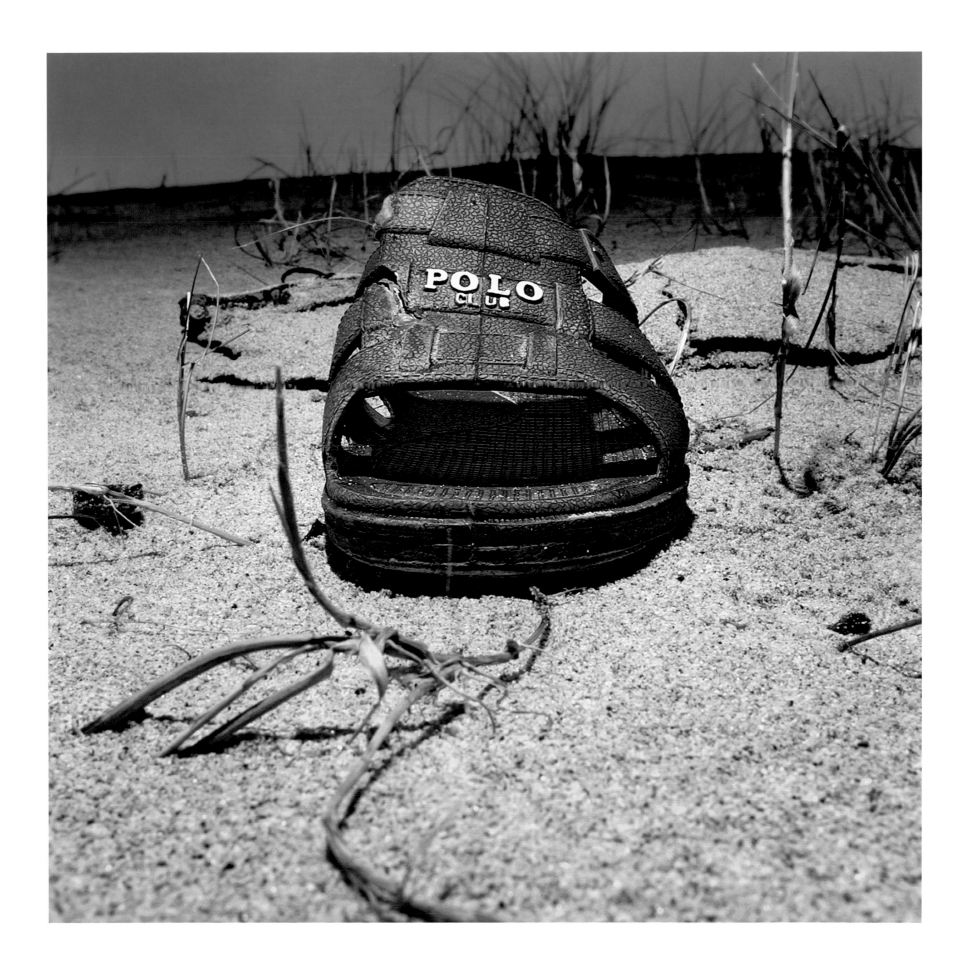

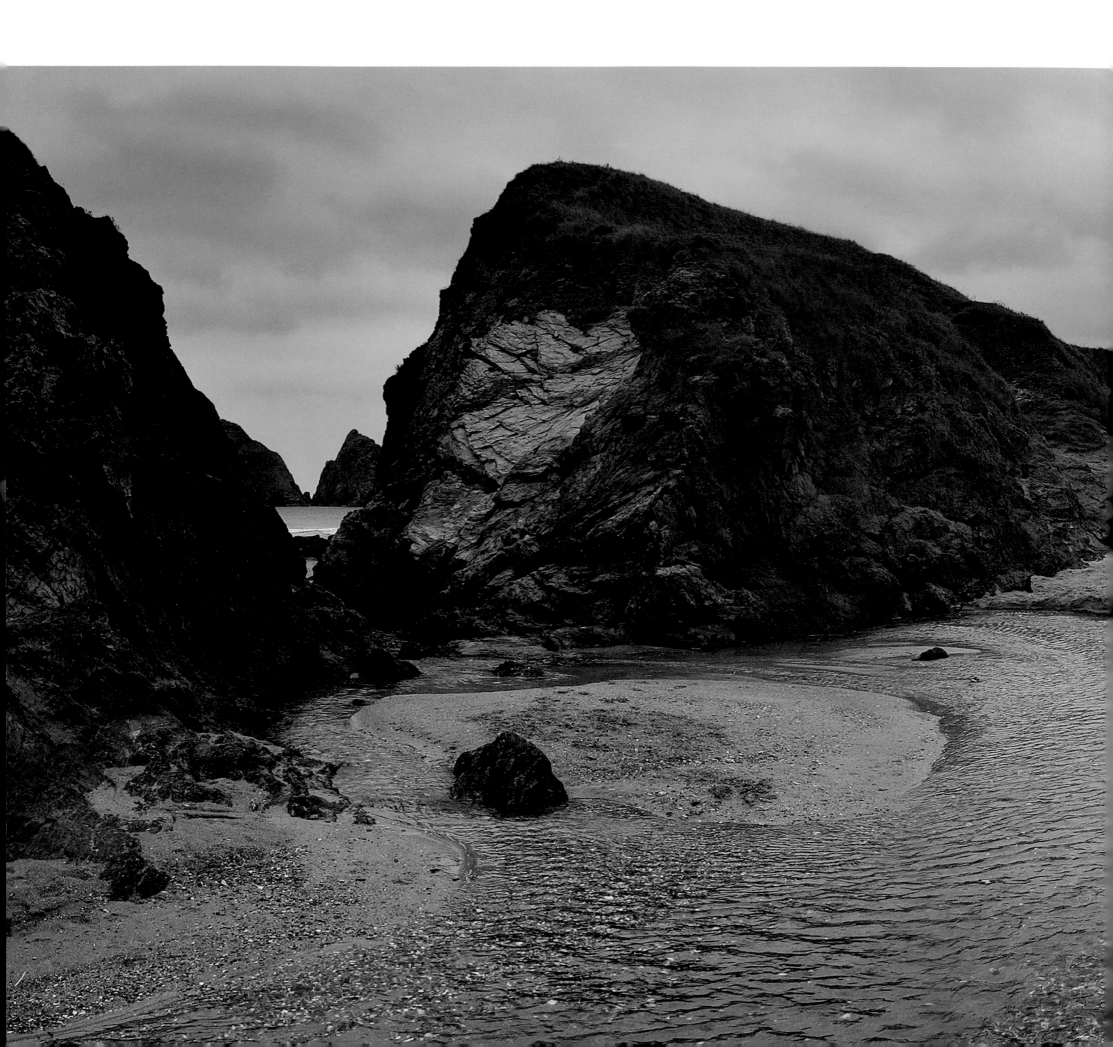

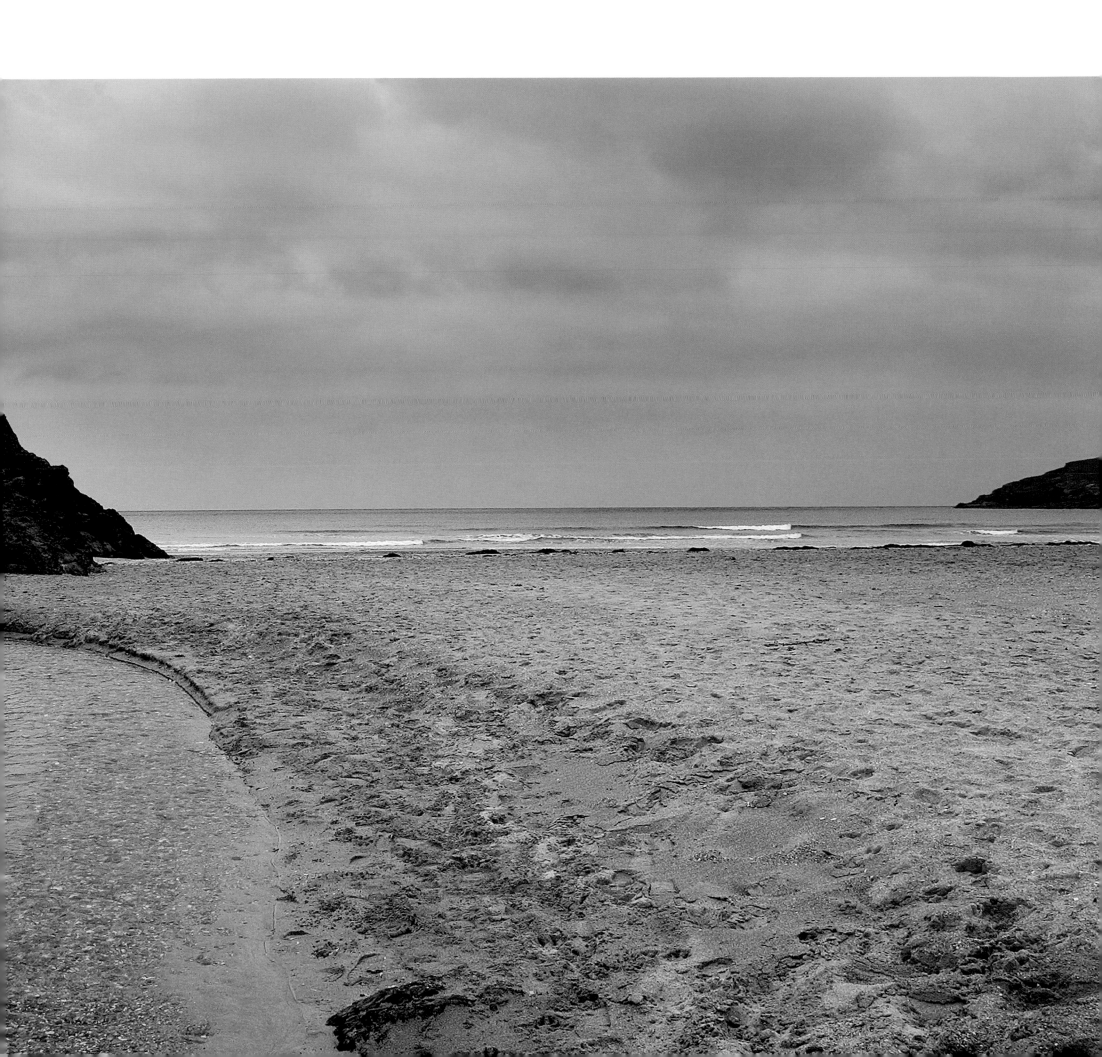

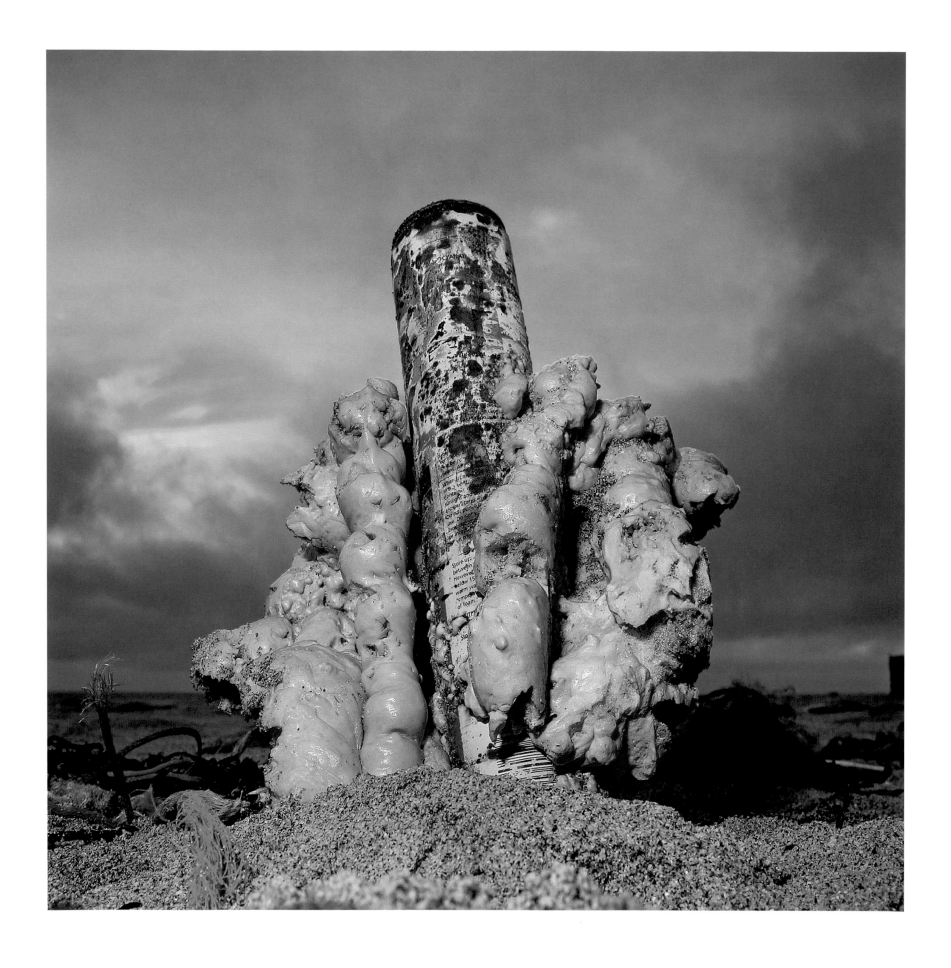

154

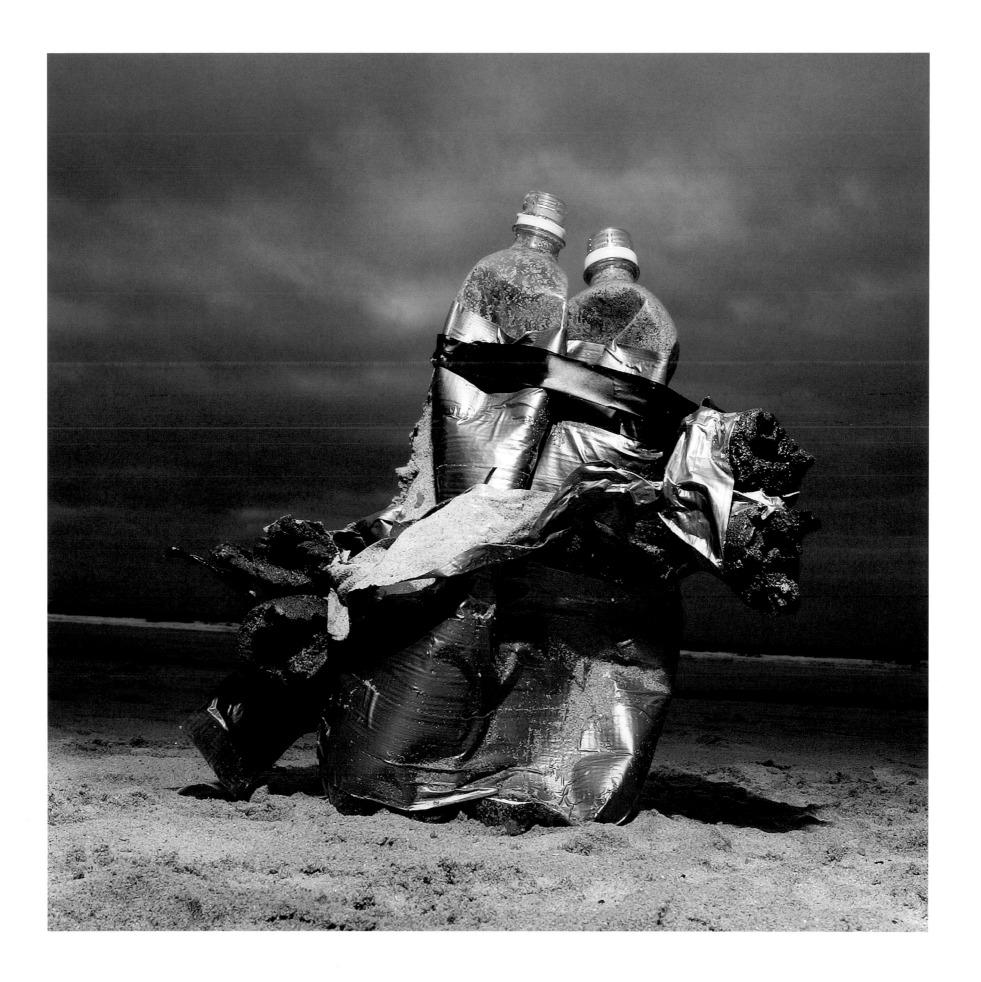

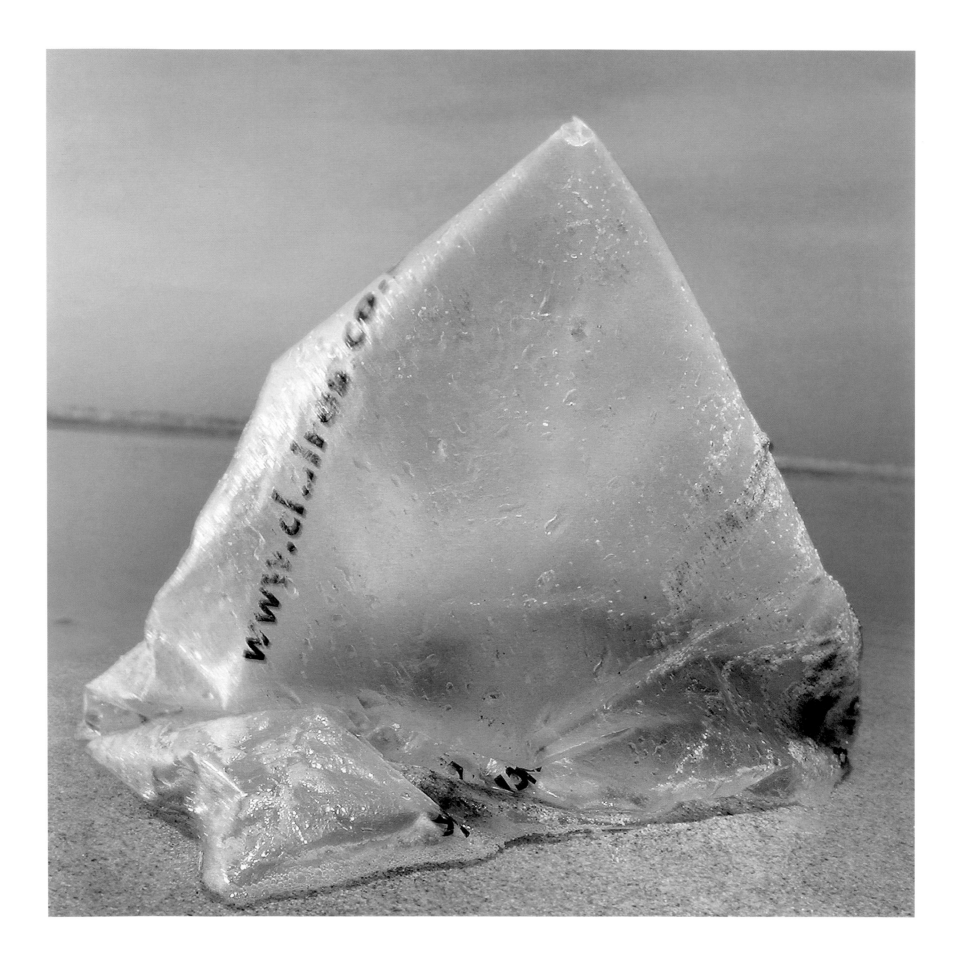

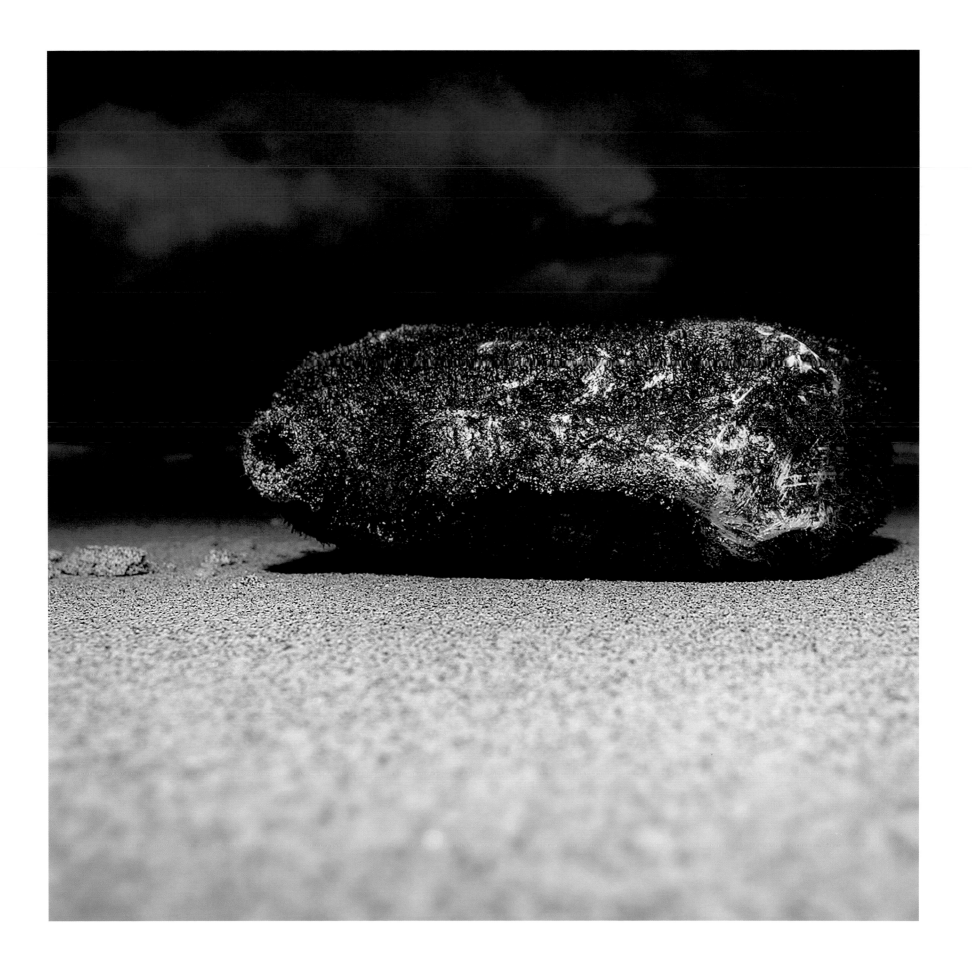

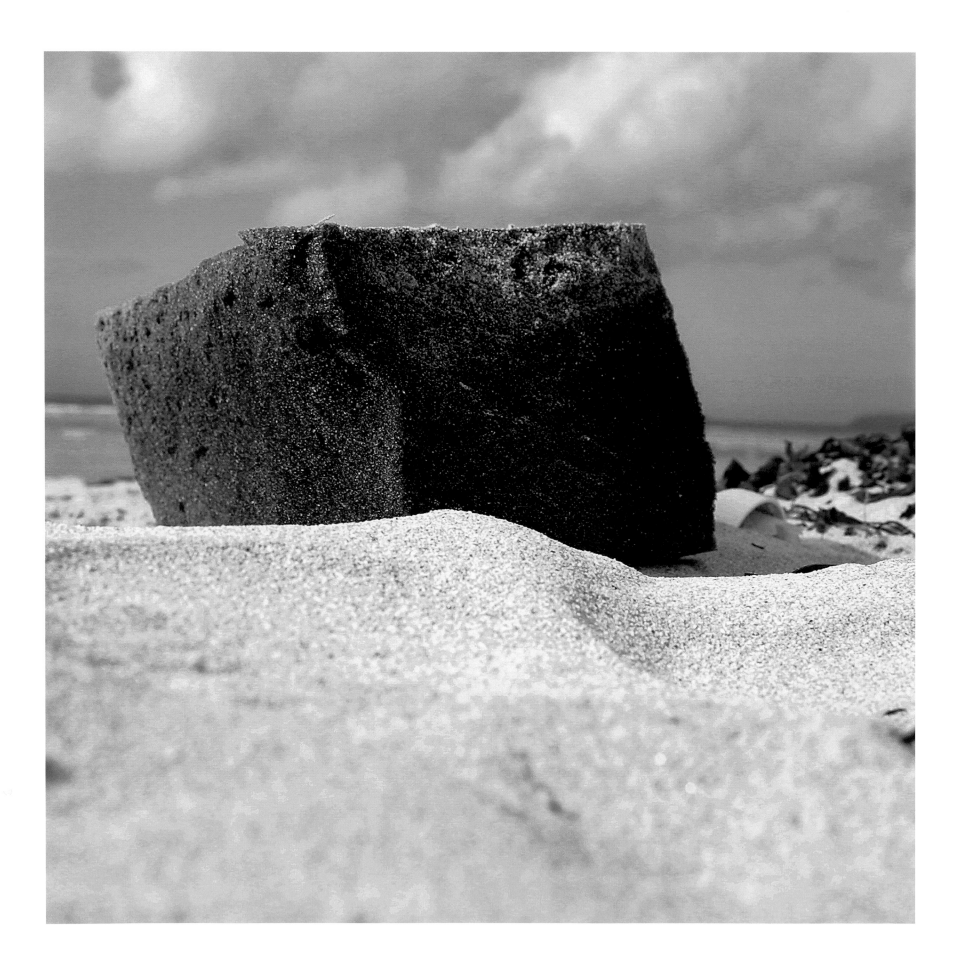

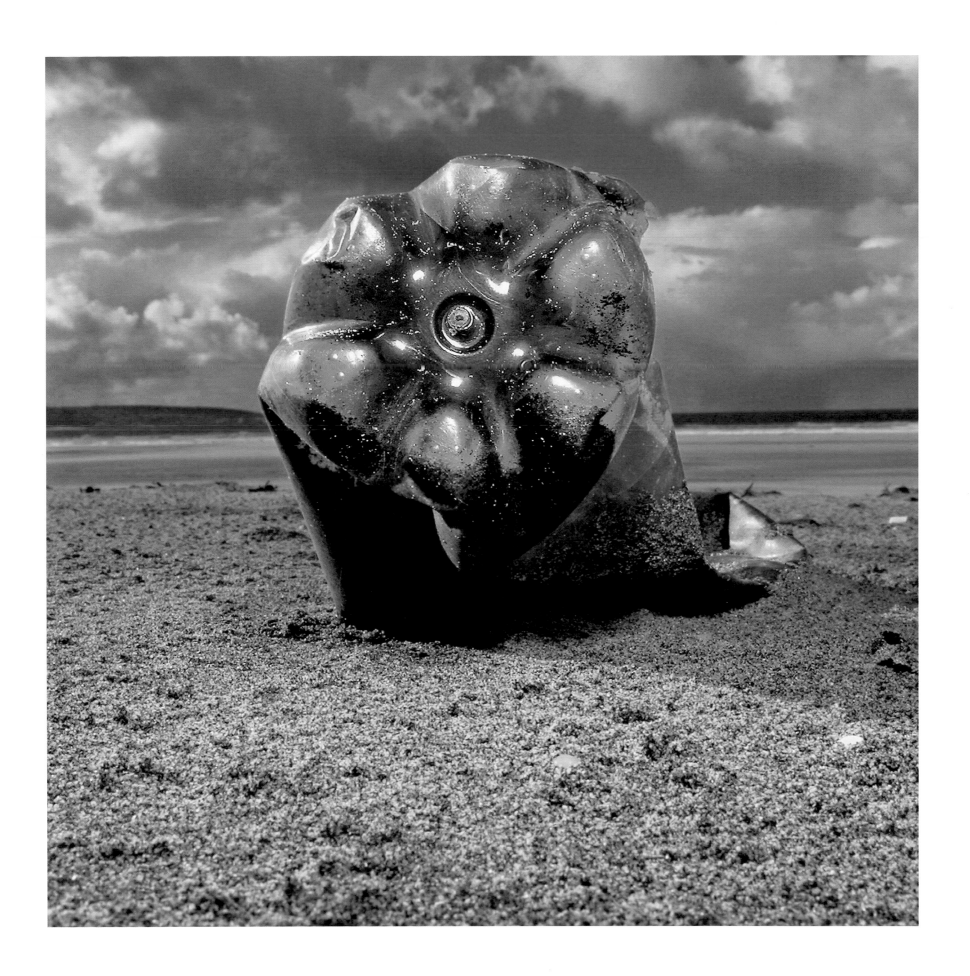

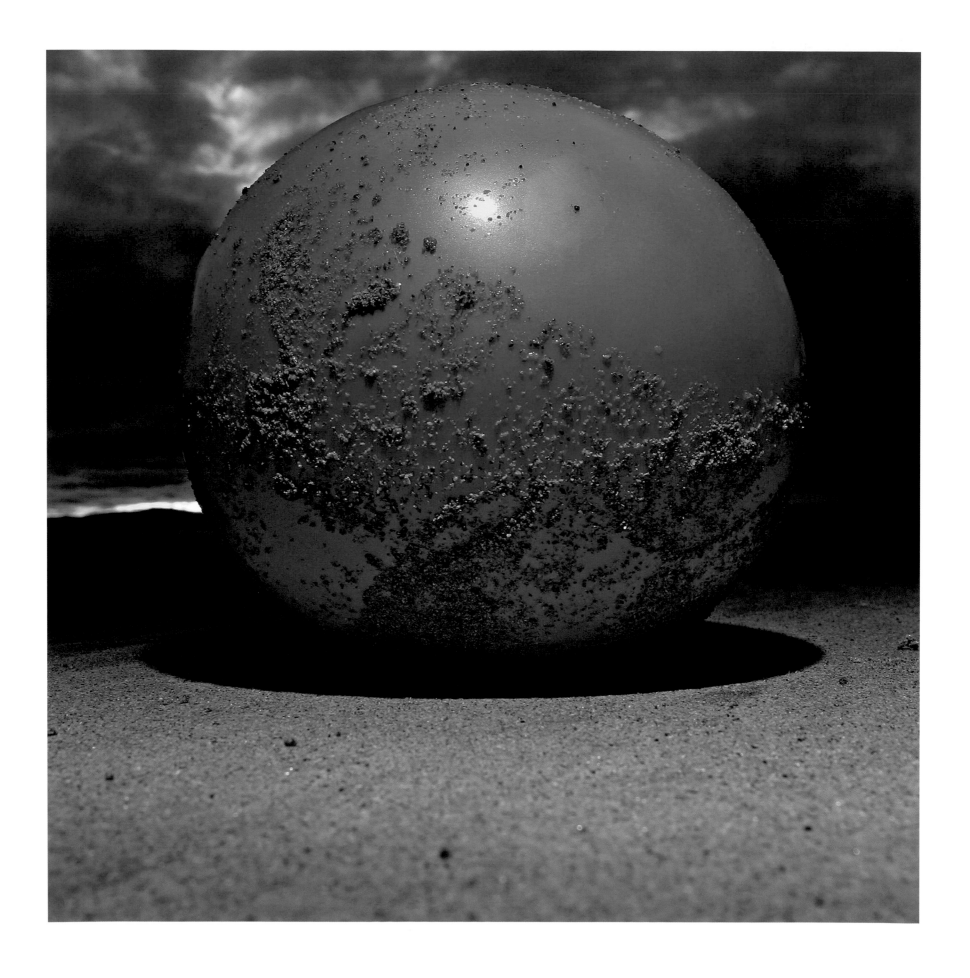

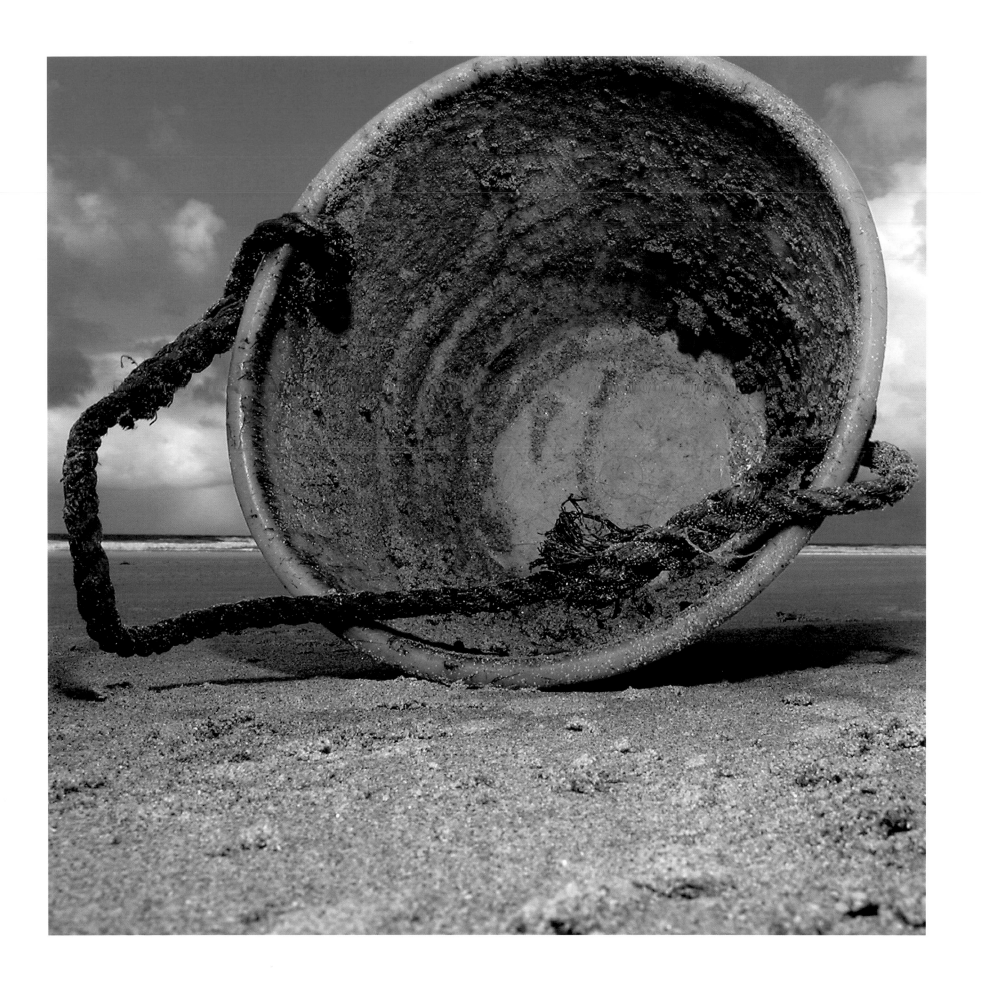

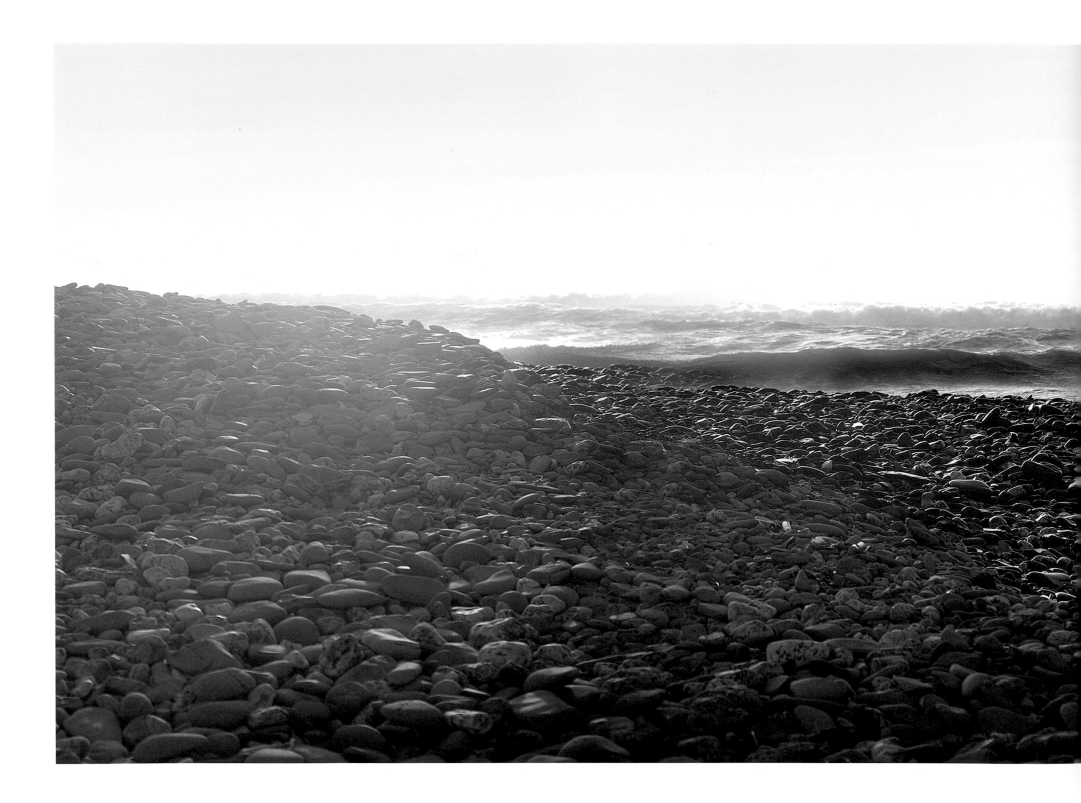

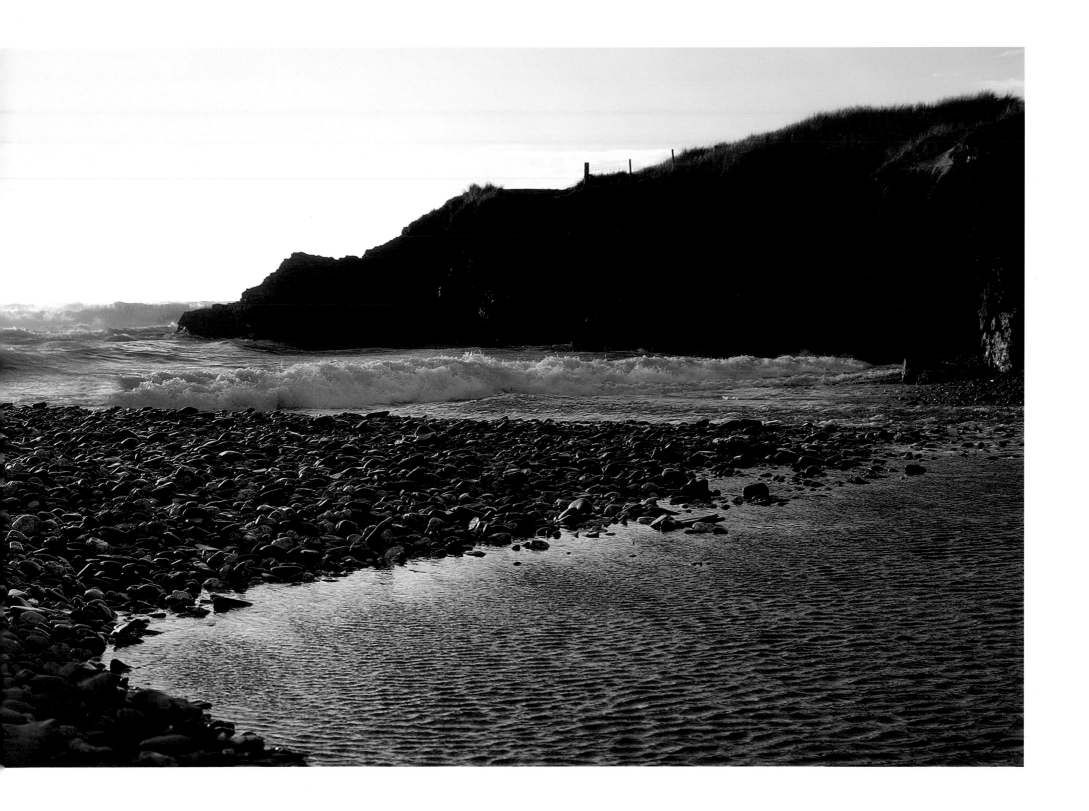

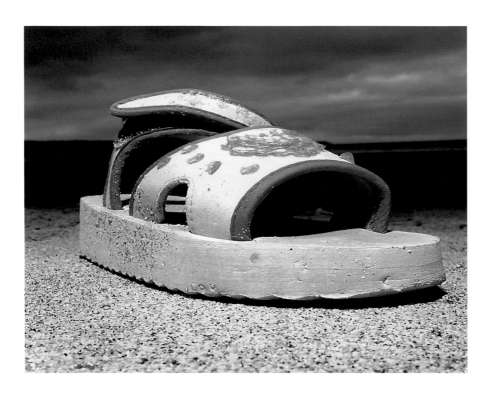

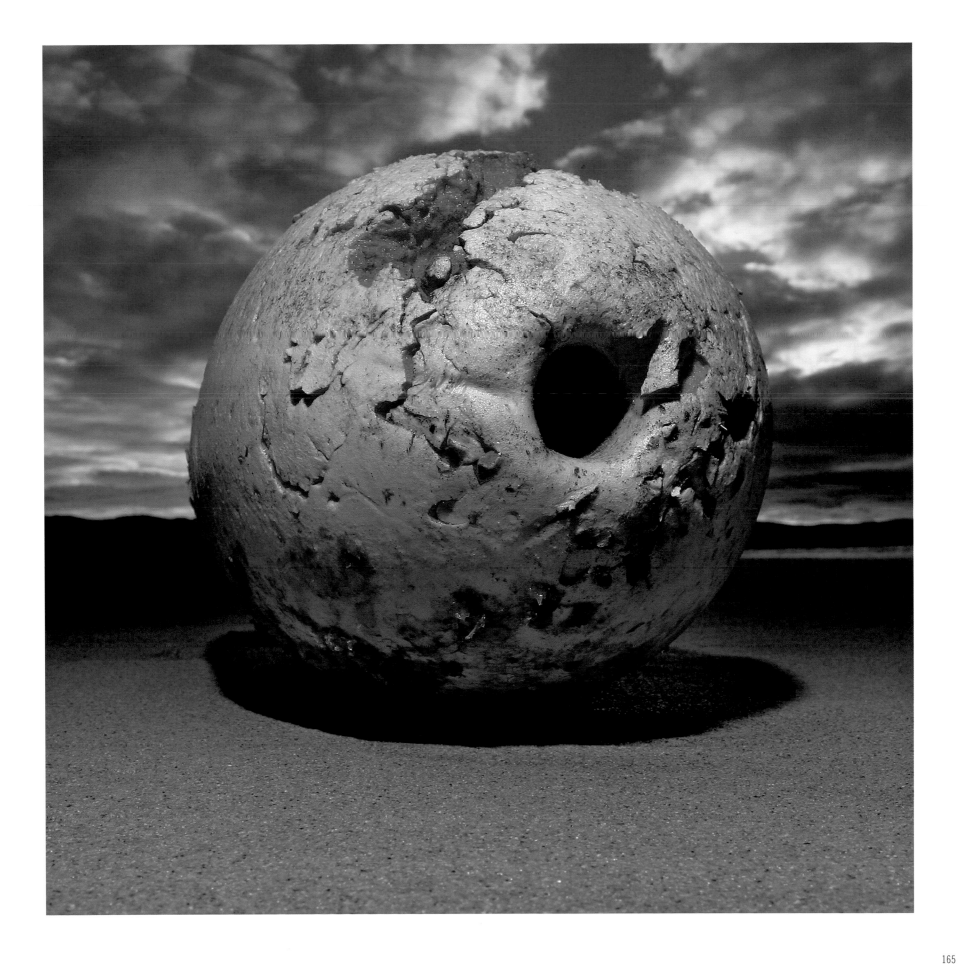

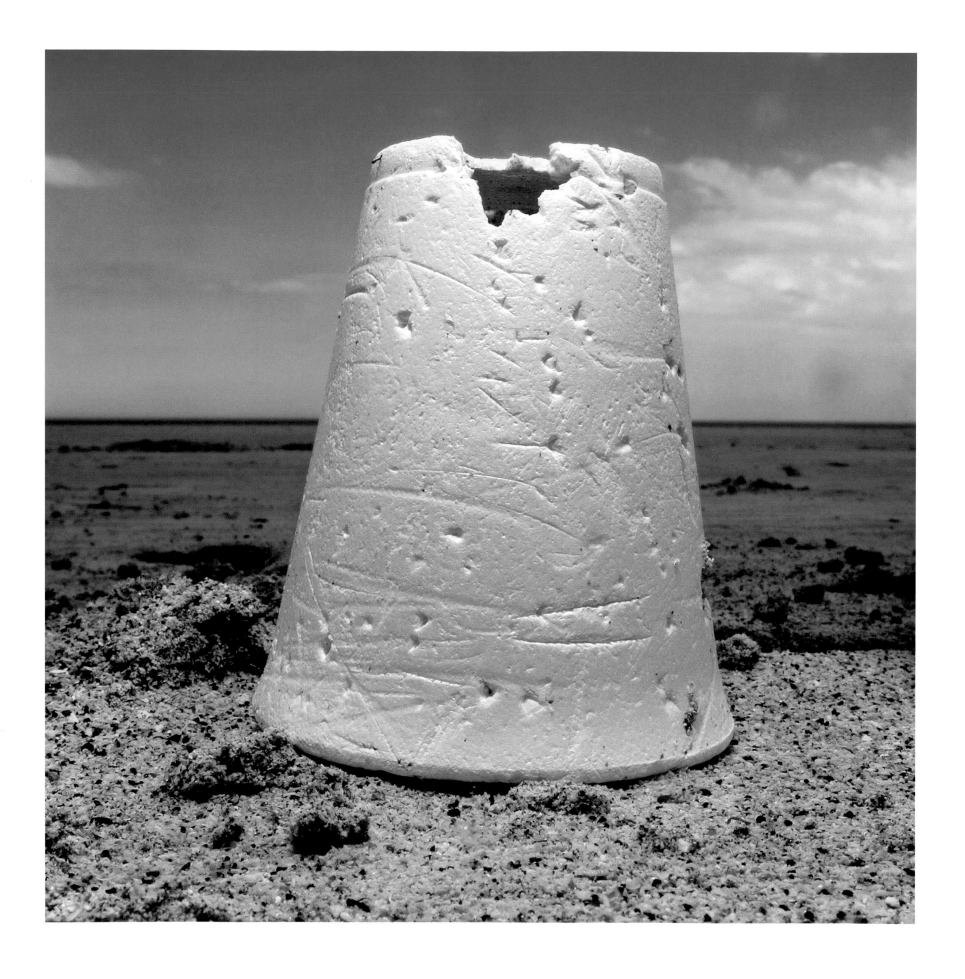

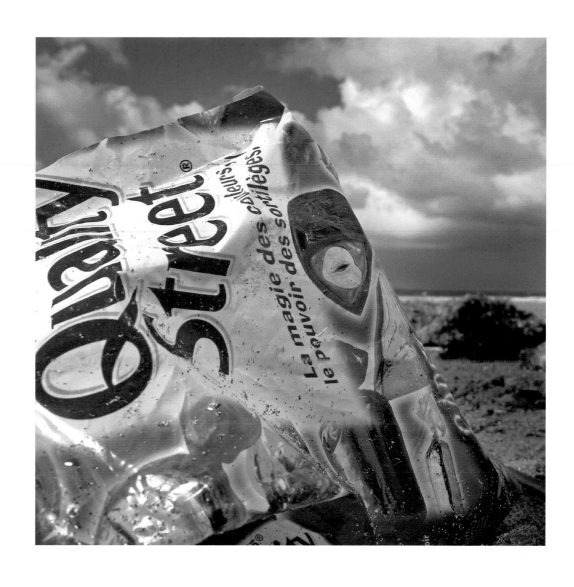

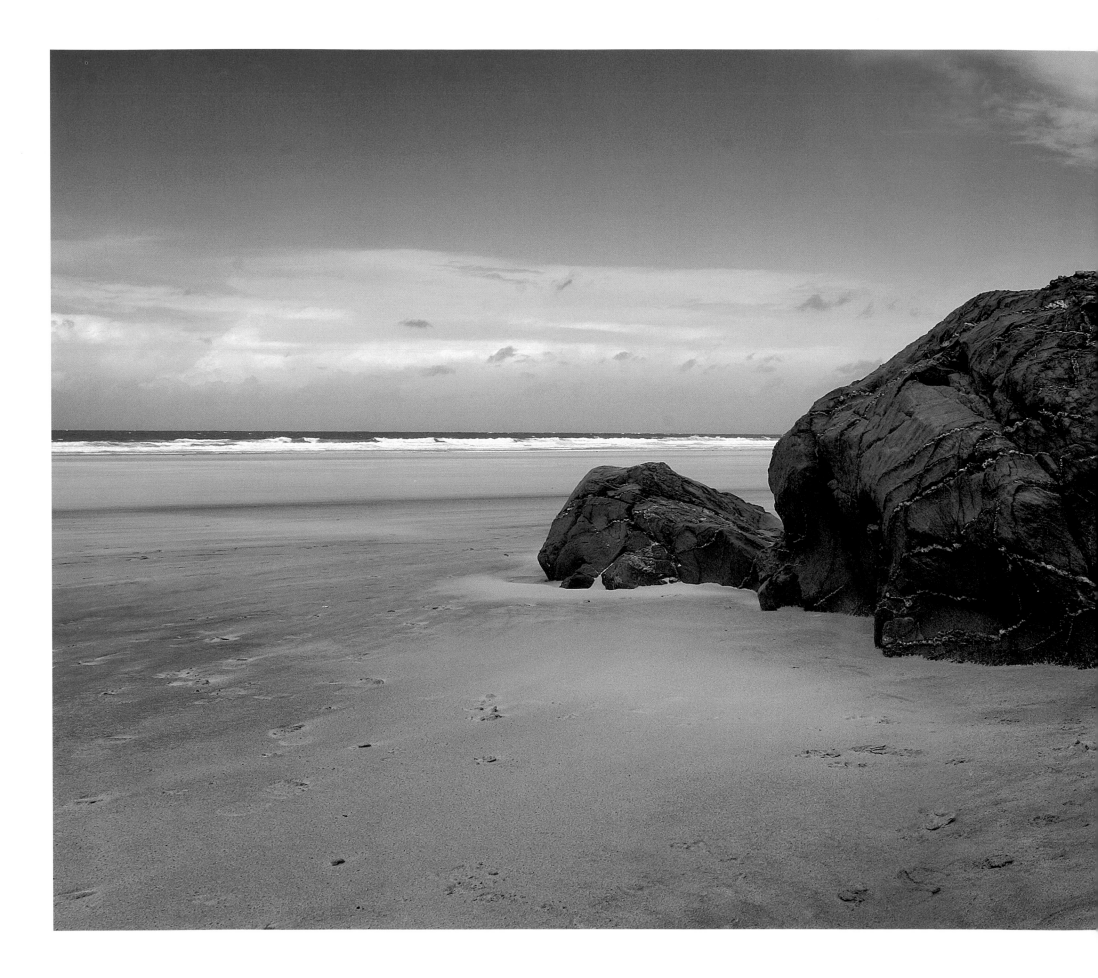

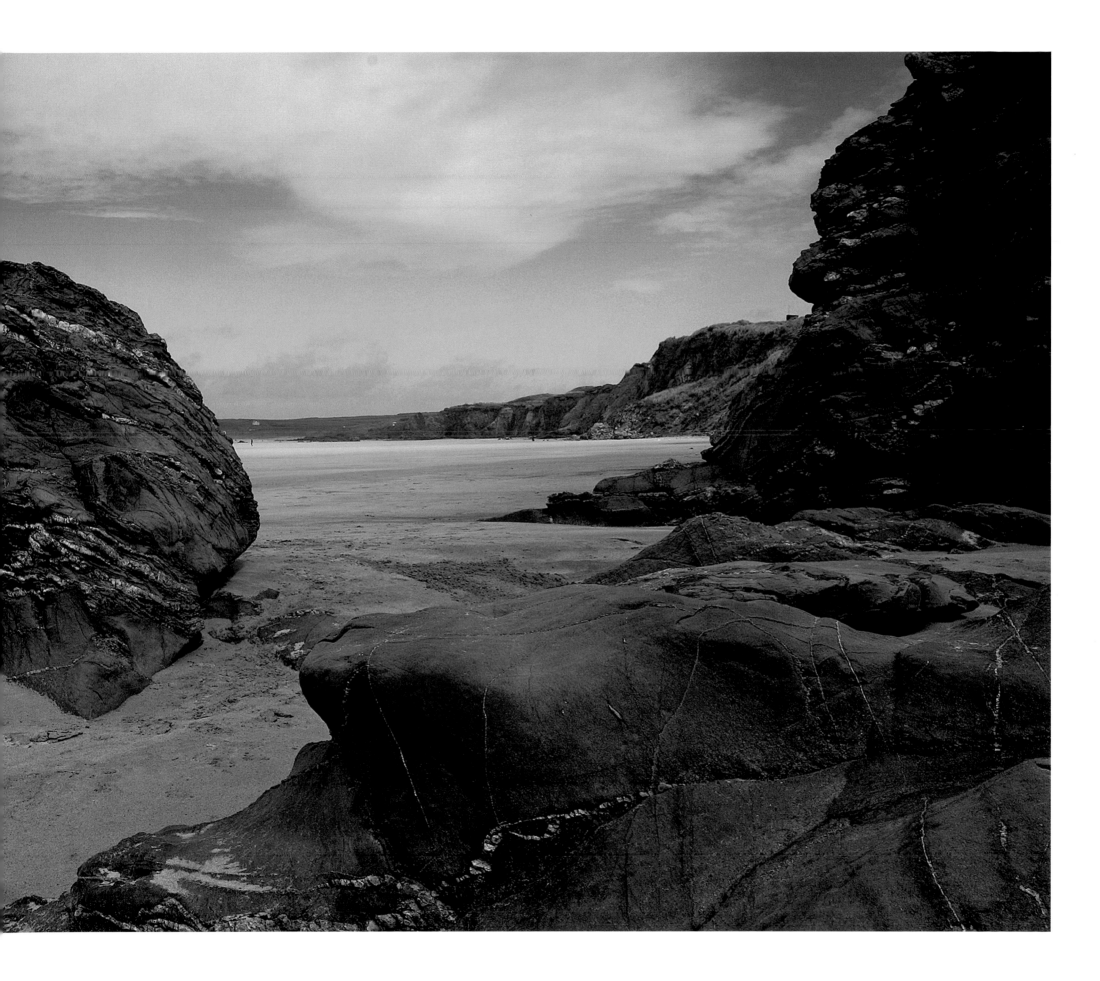

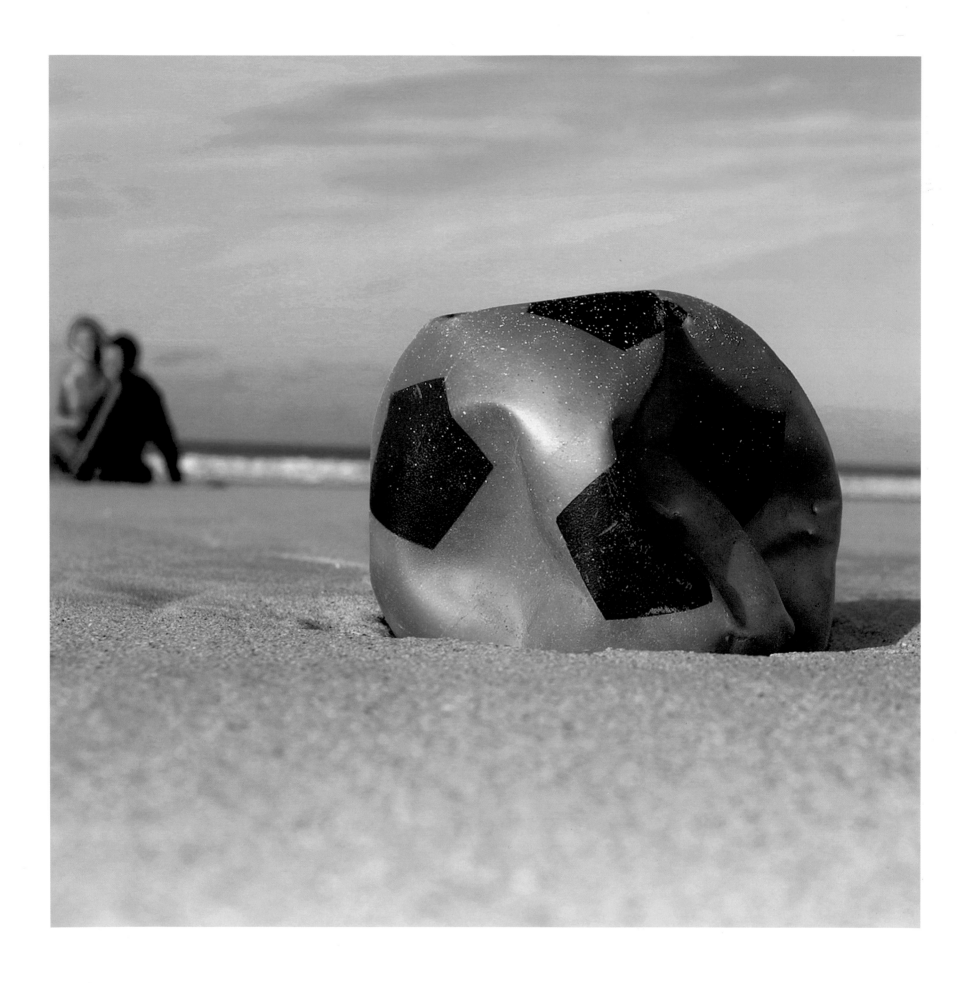

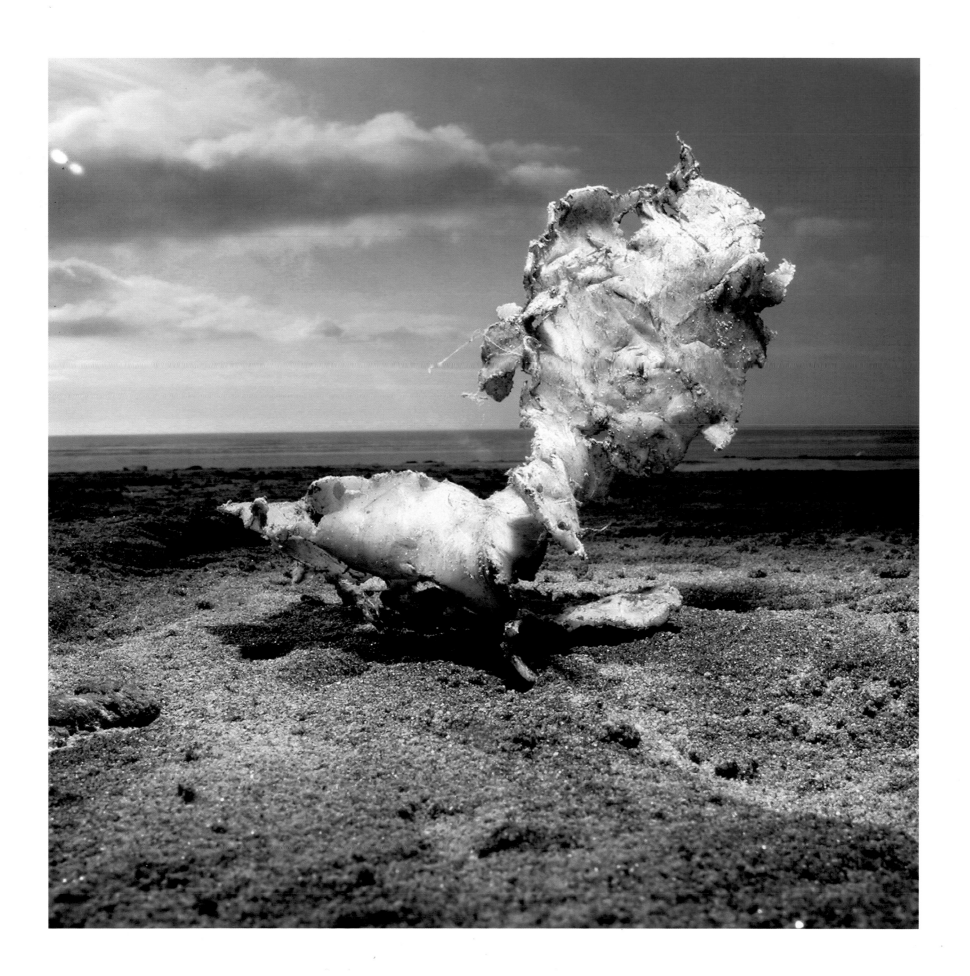

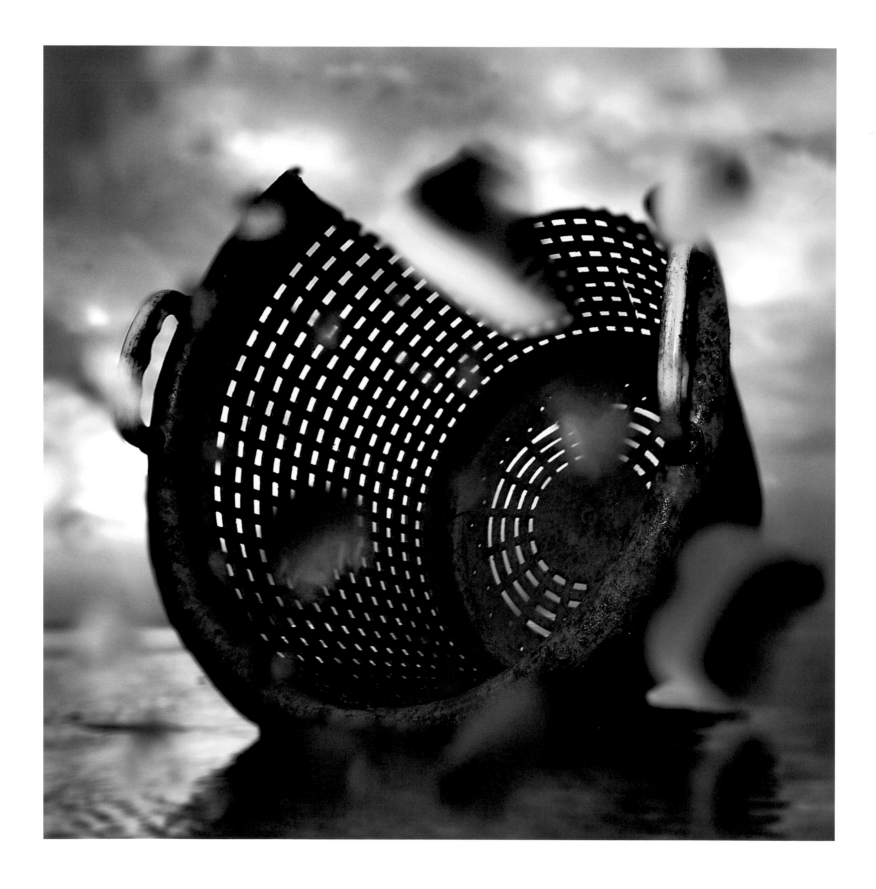

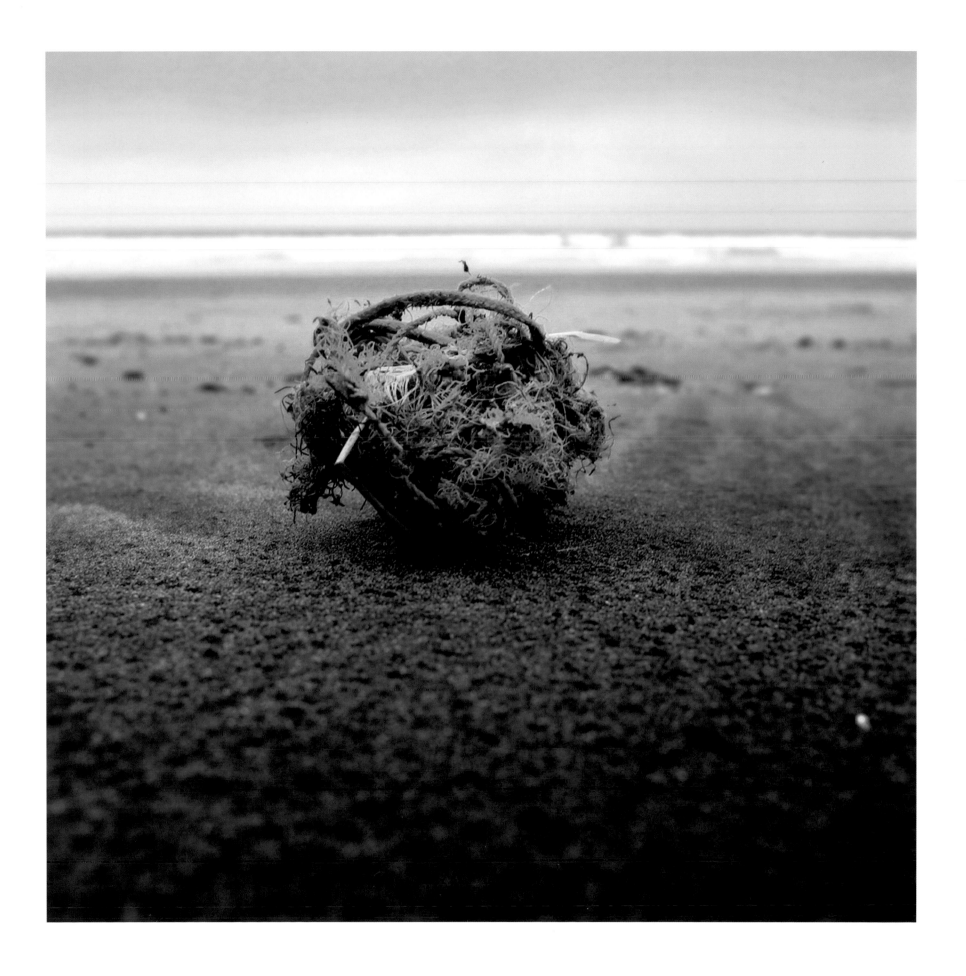

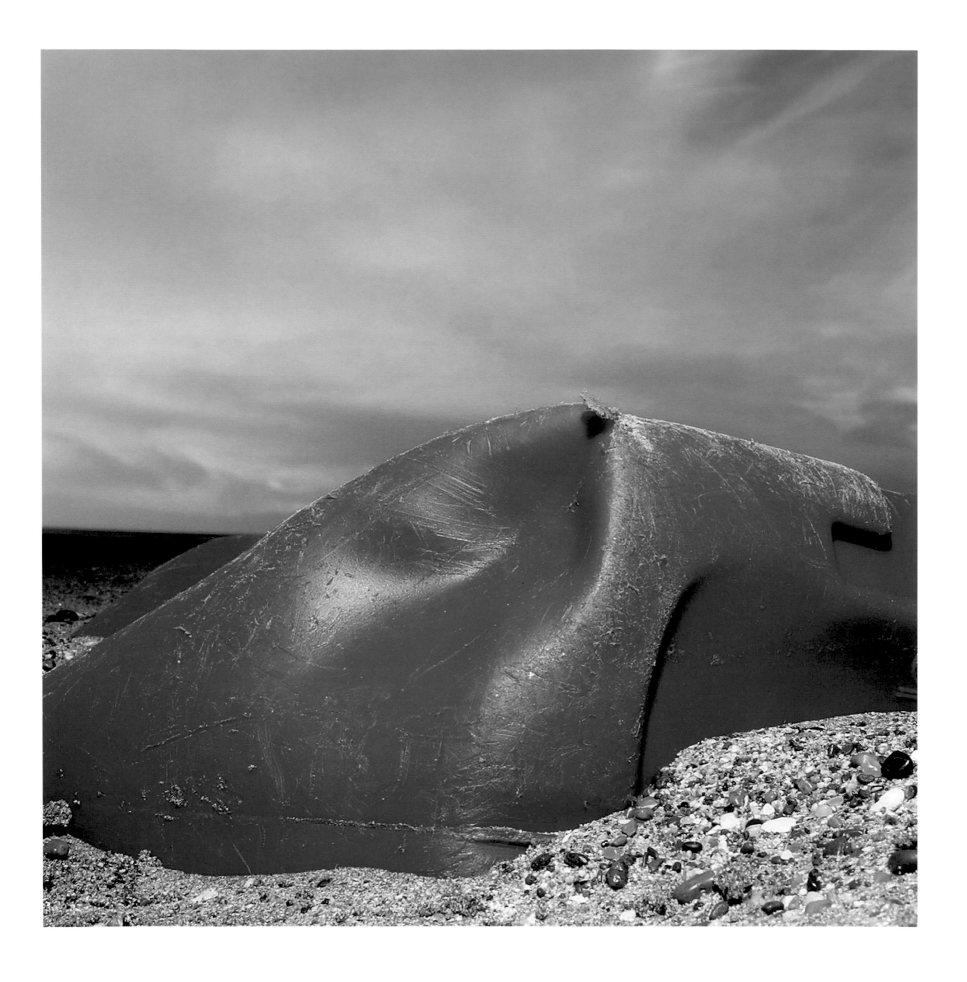

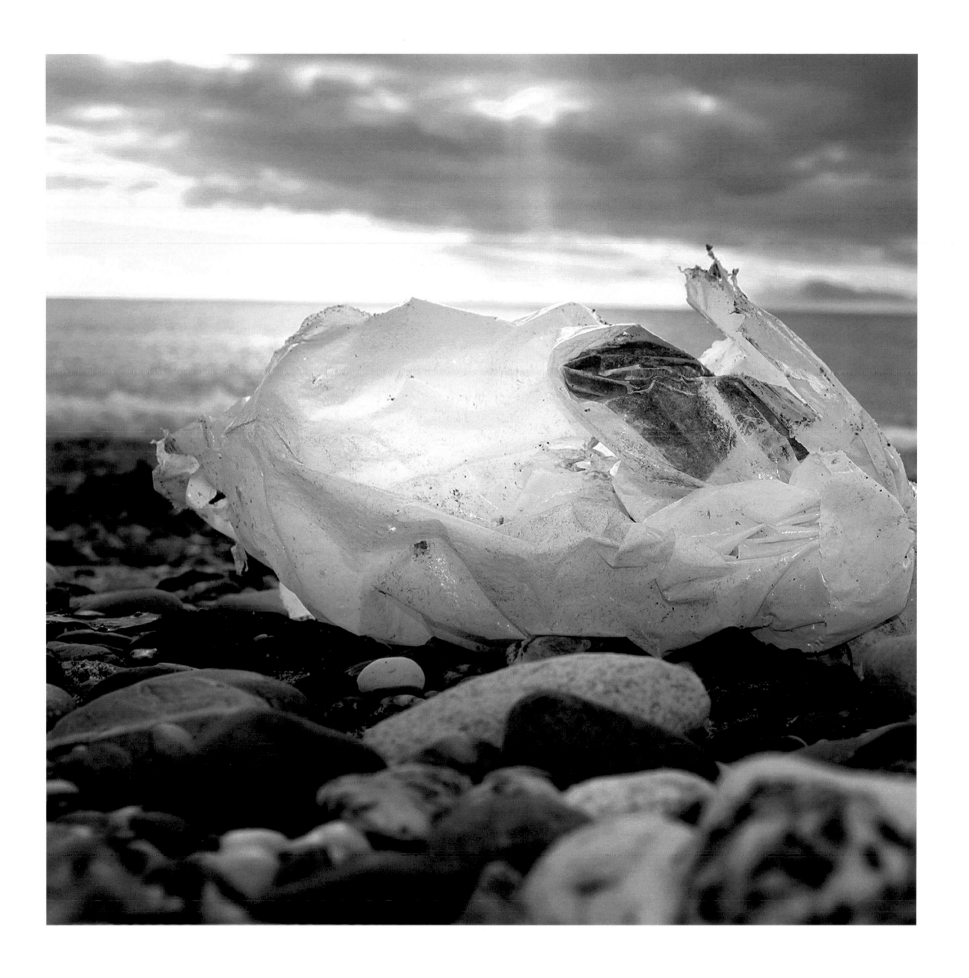

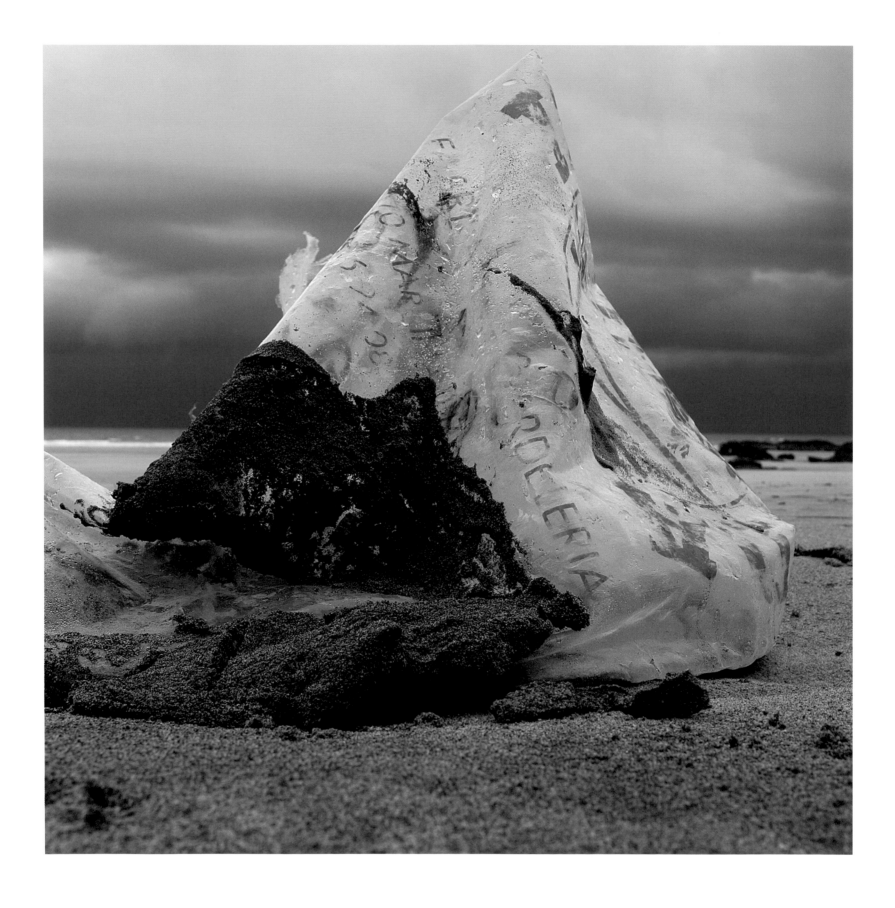

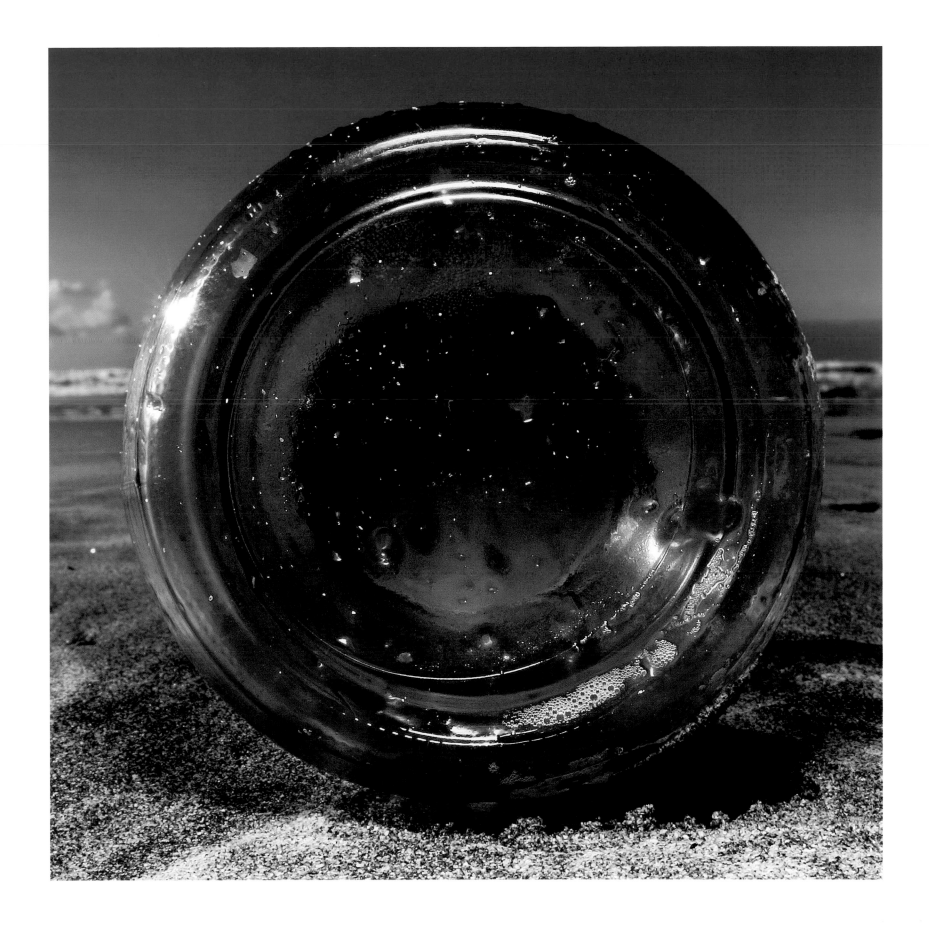

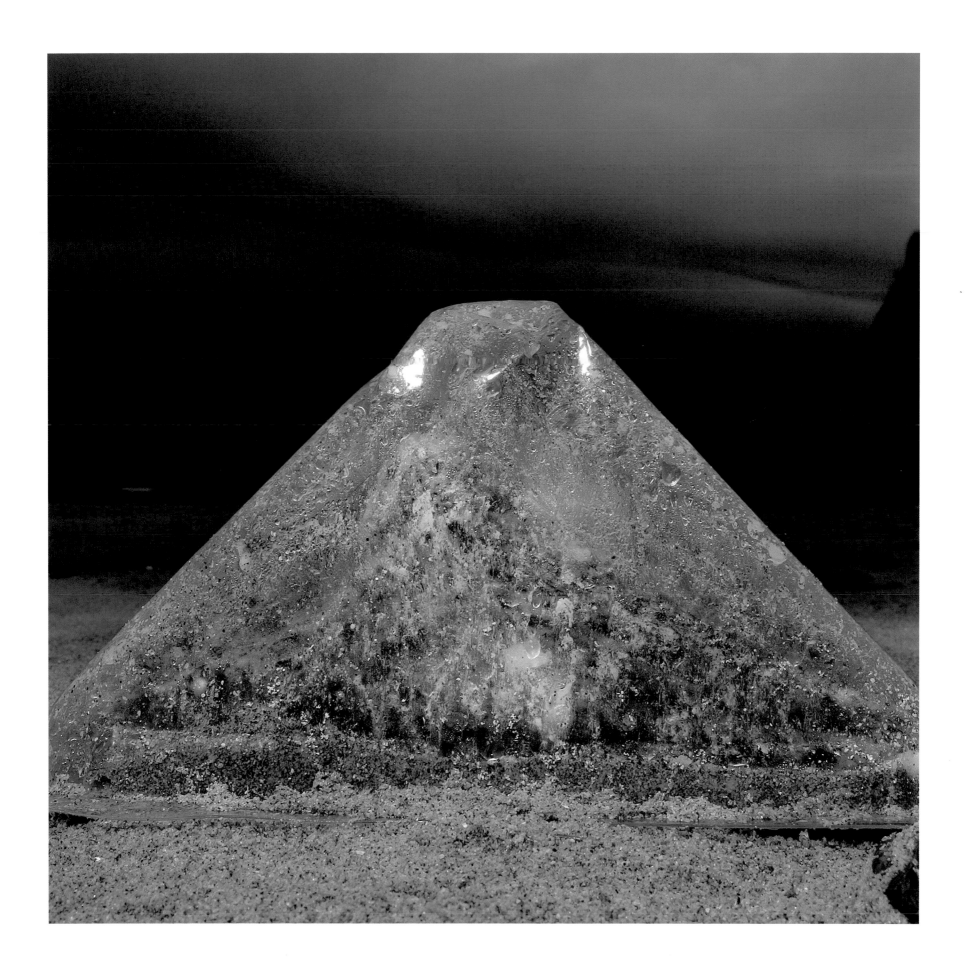

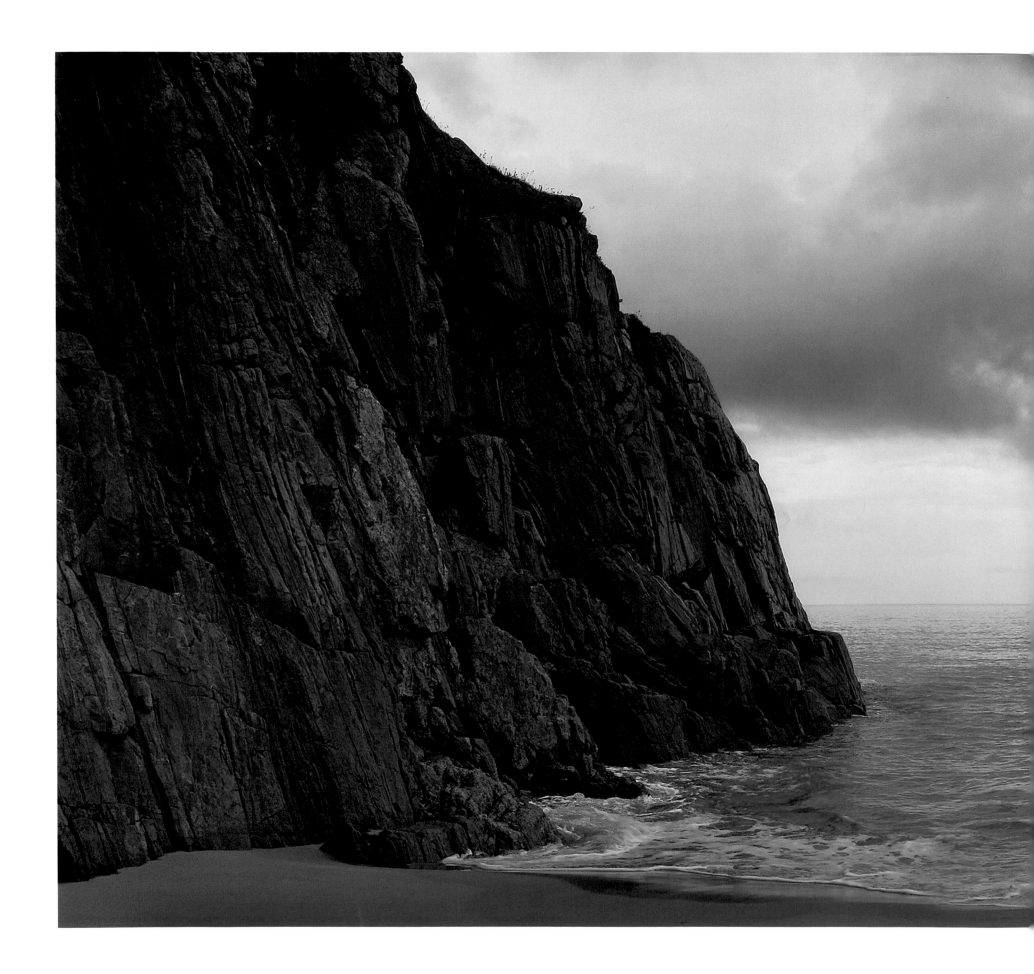

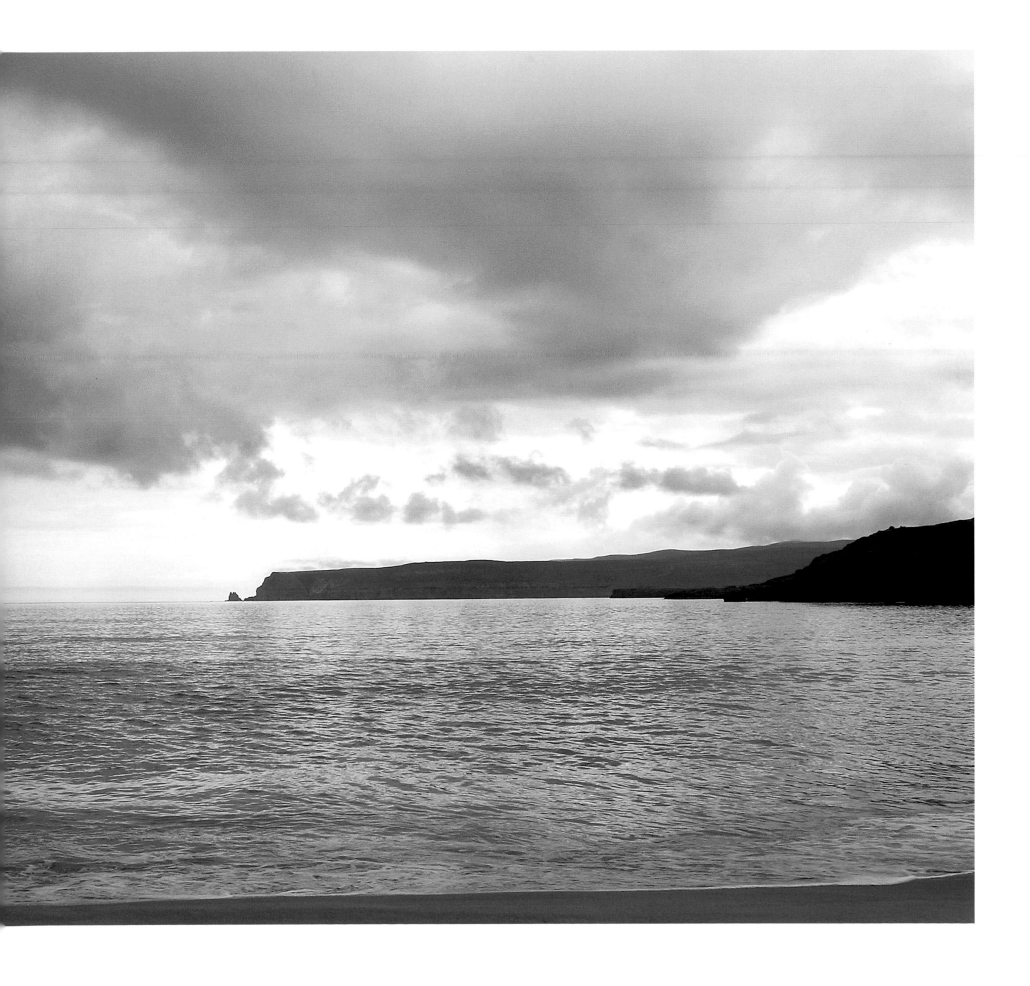

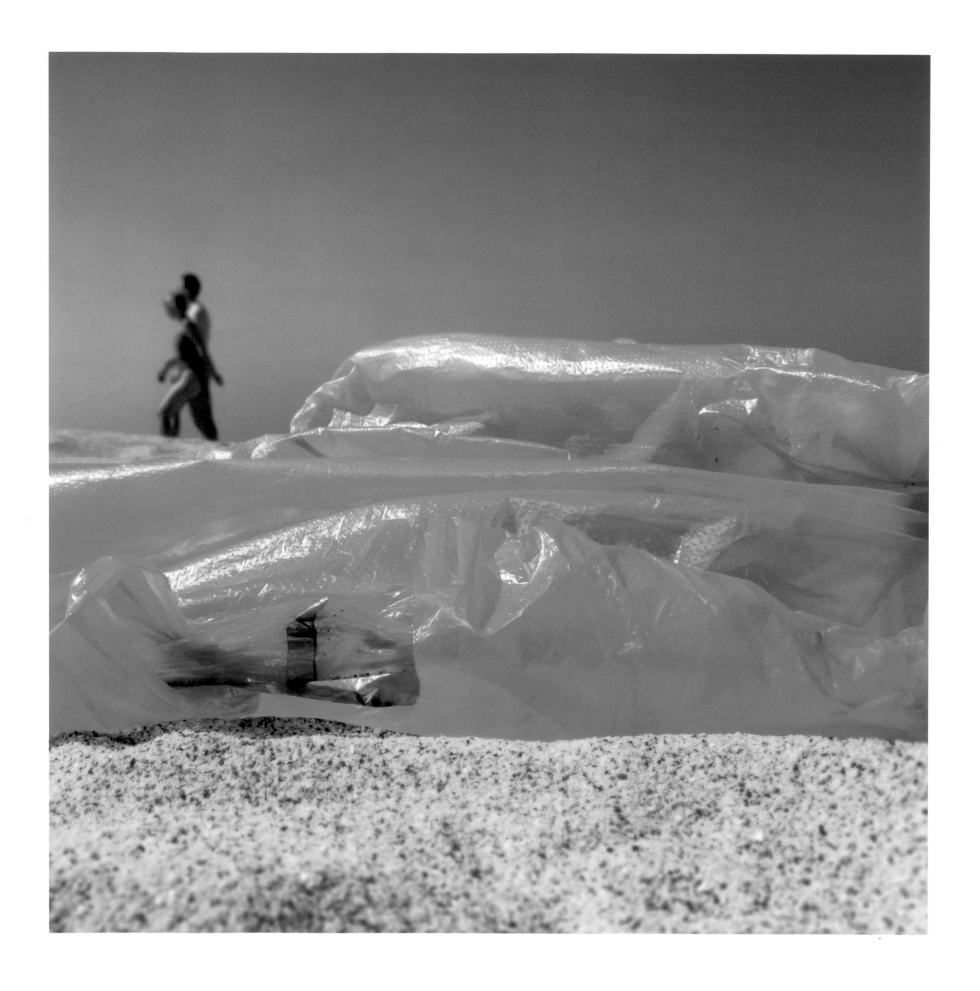

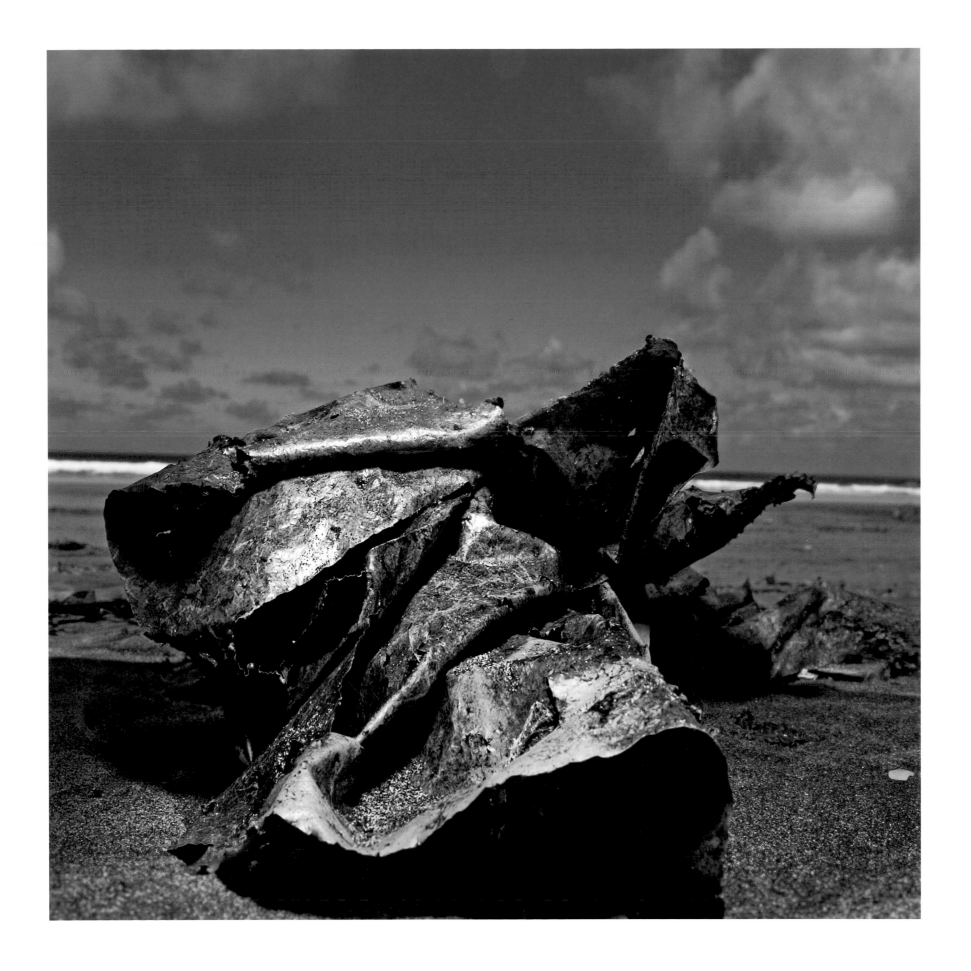

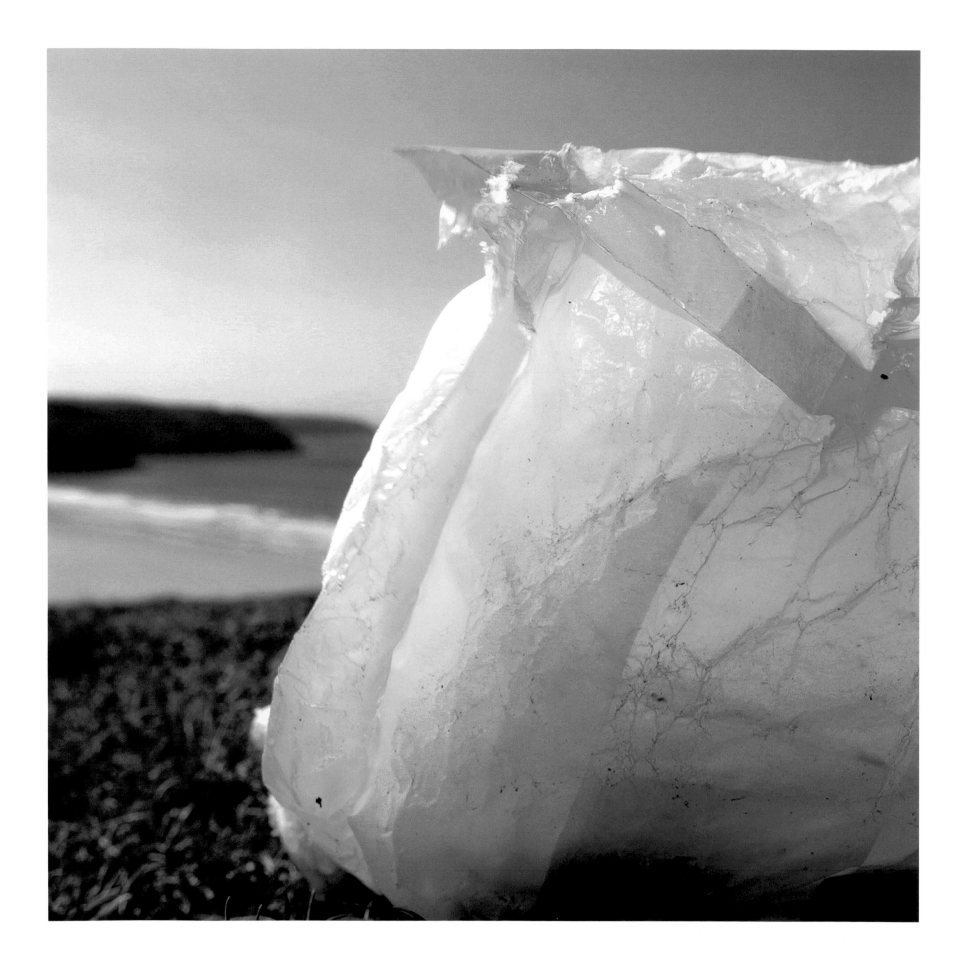

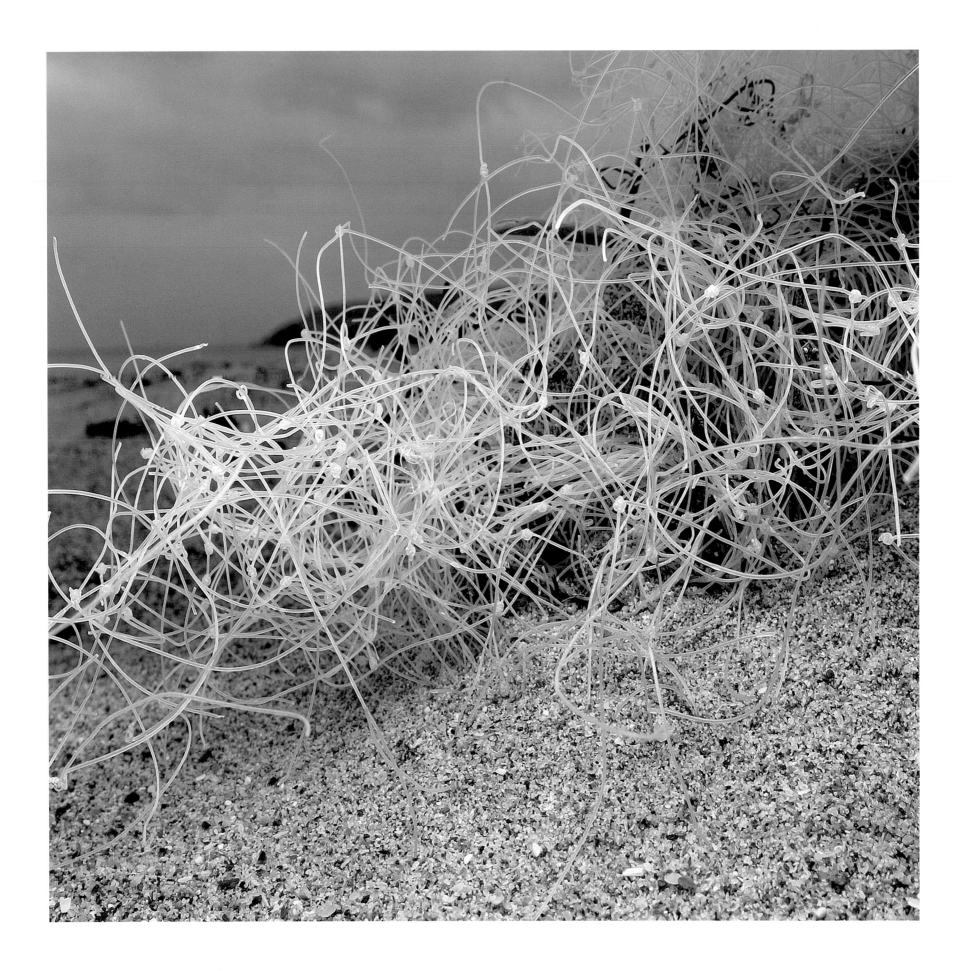

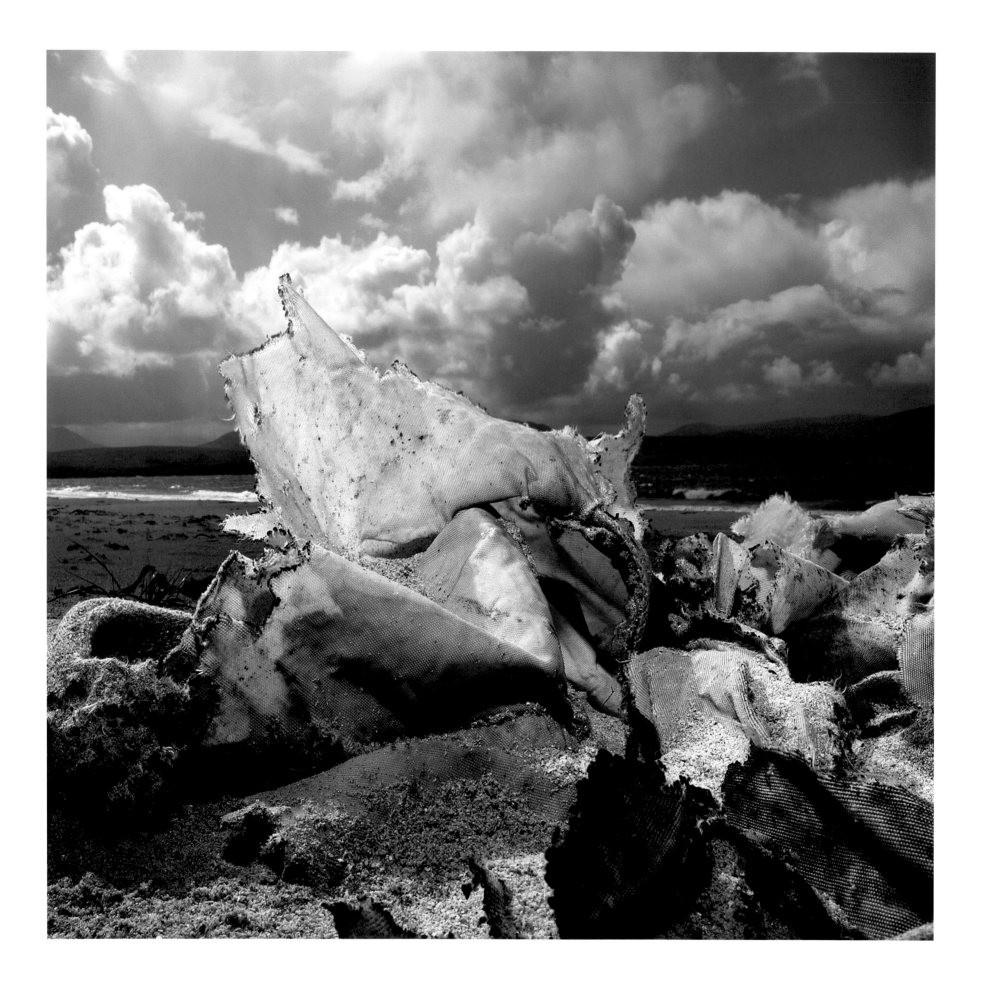

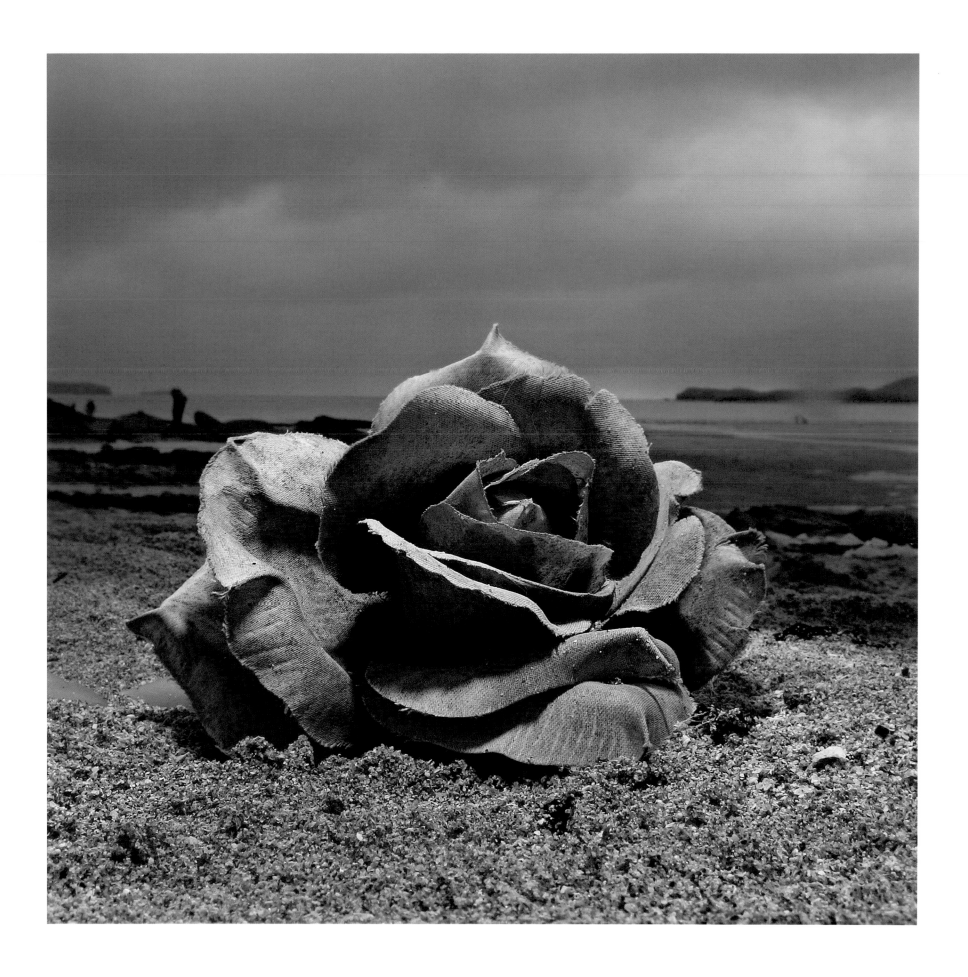

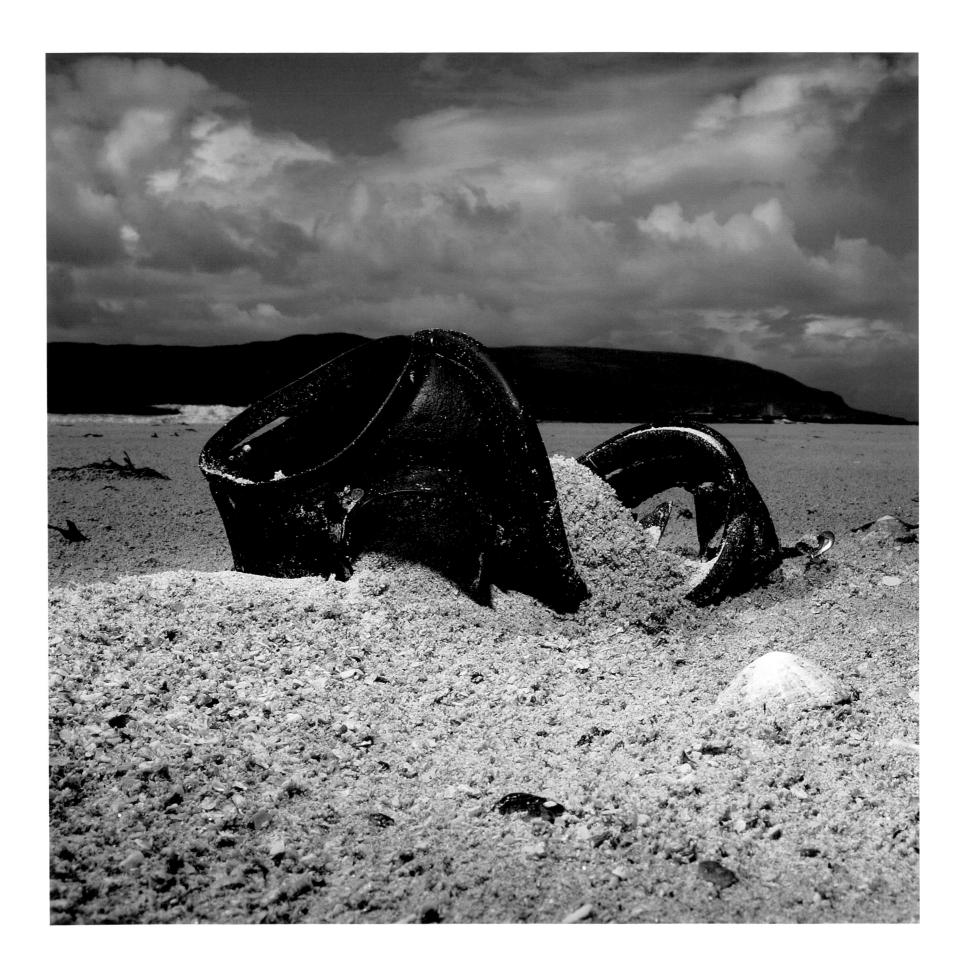

188

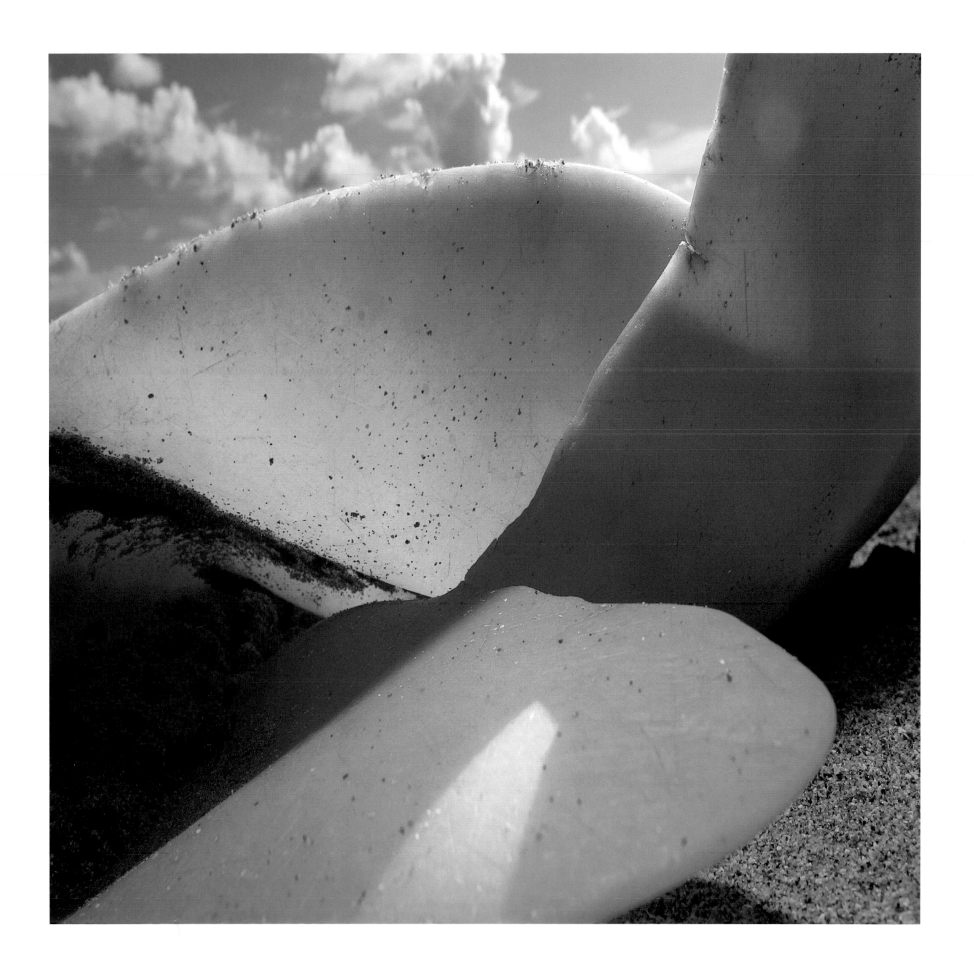

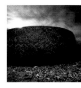

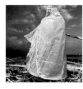
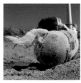
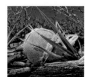
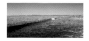
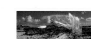
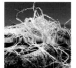

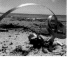
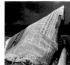
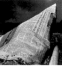

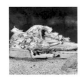
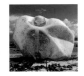
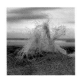
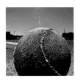
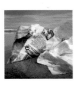
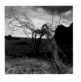
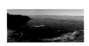
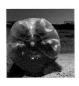
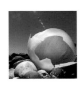
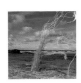
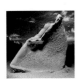
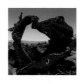
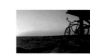
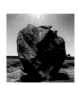
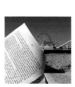

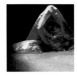
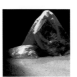

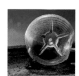
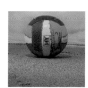

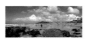
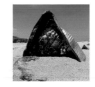
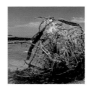
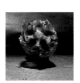
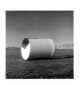

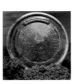
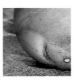
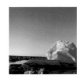
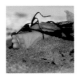

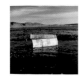

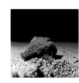
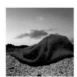
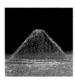
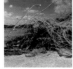
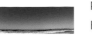
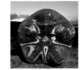

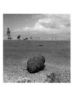

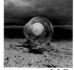

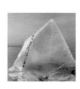
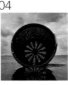
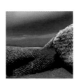
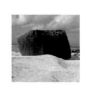

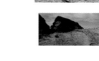

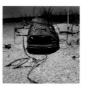
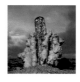
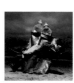
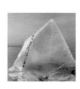

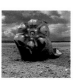
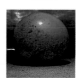
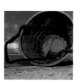

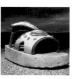
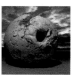
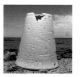

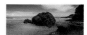
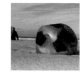

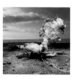

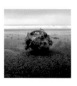
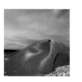
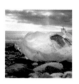
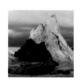
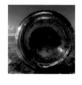
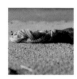
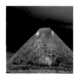

Mexico Towans

Hayle, West Cornwall, England, 2005

page 183

Gwithian Beach

West Cornwall, England, 2005

page 184

Perranporth Sand Dunes

Perranporth, Cornwall, England, 2004

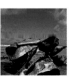

page 185

Holywell Beach

Newquay, Cornwall, England, 2005

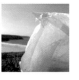

page 186

Balnakeil Beach

Sutherland, Scotland, 2004

page 187

Balnakeil Beach

Sutherland, Scotland, 2004

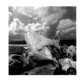

page 188

Balnakeil Beach

Sutherland, Scotland, 2004

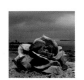

page 189

Sandside Beach

Dounreay, Caithness, Scotland, 2004

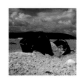

Acknowledgment_

I thank all those friends and colleagues who have encouraged me to make this project happen. This book is also well served by all of the contributing authors who, with patience and insight, complemented and expanded upon the photographic content. I am especially grateful to the following for their thoughts, support and for putting up with my compulsive habit of looking for trash: Anna, Dave, Claire, the Porthtowan posse (they know who they are), Surfers Against Sewage and Jo Geever. My two faithful Jack Russell Terriers, Lily and Maui, have helped me discover particularly gruesome finds along the beach which have not been included in this present volume of work...

Graphic designer David Carson has long been an inspiration for many. His sympathies, perfect for this book, are reflected in his exquisite design and subjective, intuitive approach. I also thank Edward Booth-Clibborn for his judgment, clear vision and willingness to take risks.

Finally, my support and thanks go to those organizations and agencies that offer hope for a better and cleaner world for not only humans but all other organisms that depend upon a greener and cleaner planet, in particular Surfers Against Sewage, the Surfrider Foundation and the Marine Conservation Society.

Andy Hughes 2006

Designer: David Carson has offices in New York, Charleston, South Carolina and Hamburg. His work has been featured in over 180 magazines and newspaper articles around the world.
Newsweek magazine said of Carson that "he changed the public face of graphic design." London based magazine Creative Review dubbed him "Art Director of the Era." He has had many books published and continues to be one of the world's most distinctive typographic voices - much imitated but never matched. He continues to lecture worldwide including a recent relief project in Indonesia to benefit victims of the tsunami disaster.